# Post-Cinematic Affect

# Post-Cinematic Affect

## Steven Shaviro

BOOKS

Winchester, UK
Washington, USA

First published by O-Books, 2010
O Books is an imprint of John Hunt Publishing Ltd., The Bothy, Deershot Lodge, Park Lane, Ropley,
Hants, SO24 0BE, UK
office1@o-books.net
www.o-books.com

For distributor details and how to order please visit the 'Ordering' section on our website.

Text copyright Steven Shaviro 2009

ISBN: 978 1 84694 431 4

A CIP catalogue record for this book is available from the British Library.

Design: Stuart Davies

Printed in the UK by CPI Antony Rowe

We operate a distinctive and ethical publishing philosophy in all
areas of its business, from its global network of authors to
production and worldwide distribution.

# CONTENTS

# Preface

This book is an expanded version of an essay that originally appeared in the online journal *Film-Philosophy*.

Earlier versions of portions of this book were delivered as talks sponsored by the Affective Publics Reading Group at the University of Chicago, by the film and media departments at Goldsmiths College, Anglia Ruskin University, University of the West of England, and Salford University, by the "Emerging Encounters in Film Theory" conference at Kings College, by the Experience Music Project Pop Conference, by the Nordic Summer University, by the Reality Hackers lecture series at Trinity University, San Antonio, and by the War and Media Symposium and the Humanities Center at Wayne State University. My thanks to all my interlocutors at these talks for their comments and suggestions.

This book originated from postings made on my blog, *The Pinocchio Theory* (<http://www.shaviro.com/Blog>), between 2007 and 2009. I also owe a lot to my continual readings of, and conversations with, other bloggers too numerous to mention here. While there is an enormous difference between spur-of-the-moment blog postings, conversations, and rejoinders, and the much slower process of meditating and rewriting that is necessary in order to complete a book, in my case the second of these processes could not have happened without the impetus provided by the first.

This book is dedicated to my daughters, Adah Mozelle Shaviro and Roxanne Tamar Shaviro.

# 1 Introduction

In this book, I look at four recent media productions – three films and a music video – that reflect, in particularly radical and cogent ways, upon the world we live in today. Olivier Assayas' *Boarding Gate* (starring Asia Argento) and Richard Kelly's *Southland Tales* (with Justin Timberlake, Dwayne Johnson, Seann William Scott, and Sarah Michelle Gellar) were both released in 2007. Nick Hooker's music video for Grace Jones' song "Corporate Cannibal" was released (as was the song itself) in 2008. Mark Neveldine and Brian Taylor's film *Gamer* was released in 2009. These works are quite different from one another, in form as well as content. "Corporate Cannibal" is a digital production that has little in common with traditional film. *Boarding Gate*, on the other hand, is not a digital work; it is thoroughly cinematic, in terms both of technology, and of narrative development and character presentation. *Southland Tales* lies somewhat in between the other two. It is grounded in the formal techniques of television, video, and digital media, rather than those of film; but its grand ambitions are very much those of a big-screen *movie*. *Gamer*, for its part, is a digital film made in emulation of computer games. Nonetheless, despite their evident differences, all four of these works express, and exemplify, the "structure of feeling" that I would like to call (for want of a better phrase) post-cinematic affect.

Why "post-cinematic"? Film gave way to television as a "cultural dominant" a long time ago, in the mid-twentieth century; and television in turn has given way in recent years to computer- and network-based, and digitally generated, "new media." Film itself has not disappeared, of course; but filmmaking has been transformed, over the past two decades, from an analog process to a heavily digitized one. It is not my aim here to offer any sort of precise periodization, nor to rehash

1

the arguments about postmodernity and new media forms that have been going on for more than a quarter-century. Regardless of the details, I think it is safe to say that these changes have been massive enough, and have gone on for long enough, that we are now witnessing the emergence of a different media regime, and indeed of a different mode of production, than those which dominated the twentieth century. Digital technologies, together with neoliberal economic relations, have given birth to radically new ways of manufacturing and articulating lived experience. I would like to use the four works I have mentioned in order to get a better sense of these changes: to look at developments that are so new and unfamiliar that we scarcely have the vocabulary to describe them, and yet that have become so common, and so ubiquitous, that we tend not even to notice them any longer. My larger aim is to develop an account of *what it feels like* to live in the early twenty-first century.

I am therefore concerned, in what follows, with effects more than causes, and with evocations rather than explanations. That is to say, I am not looking at Foucauldian genealogies so much as at something like what Raymond Williams called "structures of feeling" (though I am not using this term quite in the manner that Williams intended). I am interested in the ways that recent film and video works are *expressive*: that is to say, in the ways that they give voice (or better, give sounds and images) to a kind of ambient, free-floating sensibility that permeates our society today, although it cannot be attributed to any subject in particular. By the term *expressive*, I mean both *symptomatic* and *productive*. These works are symptomatic, in that they provide indices of complex social processes, which they transduce, condense, and rearticulate in the form of what can be called, after Deleuze and Guattari, "blocs of affect."[1] But they are also productive, in the sense that they do not *represent* social processes, so much as they participate actively in these processes, and help to constitute them. Films and music videos, like other

2

media works, are *machines for generating affect*, and for capitalizing upon, or extracting value from, this affect. As such, they are not ideological superstructures, as an older sort of Marxist criticism would have it. Rather, they lie at the very heart of social production, circulation, and distribution. They generate subjectivity, and they play a crucial role in the valorization of capital. Just as the old Hollywood continuity editing system was an integral part of the Fordist mode of production, so the editing methods and formal devices of digital video and film belong directly to the computing-and-information-technology infrastructure of contemporary neoliberal finance. There's a kind of fractal patterning in the way that social technologies, or processes of production and accumulation, repeat or "iterate" themselves on different scales, and at different levels of abstraction.[2]

What does it mean to describe such processes in terms of affect? Here I follow Brian Massumi (2002, 23-45) in differentiating between *affect* and *emotion*. For Massumi, affect is primary, non-conscious, asubjective or presubjective, asignifying, unqualified, and intensive; while emotion is derivative, conscious, qualified, and meaningful, a "content" that can be attributed to an already-constituted subject. Emotion is affect captured by a subject, or tamed and reduced to the extent that it becomes commensurate with that subject. Subjects are overwhelmed and traversed by affect, but they *have* or *possess* their own emotions. Today, in the regime of neoliberal capitalism, we see ourselves as subjects precisely to the extent that we are autonomous economic units. As Foucault puts it, neoliberalism defines a new mutation of "*Homo oeconomicus* as entrepreneur of himself, being for himself his own capital, being for himself his own producer, being for himself the source of [his] earnings" (2008, 226). For such a subject, emotions are resources to invest, in the hope of gaining as large a return as possible. What we know today as "affective labor" is not really

3

affective at all, as it involves rather the sale of labor-power in the form of pre-defined and pre-packaged emotions.[3]

However, emotion as such is never closed or complete. It also still testifies to the affect out of which it is formed, and that it has captured, reduced, and repressed. Behind every emotion, there is always a certain surplus of affect that "escapes confinement" and "remains unactualized, inseparable from but unassimilable to any *particular*, functionally anchored perspective" (Massumi 2002, 35). Privatized emotion can never entirely separate itself from the affect from which it is derived. Emotion is representable and representative; but it also points beyond itself to an affect that works transpersonally and transversally, that is at once *singular* and *common* (Hardt and Negri 2004, 128-129), and that is irreducible to any sort of representation. Our existence is always bound up with affective and aesthetic flows that elude cognitive definition or capture.[4]

On the basis of his distinction between affect and emotion, Massumi rejects Fredric Jameson's famous claim about the "waning of affect" in postmodern culture (Jameson 1991, 10-12). For Massumi, it is precisely subjective emotion that has waned, but not affect. "If anything, our condition is characterized by a surfeit of [affect]... If some have the impression that affect has waned, it is because it is unqualified. As such, it is not ownable or recognizable and is thus resistant to critique" (Massumi 2002, [27-28]. "The disappearance of the individual subject" with which Jameson is concerned (1991, 16) leads precisely to a magnification of affect, whose flows swamp us, and continually carry us away from ourselves, beyond ourselves. For Massumi, it is precisely by means of such affective flows that the subject is opened to, and thereby constituted through, broader social, political, and economic processes.[5]

Indeed, and despite their explicit disagreement, there is actually a close affinity between Massumi's discussion of transpersonal affect which always escapes subjective

representation, and Jameson's account of how "the world space of multinational capital" is "unrepresentable," or irreducible to "existential experience" (Jameson 1991, 53-54). Intensive affective flows and intensive financial flows alike invest and constitute subjectivity, while at the same time eluding any sort of subjective grasp. This is not a loose analogy, but rather a case of *parallelism*, in Spinoza's sense of the term. Affect and labor are two attributes of the same Spinozian substance; they are both powers or potentials of the human body, expressions of its "vitality," "sense of aliveness," and "changeability" (Massumi 2002, 36). But just as affect is captured, reduced, and "qualified" in the form of emotion, so labor (or unqualified human energy and creativity) is captured, reduced, commodified, and put to work in the form of "labor power." In both cases, something intensive and intrinsically unmeasurable – what Deleuze calls *difference in itself* (Deleuze 1994, 28-69) – is given identity and measure. The distinction between affect and emotion, like the distinction between labor and labor power, is really a radical incommensurability: an excess or a surplus. Affect and creative labor alike are rooted in what Gayatri Spivak describes as "the irreducible possibility that the subject be more than adequate – super-adequate – to itself" (Spivak 1985, 73).

This super-adequacy is the reason why neither the metamorphoses of capital nor the metamorphoses of affect can be grasped intuitively, or represented. But Jameson is quick to point out that, although the "global world system" is "unrepresentable," this does not mean that it is "unknowable" (Jameson 1991, 53). And he calls for "an aesthetic of cognitive mapping" (54) that would precisely seek to "know" this system in a non-representational and non-phenomenological way. This proposal, again, is closer than has generally been recognized to the cartographic project that Massumi inherits from Deleuze and Guattari, and that I would like to call, for my own purposes, an aesthetic of affective mapping.[6] For Jameson and Deleuze and

Guattari alike, maps are not static representations, but tools for negotiating, and intervening in, social space. A map does not just replicate the shape of a territory; rather, it actively *inflects* and *works over* that territory.[7] Films and music videos, like the ones I discuss here, are best regarded as affective maps, which do not just passively trace or represent, but actively construct and perform, the social relations, flows, and feelings that they are ostensibly "about."

In what follows, I map the flows of affect in four dimensions, in conjunction with four "diagrams" of the contemporary social field.[8] All four of these diagrams are more or less relevant to all four of the works that I am discussing; but for heuristic purposes, I will link each work preferentially to a single diagram. The first diagram is that of Deleuze's "control society," a formation that displaces Foucault's Panoptical or disciplinary society (Deleuze 1995, 177-182). The control society is characterized by perpetual modulations, dispersed and "flexible" modes of authority, ubiquitous networks, and the relentless branding and marketing of even the most 'inner' aspects of subjective experience. Such processes of control and modulation are especially at work in the "Corporate Cannibal" video. The second diagram marks out the delirious financial flows, often in the form of derivatives and other arcane instruments, that drive the globalized economy (LiPuma and Lee, 2004). These flows are at once impalpable and immediate. They are invisible abstractions, existing only as calculations in the worldwide digital network, and detached from any actual productive activity. And yet they are brutally material in their "efficacy," or in their impact upon our lives – as the current financial crisis makes all too evident. Financial flows are the motor of subjectivity, most crucially, in *Boarding Gate*. The third diagram is that of our contemporary digital and post-cinematic "media ecology" (Fuller 2005), in which all activity is under surveillance from video cameras and microphones, and in return video screens and speakers, moving images and

synthesized sounds, are dispersed pretty much everywhere. In this environment, where all phenomena pass through a stage of being processed in the form of digital code, we cannot meaningfully distinguish between "reality" and its multiple simulations; they are all woven together in one and the same fabric. *Southland Tales* is particularly concerned with the dislocations that result from this new media ecology. Finally, the fourth diagram is that of what McKenzie Wark calls "gamespace," in which computer gaming "has colonized its rivals within the cultural realm, from the spectacle of cinema to the simulations of television" (Wark 2007, 7). *Gamer* posits a social space in which the ubiquity of gaming has become nearly absolute.

In three of the four works I am discussing, I focus upon the figure of the media star or celebrity. Grace Jones has always been a performance artist as much as a singer. Her music is only one facet of her self-constructed image or persona. "Corporate Cannibal" gives this persona a new twist. *Boarding Gate* is a star vehicle for Asia Argento. Its concerns are close to those of Assayas' earlier films, and especially *Demonlover* (2002); but these concerns are filtered, and rearticulated, through Argento's visceral, self-consciously performative onscreen presence. *Southland Tales* has sprawling, multiple plotlines and an ensemble cast; but nearly all its actors, including Justin Timberlake, are pop culture figures who actively play against their familar personas. Kelly thereby creates a sort of affective (as well as cognitive) dissonance, a sense of hallucinatory displacement that largely drives the film.

Jones, Argento, and Timberlake are all perturbing presences, exemplary figures of post-cinematic celebrity. They circulate endlessly among multiple media platforms (film, television talk shows and reality shows, music videos and musical recordings and performances, charity events, advertisements and sponsorships, web- and print-based gossip columns, etc.), so that

7

they seem to be everywhere and nowhere at once. Their ambivalent performances are at once affectively charged and ironically distant. They enact complex emotional dramas, and yet display a basic indifference and impassivity. I feel involved in every aspect of their lives, and yet I know that they are not involved in mine. Familiar as they are, they are always too far away for me to reach. Even the *Schadenfreude* I feel at the spectacle of, say, Britney's breakdown or Madonna's divorce backhandedly testifies to these stars' inaccessibility. I am enthralled by their all-too-human failures, miseries, and vulnerabilities, precisely because they are fundamentally inhuman and invulnerable. They fascinate me, precisely because it is utterly impossible that they should ever acknowledge, much less reciprocate, my fascination.

In short, post-cinematic pop stars allure me. The philosopher Graham Harman describes *allure* as "a special and intermittent experience in which the intimate bond between a thing's unity and its plurality of notes somehow partly disintegrates" (Harman 2005,143). For Harman, the basic ontological condition is that objects always withdraw from us, and from one another. We are never able to grasp them more than partially. They always hold their being in reserve, a mystery that we cannot hope to plumb. An object is always more than the particular qualities, or "plurality of notes," that it displays to me. This situation is universal; but most of the time I do not worry about it. I use a knife to cut a grapefruit, without wondering about the inner recesses of knife-being or grapefruit-being. And usually I interact with other people in the same superficial way. Now, in general this is a good thing. If I were to obsess over the inner being of each person I encountered, ordinary sociability would become impossible. It is only in rare cases – for instance when I intensely love, or intensely hate, someone – that I make the (ever-unsuccessful) attempt to explore their mysterious depths, to find a real being that goes beyond the particular qualities that they display to me. *Intimacy* is what we call the situation in which

people try to probe each other's hidden depths.[9]

What Harman calls *allure* is the way in which an object does not just display certain particular qualities to me, but also insinuates the presence of a hidden, deeper level of existence. The alluring object explicitly *calls attention* to the fact that it is something more than, and other than, the bundle of qualities that it presents to me. I experience allure whenever I am intimate with someone, or when I am obsessed with someone or something. But allure is not just my own projection. For any object that I encounter *really is* deeper than, and other than, what I am able to grasp of it. And the object becomes alluring, precisely to the extent that it forces me to acknowledge this hidden depth, instead of ignoring it. Indeed, allure may well be strongest when I experience it *vicariously*: in relation to an object, person, or thing that I do not actually know, or otherwise care about. Vicarious allure is the ground of aesthetics: a mode of involvement that is, at the same time, heightened and yet (as Kant puts it) "disinterested." The inner, surplus existence of the alluring object is something that I cannot reach – but that I also cannot forget about or ignore, as I do in my everyday, utilitarian interactions with objects and other people. The alluring object insistently displays the fact that it is separate from, and more than, its qualities – which means that it exceeds everything that I feel of it, and know about it. This is why what Kant calls a judgment of beauty is non-conceptual and non-cognitive. The alluring object draws me beyond anything that I am actually able to experience. And yet this 'beyond' is not in any sense otherworldly or transcendent; it is situated in the here and now, in the very flows and encounters of everyday existence.

Pop culture figures are vicariously alluring, and this is why they are so affectively charged. They can only be grasped through a series of paradoxes. When a pop star or celebrity allures me, this means that he or she is someone to whom I respond in the mode of intimacy, even though I am not, and

cannot ever be, actually intimate with him or her. What I become obsessively aware of, therefore, is the figure's distance from me, and the way that it baffles all my efforts to enter into any sort of relation with it. Such a figure is forever unattainable. Pop stars are slippery, exhibiting singular qualities while, at the same time, withdrawing to a distance beyond these qualities, and thus escaping any final definition. This makes them ideal commodities: they always offer us more than they deliver, enticing us with a "promise of happiness" that is never fulfilled, and therefore never exhausted or disappointed. In terms of a project of affective and cognitive mapping, pop stars work as anchoring points, as particularly dense nodes of intensity and interaction. They are figures upon which, or within which, many powerful feelings converge; they *conduct* multiplicities of affective flows. At the same time, they are always more than the sum of all the forces that they attract and bring into focus; their allure points us elsewhere, and makes them seem strangely absent from themselves. Pop culture figures are *icons*, which means that they exhibit, or at least aspire to, an idealized stillness, solidity, and perfection of form. Yet at the same time, they are fluid and mobile, always displacing themselves. And this contrast between stillness and motion is a generative principle not just for celebrities themselves, but also for the media flows, financial flows, and modulations of control through which they are displayed, and that permeate the entire social field.

# 2 Corporate Cannibal

Nick Hooker's video for Grace Jones' "Corporate Cannibal" is in black and white. Or, more precisely, it is just in black. The only images that appear on the screen are those of Jones' face and upper body. These images were captured by two video cameras, in a single take. The director recalls that, at the time of the shoot, Jones had just spent several months in Jamaica; as a result her skin "was intensely black, like *dark*, dark black." There is no background to contrast with the black of Jones' figure, or with what Hooker calls "the raw glow of her skin" (Hermitosis 2008). The video was actually shot in color, with a white wall for background; but in postproduction the director "desaturated the footage...and brought up the contrast which made the white wall fall away entirely and consequently enhanced the blackness of her skin" (Hooker 2009). As a result of this treatment, there is literally nothing in the video aside from Jones' skin, her features, and her silhouette. Behind her, there is only an empty blankness; it is this absence of any image whatsoever that we see as white. Evidently this play of black and white, and of full and empty, has racial implications, as well as formal and visual ones – implications to which I shall return.

The video works by continually manipulating Grace Jones' figure. In the course of the song's six minutes and eight seconds, this figure swells and contracts, bends and fractures, twists, warps, and contorts, and flows from one shape to another. At the start, there is just a twisted, diagonal double band, extending across the empty screen like a ripple of electronic disturbance; but this quickly expands into Jones' recognizable image. At the end of the video, the entire screen goes black, as if it had been entirely consumed by Jones' presence. In between, Jones' image is unstable and in flux; nothing remains steady for more than a few seconds. Certain configurations tend to recur, however. In

the most common of these, Jones' body, and especially her face, are elongated upwards. It is as if she had an impossibly long forehead, or as if her notorious late-1980s flattop haircut had somehow expanded beyond all dimensions. Along with being distended, Jones' body is also thinned out: made gracile (if that isn't too much of a pun) and almost insectoid. At other times, in extreme close-up, Jones' mouth stretches alarmingly as if it were about to devour you; or one of her eyes bulges out and smears across the screen like a toxic stain. Sometimes her whole figure multiplies, as if in a house of mirrors, into several imperfectly separated clones. And sometimes, we even get to see a nearly undistorted shot of Jones' eyes, nose, and mouth. But then it is gone, twisted out of shape again, almost before we are able to take it in.

In spite of all these distortions, Jones remains recognizable throughout. This is not surprising when you consider that, after all, Grace Jones has never looked (or sounded) remotely like anyone else. Even in her early modeling days, before she became a singer and performer, she stood out by dint of sheer ferocity. At the peak of her popularity, in the late 1970s and early 1980s, her persona was hard-edged and confrontational. She went through many changes, but what always remained the same was a sense that nobody could mimic her or replace her – and that they'd better not even try. The "Corporate Cannibal" video extends this history. Even as it melts and scatters Jones' features, it retains their abrasive, angular uniqueness. In the course of the video's manipulations of her image, Jones' appearance loses all identity; it is never "the same" from one moment to the next. And yet her figure continues to insistently confront us. As we hear her voice on the soundtrack, her lips and mouth hold our visual attention. Through all its changes, Jones' figure projects a certain *style* or *emphasis*; it *marks* the screen in a unique way. Such is Jones' *singularity* as a pop culture icon. I mean this in an almost material way. Nick Hooker recalls that, when he started to work on Jones'

image in post-production, "I realised quickly that she started to feel like an oil spill" (Hooker 2009). I take this to mean that her figure on screen is fluid and mutable, but at the same time thick and viscous. It never goes away; and it retains a certain dense materiality, even within the weightless realm of digital, electronic images. It thereby resists the very transformations that it also expresses. "When the music ended," Hooker says, "I imagined Grace returning to such a state: silent, still, shapeless" (Hooker 2009). The stickiness and inertia of Jones' image, its material self-retention through all its fluid transformations, is what I call her iconic singularity, without identity.[10]

Nick Hooker's earlier music videos, for U2 and other bands, make use of the same kinds of electronic manipulation that we find in "Corporate Cannibal."[11] But many of these earlier videos are in full color; they are often wholly abstract; and they tend to involve full-field transformations, rather than concentrating on a single human figure. As a result, they feel trippy and psychedelic – in contrast to the harshness and ferocity of "Corporate Cannibal." These earlier videos are about free-flowing metamorphosis; but "Corporate Cannibal" is about *modulation*, which is something entirely different. Metamorphosis is expansive and open-ended, while modulation is schematic and implosive. Metamorphosis implies "the ability...to move laterally across categories" (Krasniewicz 2000, 53); but modulation requires an underlying fixity, in the form of a carrier wave or signal that is made to undergo a series of controlled and coded variations.[12] Metamorphosis gives us the sense that anything can happen, because form is indefinitely malleable. But the modulations of "Corporate Cannibal" rather imply that no matter what happens, it can always be contained in advance within a predetermined set of possibilities. Everything is drawn into the same fatality, the same narrowing funnel, the same black hole. There is no proliferation of meanings, but rather a capture of all meanings. Every event is translated into the same binary

code, and placed within the same algorithmic grid of variations, the same phase space.

The "Corporate Cannibal" video consists in continual modulations of Grace Jones' figure. It thereby exemplifies – and internalizes or miniaturizes – *modulation* as the central mechanism of what Gilles Deleuze calls the emerging *control society*. Modulation works, Deleuze says, "like a self-transmuting molding continually changing from one moment to the next, or like a sieve whose mesh varies from one point to another" (Deleuze 1995, 179). That is to say, in a regime of modulation there are no fixed or pregiven forms. In Foucault's disciplinary society, as in the regime of Fordist industrial production, everything was forced into the same fixed mold: workers were held to the same disciplinary rhythms on the assembly line, and products were identical and interchangeable. But in the control society, or in the post-Fordist information economy, forms can be changed at will to meet the needs of the immediate situation. The only fixed requirement is precisely to maintain an underlying *flexibility*: an ability to take on any shape as needed, a capacity to adapt quickly and smoothly to the demands of any form, or any procedure, whatsoever.

Flexibility is valued today, in the first place, as a way to cut costs, by making just-in-time production possible. In the second place, flexibility is the attribute that "new economy" corporations look for in their employees: workers must be *"adaptible* and *flexible,* able to switch from one situation to a very different one, and adjust to it; and *versatile,* capable of changing activity or tools, depending on the nature of the relationship entered into with others or with objects" (Boltanski and Chiapello 2007, 112). And finally, flexibility also characterizes consumers, who no longer settle for Fordist standardization and uniformity, but instead demand products that are customized for their own particular "preferences," or whims of the moment. In a world of *flexible accumulation* (Harvey 2006, 141-172), modulation is the

process that allows for the greatest difference and variety of products, while still maintaining an underlying control.

Of course, modulation is not just a special feature of "Corporate Cannibal"; it is a basic characteristic of digital processes in general.[13] All digital video is expressed in binary code, and treated by means of algorithmic procedures, allowing for a continual modulation of the image. But in "Corporate Cannibal," these technical means, or conditions of possibility, become the video's overt, actual content. Here, the medium really is the message. I have already noted that the whiteness behind Jones' image is a void and not a background. This has important consequences for how we apprehend the video. Usually we 'read' images in terms of a figure-ground relationship; but we cannot look at "Corporate Cannibal" in such a way. Jones' imaged body is not a figure in implied space, but an electronic *signal* whose modulations pulse across the screen. The screen works as a material support *for* this signal/image. But the screen does not itself emit a signal; and it is not present, and does not figure anything, *within* the image. "Corporate Cannibal" is therefore neither a classical work (like, say, the films of Renoir) in which the screen is a window upon a represented world, nor a modernist work (like, say, the films of Godard) that reflexively focuses upon the materiality of the screen itself as a surface.[14]

In contrast to both classical and modernist paradigms, "Corporate Cannibal" does not offer us any preexisting structure of space within which Jones' signal/image might be located. There is only an electromagnetic field that is dynamically generated by the signal itself in the course of its continual modulations. "Corporate Cannibal," therefore, does not imply, and does not take place within, the absolute, perspectival space of ordinary perceptual experience. Rather, the video constructs a *relational space*, of the sort theorized by Leibniz and Whitehead, and more recently by David Harvey. As Harvey describes it, "the relational view of space holds that there is no such thing as space

or time outside of the processes that define them... Processes do not occur *in* space but define their own spatial frame. The concept of space is embedded in or internal to process" (Harvey 2006, 123). Relational space varies from moment to moment, along with the forces that generate and invest it. It continually alters its curvature and its dimensions; it does not persist as a stable, enduring container for objects that would be situated solidly within it.[15]

This means that the space presented by "Corporate Cannibal" is radically different from any sort of cinematic space. Analog photography and film are indexical; as David Rodowick puts it, they "transcribe or document rather than represent" (Rodowick 2007, 58). Their very materiality consists in the persisting chemical traces of objects that actually stood before the camera at a particular time, in a particular place. Cinema therefore always assumes – because it always refers back to – some sort of absolute, pre-existing space. And this referentiality, or "see[ing] at a distance in time" (Rodowick 2007, 64), is what allows it to be, as well, a record of *duration*. But such is no longer the case for digital video. As we have seen, Grace Jones' hyperbolic figure in "Corporate Cannibal" generates its own space, in the course of its modulations. And these modulations happen in "real time," in a perpetual present, even though the video is prerecorded.

It is true, of course, that Jones actually did stand before the camera, at one point in the production of "Corporate Cannibal." But the video's *ontological consistency* does not depend, in the way that a film would, upon the fact of this prior physical presence. "Corporate Cannibal" does not point us back to what André Bazin described as the fundamental stake of all photography and cinematography: "the object itself... the image of things [that] is likewise the image of their duration" (Bazin 2004, 14-15). In contrast to analog photography as described by Roland Barthes, digital video no longer offers us "a certificate of presence"; it can no longer "attest that what I see has indeed existed" (Barthes

1981, 87, 82). More generally, there is no room, in relational space, for the uncanny sense of "space past...the curious sentiment that things absent in time can be present in space," that Rodowick identifies as a basic ontological feature of traditional photography and film (Rodowick 2007, 63, 67).

Instead, as Rodowick complains, "nothing moves, nothing endures in a digitally composed world... in digital cinema there is no longer continuity in space and movement, but only montage or combination" (Rodowick 2007,171-173). Where classical cinema was analogical and indexical, digital video is processual and combinatorial. Where analog cinema was about the duration of bodies and images, digital video is about the articulation and composition of forces. And where cinema was an art of individuated presences, digital video is an art of what Deleuze calls the *dividual*: a condition in which identities are continually being decomposed and recomposed, on multiple levels, through the modulation of numerous independent parameters (Deleuze 1995, 180, 182).[16]

"Corporate Cannibal," therefore, does not refer back indexically to Grace Jones' body as a source or model. It does not image, reflect, and distort some prior, and supposedly more authentic, actuality of Jones-as-physical-presence. We should say, instead, that the video's multiple inputs include images of Jones lip-synching her song. These inputs were sampled by two digital devices, one sensitive to signals in the visual spectrum, and the other to infrared signals. In the course of post-production, these inputs were made to *enter into composition* with one another, and with certain other inputs: most notably, with the audio signals of the prerecorded song (which include, but are not limited to, digital samples of Jones' voice). This means that Grace Jones' figure is a complex, aggregated, and digitally coded electronic signal – rather than a "visual transcription," a "witnessing or testimony," as Rodowick characterizes the cinematic image (Rodowick 2007, 58, 61). Jones' face, her torso,

and her voice – the dividual elements of her persona – are themselves, already, electricity, light (or darkness) and sound, digital matrix and intense vibration. Nick Hooker does not manipulate Jones' image, so much as he modulates, and actively recomposes, the electronic signals that she already is, and whose interplay defines the field of her becoming.[17]

In other words, the electronic image is one more iteration – and a particularly visceral one, at that – of "Grace Jones" as a celebrity icon. I say *iteration*, rather than *version*, or *copy*, because there is no original, or Platonic ideal, of a celebrity: all instances are generated through the same processes of composition and modulation, and therefore any instance is as valid (or "authentic") as any other. "Corporate Cannibal" is only the most recent in a long string of Jones' reinventions of herself. Over the course of her career, she has continually rearranged her body, her appearance, and her overall persona. Now, there may well be a gap between Grace Jones the private person, and "Grace Jones" the iconic celebrity. Indeed, Jean-Paul Goude, Jones' partner and artistic collaborator in the late 1970s and early 1980s, and the father of her son, says that their personal relationship fell apart when Jones "felt I had started to love the character we had created more than I loved her" (McDowell 2005). But the very point of this anecdote is that "Grace Jones," the character or persona, exists actually in the world, just as much as Jones the private person does – and precisely because these two do not coincide. Jones the private person is not the model, or the privileged source, of Jones the icon. If anything, the problem for Goude, and perhaps for us as well, has to do with whether it is even possible for Jones the human person to have as full an existence as her image does: to live up to the demands, and the promises, of Jones the celebrity figure.[18] In any case, the iconic "Grace Jones" is just as 'real' an object, or a presence, as any other – even if its mode of being involves, not just the medium of the flesh, but many other media as well. We encounter "Grace Jones"

the icon in the physical spaces of the runway and the concert stage, the virtual spaces of television studios and movie sets, and the relational spaces of video screens and computer monitors. Jones as celebrity construct is present in her skin, in her make-up, in her clothes, in her live performances, in her photographs and movies and videos, and in her sound recordings, both analog and digital. The figure we know as "Grace Jones" simply *is* the "historic route of living occasions" (as Whitehead would call it: 1929/1978, 119) through which it has passed, the entire series of its transductions, translations, and modulations.

These transformations have always had a transgressive and confrontational edge. Jones' performances in the late 1970s and early 1980s appropriated, mocked, and inverted traditional (racist and sexist) signifiers of blackness and whiteness, and of femininity and masculinity. In the first place, Jones created spectacles that parodically embraced historically dominant white Euro-American images of black people – including animalistic images, and images drawn from minstrelsy – in order to throw them back in the face of the audience. And in the second, she alternately exhibited herself in masculine drag (with references to boxers and other athletes) and in such stereotypical items of "feminine" (drag queen) display as stiletto heels. Jones' performances of this period, as Miriam Kershaw puts it, "oscillated between exploiting the 'feminine' myth of 'primitive' sensuality and the 'masculine' construction of threatening savagery," in order to make an "ironic commentary on this iconography of power and subordination" (Kershaw 1997, 21). In other words, Jones *embodied* an all-too-familiar racist and sexist iconography with such vicious, sarcastic excess as to blow it apart. At the same time, she crossed the boundaries separating men from women not with a cozy androgyny, nor even with the 'glam rock' stylizations of the period, but by displaying a cold and forbidding, more-than-masculine, and ultimately ungenderable hardbody.

In thus transgressing boundaries of gender and race, the iconic "Grace Jones" pushes beyond the human altogether. She embraces her own extreme objectification, her packaging as a saleable commodity. And she transforms herself (well before this became fashionable) into a posthuman or transhuman being, a robot or cyborg. In the words of Anneke Smelik, Jones appears as "the ultimate hi-tech product... present[ing] self-images with quotations from the world of advertising and fashion photography" (Smelik 1993). Or as Mark Fisher puts it, Jones makes herself into a chilly object-machine, whose "screams and...laughter seem to come from some Other place, a dread zone from which Jones has returned, but only partially. Is it the laughter of one who has passed through death or the scream of a machine that is coming to life? " (Fisher 2006). In this way, Jones doesn't just express a new or different mode of subjectivity. She doesn't just give voice to a black female perspective that was previously excluded from public expression. In addition, she *also* transgresses the very sense of what it means to be a self or a subject at all. She turns herself into a *thing* – thereby forcing us to confront the ways that slavery and racism turn black people into things, that patriarchy turns women into things, and that capitalism turns all of us into commodities, or strangely animated things. She revivifies, and reclaims the powers latent within, all of these reifications. She embodies, and transmits, flows of affect that are so intense, and so impersonal and inhuman, that they cannot be contained within traditional forms of subjectivity. This is what makes her performances so explosively charged, and yet at the same time so cold and distant, so *alien* or inhuman. "Grace Jones" has moved beyond identification, and beyond any sort of identity politics, into an entirely different realm: one that can only be expressed in the terms of science fiction.

Donna Haraway, writing in the early 1980s – at the very moment of Jones' greatest fame as a performer – identified three

"boundary breakdowns" that she saw as harbingers of a new "informatics of domination," but also as the conditions of possibility for an emerging "cyborg politics" that would be "oppositional, utopian, and completely without innocence" (Haraway 1991, 151 and 149-181 passim). In our networked and globalized postmodern world, where "the boundary between science fiction and social reality is an optical illusion" (149), there are no longer firm oppositions, but only increasingly "leaky distinctions," first "between human and animal" (151), then "between animal-human (organism) and machine" (152), and finally "between physical and non-physical," or between material, mechanical devices and ones that are pure energy, "nothing but signals, electromagnetic waves, a section of a spectrum" (153). In the course of her crossings from black to white, and from female to male, Jones also enacts all three of Haraway's boundary breakdowns. In her performances of the late 1970s, "she becomes identified with the animal kingdom" (Kershaw 1997, 20), both mocking and reappropriating Euro-American racism's ascription of animality to black people. In her more commercial phase of the 1980s, when she moves musically from disco to "new wave and experimental-based work," and "replac[es] her S&M look of the '70s with a detached, androgynous image" (Prato 2009), she traces a passage between organism and machine. And finally, in "Corporate Cannibal," her persona casts off the constraints of locality, and achieves modulation as a digital signal.

All these transformations are dangerous – and Grace Jones evidently savors this danger. Indeed, she makes her living from it. The danger comes from the fact that transgression, reappropriation, and *détournement* are all inherently ambiguous. Precisely because it is so radical, Jones' work continaully and unavoidably "risks misreading" (Royster 2009, 84). Every act of transgression offers at least a backhanded compliment to the order, the norm, or the law that is being transgressed – since it is

only the continuing power of that order, norm, or law that gives meaning to the action of defying it. If gender binaries and hierarchies were ever to disappear, for instance, drag performance would lose all of its bite. But boundaries that are in process of breaking down have not yet, by that very fact, been altogether abolished; leaky distinctions are ones that have lost some of their force, but that nonetheless are still being made. For their part, reappropriation and *détournement* necessarily run the risk of giving new life to the very forces that they endeavor to hijack, and turn to different ends. In drawing on cultural memories of oppression and degradation, they reinforce those very memories. No performance is entirely able to control its own reception and interpretation. Jones' feral and animalistic gestures work to explode a whole racist mythology; but they cannot escape the risk of also perpetuating that mythology.

I think that the power of Grace Jones as a media icon comes from the way that she addresses these paradoxes head on, foregrounding them in her performances. In this regard, it is instructive to compare Jones' star persona with that of her younger colleague and rival, Madonna. Both divas emerged from the world of disco and camp performance. Both gained notoriety for self-consciously "performing" their femininity, and thereby denaturalizing it. And both were able to move from a cult following largely among gay men into a much broader mainstream popularity. Both Grace Jones and Madonna flaunt an aggressive sexuality that is at odds with older norms of how women were supposed to behave. But both of them nonetheless remain acutely aware that the "post-feminist" sexual freedom which they celebrate is also intensely commodified. This is why they present themselves, simultaneously, both as voraciously consuming subjects, and as glitzy, perfectly sculpted objects to be consumed.

And yet, despite this common ground, there is a vast difference between these two performers. Madonna puts on and

takes off personas as if they were clothes; indeed, the clothes are often what make the persona. The brilliance of this strategy lies in the way that it suggests that everything is merely a matter of surfaces, or of style. There is nothing beneath the surface; there are no depths and no essences. All "identities" are factitious; and this allows Madonna to play with them innocently and pleasurably. Because these personas are all stereotypes and fictions, and self-consciously known to be so, none of them is irreversible, and none of them has any real cost (apart from the up-front financial one). Madonna's transformations never have serious consequences, and this is why she is free to indulge in them.

Grace Jones' transformations are altogether more troubling. In a sense, they are incised more deeply in the performer's flesh – for all that they are (no less than Madonna's) a function of clothes and styles and the powers of the fashion world. Jones' changes are "deeper" than Madonna's because they have to be: without Madonna's white skin privilege, Jones cannot treat her self-mutations as casually as Madonna does. She cannot retreat into the anonymity that is the implicit background of Madonna's performances, the neutrality and lack-of-depth that exists (or rather, doesn't exist) behind all the costumes. Grace Jones, as a black woman, is always already "marked" as a body – in a way that Madonna Ciccone, simply by virtue of being white, is not. This means that Jones cannot simply dismiss depth, and present a play of pure surfaces, in the way that Madonna can. She has much more at stake in her transformations than Madonna could ever have.

And so, if Madonna's transformations are playful and fantasy-like, Grace Jones' transformations are considerably harder and harsher. This doesn't mean that they are devoid of pleasure. But Jones' own pleasure in them is not necessarily something that she transmits to, and shares with, her audience. She always stands alone, apart from us. That is to say, Jones'

figures, unlike Madonna's, are not necessarily ones that "we" (her admirers) can identify with. Think of the difference between the coyness of Madonna's "Like a Virgin" and the Ballardian savagery of Jones' "Warm Leatherette." Jones never stops being a dominatrix – something that Madonna definitely is not, for all of her diva airs, and her willingness to toy around with the edges of s&m. Madonna admirably plays with the image of "femininity," exulting in its artifice, its artificiality, and its inessentiality; but Grace Jones aims instead to blast this "femininity" apart, or to blast it into outer space.

The difference between Madonna and Grace Jones is therefore both affective and ontological. Where Madonna is playful, Jones is playing for keeps. And where Madonna critiques subjectivity by suggesting that it is just a surface-effect with nothing behind it, Jones critiques it by actually delving beneath the surfaces, or into the depths of the body, to discover a dense affectivity that is not subjective any longer. Jones rejects the subordination that Western culture has so long written into the designations of both "woman" and "black"; but she does this neither by recuperating femininity and blackness as positive states, nor by claiming for herself the privileges of the masculine and the white. Rather, she subjects the very field of these oppositions to implosion, or to some sort of hyperspatial torsion and distortion. And she takes up the risk that these maneuvers will fail to achieve their goal, or even backfire.

This project, and this risk, place Jones within the genealogy of what has come to be known as *Afrofuturism*. Most immediately, this term refers to "speculative fiction that treats African-American themes and addresses African-American concerns in the context of twentieth-century technoculture – and, more generally, African-American signification that appropriates images of technology and a prosthetically enhanced future" (Dery 1994, 180). But in a broader sense, Afrofuturism uses the tropes of science fiction and futuristic speculation, and a vision of

the transformative potentiality of new technologies, in order to reevaluate all aspects of Afrodiasporic (and not just African American) experience. In the case of music in particular, Kodwo Eshun (1998) traces an Afrofuturist line that runs from Sun Ra in the 1950s, through certain aspects of free jazz in the 1960s, then through George Clinton in the 1970s, on to Detroit techno in the 1980s, and beyond that to more recent electronic forms. (Today, we might think of Janelle Monae's "Metropolitan Suite" and Burnt Sugar's "More Than Posthuman" as exemplary Afrofuturist works).

In purely musical terms, this is a very diverse and heterogeneous group of artists. But they all make music in which the soulful human singing voice – traditionally at the center of Afrodiasporic music – is erased, decentered, or subjected to electronic distortion and modulation. And they all develop rhythm in startling ways, so that it ceases to be "organic" and breath- or body-centered, and instead becomes more or less *inhuman*. Either rhythm becomes mechanistically repetitive, as is generally the case in techno; or else, it becomes superhumanly polyrhythmic, dispersed beyond any single focus of attention, so that (in Erik Davis' words) it "impels the listener to explore a complex space of beats, to follow any of a number of fluid, warping, and shifting lines of flight, to submit to what the old school hip-hop act A Tribe Called Quest calls 'The rhythmic instinction to yield to travel beyond existing forces of life' " (Davis 2008, 56).[19]

Afrofuturist musical ventures also tend to invoke the imagery of science fiction – aliens and robots, and advanced electronic technologies – in order to figure both the alienation, suffering, and horror of the history of black oppression, and the utopian hope of escaping or overturning that oppression. Looking back into the past, Afrofuturists see the kidnapping and enslavement of Africans, and the Middle Passage that forcibly took them to the New World, as something like what today we would call an

episode of alien abduction. These Africans were overwhelmed and subjugated by a barbarous, but technologically powerful, invader from another world. Once taken back to that other world, the Africans themselves became aliens, as their humanity was not recognized, and they were put to work as slaves. The horror of this experience propelled them into modernity. As Eshun puts it, paraphrasing Toni Morrison, "the African subjects that experienced capture, theft, abduction, mutilation, and slavery were the first moderns. They underwent real conditions of existential homelessness, alienation, dislocation, and dehumanization that philosophers like Nietzsche would later define as quintessentially modern" (Eshun 2003, 288). These kidnapped Africans were the first to live the modern experience, even as the labor forcibly extracted from them provided the accumulation of wealth to kickstart capitalist modernization on a global scale,[20] thereby extending this experience to everyone.

Looking to the future, on the other hand, Afrofuturists also conceive liberation in terms derived from science fiction. This involves a radical inversion, in which figures of inhuman oppression and estrangement – figures of aliens and robots – now work as images of escape, via posthuman transfiguration. In contrast to the mainstream Civil Rights movement, which demanded full recognition of the humanity of black people, Afrofuturists equate 'the human' per se with white supremacy, and with the normative subject positions of white, bourgeois society. Therefore they regard humanity, not as something to be attained, but in Nietzschean fashion as "something that must be overcome." Through figures ranging from George Clinton's Starchild to the cybernetic machines of Detroit techno, Afrofuturist musicians construct their own versions of the so-called "Singularity," in which all-too-human limitations are transcended through new technologies, and by the subsumption of flesh into machines.[21] For Eshun, Afrofuturist music is a "Postsoul" phenomenon, involving "a 'webbed network' of

26

computerhythms, machine mythology and conceptronics which routes, reroutes and crisscrosses the Black Atlantic" (Eshun 1998, -6). This music "alienates itself from the human; it arrives from the future"; it manifests "an extreme indifference towards the human," a refusal to understand black experience in traditionally soulful, humanistic terms, since these are seen as implying continued oppression (-5).

Grace Jones' music works through the consequences of this Afrofuturist "line of flight" from the human, this sense in which "black existence and science fiction are one and the same" (Eshun 2003, 298). Jones' sound is rooted first of all in disco, which Eshun identifies as "the moment when Black Music falls from the grace of gospel tradition into the metronymic assembly line" (Eshun 1998, -6). Not only is the disco beat hypnotically precise; but disco vocals, buried deep in the mix and reduced to phrases repeated like mantras, convey a muffled and depersonalized affect.[22] A 1970s disco diva like Donna Summer is already "Postsoul," in that her vocal stylings are cool, sublimely distant, and (in Simon Reynolds' words) "curiously unbodied" (Reynolds 1998, 25). But Jones' singing moves several steps beyond this. Her voice is harsh, precise, indifferent, and almost scornfully detached; or (to cite Reynolds again) "simultaneously imperious and fatalistic" (Reynolds 2005, 513). This is the diction of a robot dominatrix. It demands our obedience, without promising us any hope of empathy, intimacy, or identification in return.

All this is audible in Jones' 1985 song "Slave to the Rhythm." The music, produced by Trevor Horn, is a strange hybrid: as Reynolds (again) puts it, it "started life sounding Germanic, but veered off in a radically (even racially) different direction when welded to the polyrhythmic chassis of go-go" (Reynolds 2005, 513). That is to say, "Slave to the Rhythm" simultaneously embraces both extremes of the Afrofuturist sound continuum: Kraftwork-style roboticism on the one hand, and African-

derived rhythmic multiplicity on the other. Listening to it is a strange experience, a bit like looking at the famous figure of the duck-rabbit. You can pay attention either to the song's mechanistic onward thrust, or to the undertow of its polyrhythms; but it is nearly impossible to focus upon both at the same time.

Jones sings "Slave to the Rhythm" without any warmth or soul; her tone is domineering, but cold and uninvolved. She is the stern taskmistress of the dancefloor, ruthlessly imposing its despotic rhythm, compelling us to dance. This is entirely appropriate to the song's lyrics, which equate the ecstasy of dancing with the numbing repetition of work on the assembly line, and trace both of these activities back to the toil of slavery. Disco dancing, industrial labor, and working in the fields to harvest cotton or sugar cane all require a strict discipline of the body. An agitated, but precisely articulated, motion must be repeated over and over again, for long hours, without stopping. In this way, work and leisure both respond in the same way to the relentless demands of capital: with a terrible, self-abnegating *jouissance*. The song exhorts us to "work all day... never stop the action, keep it up, keep it up." The cliche of self-abandonment on the dancefloor is thus identical to the command of Taylorist workflow management. We are also told to "sing out loud the chain gang song"; this links Jones' own role as a musical entertainer back through minstrelsy to convict labor, and before that slave labor. The phrase "slave to the rhythm" starts out as a metaphor, but it has been literalized by the end of the song. The same disciplinary rhythm dominates everything, compelling us to move in accordance with its beat; we must breathe to it, dance to it, work to it, live to it, love to it. Rhythm isn't everything; it's the *only* thing.[23]

"Corporate Cannibal" explicitly hearkens back to "Slave to the Rhythm"; the lyrics include a line about being "slave to the rhythm/ Of the corporate prison." But the change of context is

significant. Jones moves from a vision of hard labor (on both the dance floor and the factory floor) to one of the corporation itself as a malevolent, rapacious entity. Instead of being a dominatrix, now she is a vampire – and not a romantic one, at that. Rather, her cold passion recalls Marx's famous description: "Capital is dead labour which, vampire-like, lives only by sucking living labour, and lives the more, the more labour it sucks" (Marx 1992, 342). In "Corporate Cannibal," Jones is similarly predatory; she is a force of life-in-death that can never get enough. Her voice is wheedling at first: "Pleased to meet you/ Pleased to have you on my plate." But it quickly turns severe, imperative, and threatening, as we become aware that "have you on my plate" is not just a metaphor. Jones informs us, in a calmly menacing voice that barely reaches above a whisper, that she will devour us: "I'm a man-eating machine... Eat you like an animal... Every man, woman, and child is a target." As Jones heats up, the song's lyrics absurdly juxtapose the cliches of corporate-speak ("Employer of the year") with those of pulp horror ("Grandmaster of fear"). Jones mockingly embraces the language of neoliberal politicians, to the point of even giving her own version of the Laffer Curve: "You'll pay less tax but I will gain more back." The music that accompanies these declarations has an easy, loping backbeat, but with grinding, dissonant guitars shrieking above it: the aural equivalent of an iron fist in a velvet glove. Jones' bottom line in this song is that "I deal in the market"; she promises that "I'll consume my consumers." By the end of the song, Jones' voice has modulated yet again: this time beyond words, into a predatory snarl.

In taking on the role of the "Corporate Cannibal," Grace Jones expresses an absolute identification with capital itself. This is something that goes well beyond any of her previous demonstrations of mastery. Francesca Royster remarks that "a complicating factor of Jones' art has always been its collaboration with commercialism, even as it comments on that process"

(Royster 2009, 91). But this "collaboration" now reaches a hyperbolic extreme. Jones embodies capital unbound, precisely because she has become a pure electronic pulse. Just as the groundless figures of digital video are no longer tied to any indexical referents, so too the endlessly modulating financial flows of globalized network capitalism are no longer tied to any concrete processes of production. Incessantly leveraged and reinvested, these flows proliferate cancerously – at least until they reach a point of necrosis, or sheer implosion. And just as capital continually devours and accumulates value, transforming its materials into more of itself, so Jones-as-electronic-pulse devours whatever she encounters, converting it into more image, more electronic signal, more of herself. Jones' electronic modulations track and embrace the transmutations of capital; they express the inner being of a world of hedge funds, currency manipulations, arcane financial instruments, and bad debts passed on from one speculator to the next. Nick Hooker's video modulations and the worldwide "culture of finanical circulation" (LiPuma and Lee 2004, 18ff.) are both driven by the same digital technology.

A lot has changed – politically, socially, economically, and technologically – since Grace Jones' heyday in the late 1970s and early 1980s. "Corporate Cannibal" takes the measure of these changes. The song and the video are terrifying; but they overlay this terror with an exacerbated awareness that 'inducing terror' has itself become, after long years of media overexposure, a stereotype or a cliché. Jones has always been an aesthetic and cultural extremist. But "Corporate Cannibal" gives extreme expression to a world in which there are no extremes any longer – since everything can be tweaked or modulated in one way or another, until it finds a niche within which it can be successfully marketed. Jones forces us to confront the fact that even her transgressions of race, sexuality, and gender, which so thrilled us twenty-five years ago, are now little more than clever marketing

concepts. Beyond all those enthralling discourses about race and gender and power and "the body," the only thing that remains "transgressive" today is capital itself, which devours everything without any regard for boundaries, distinctions, or degrees of legitimacy. Postmodern finance capital "transgresses" the very possibility of "transgression," because it is always only transgressing itself in order to create still more of itself, devouring not only its own tail but its entire body, in order to achieve even greater levels of monstrosity.

Of course, all this has grave consequences for the Afrofuturist project. Without transgression, how can there be transformation or transcendence? In his "Further Considerations on Afrofuturism" (2003), Kodwo Eshun points out how problematic posthuman futurism has become, at a time when the dominant order is itself entirely futuristic and science fictional: "power now operates predictively as much as retrospectively. Capital continues to function through the dissimulation of the imperial archive, as it has done throughout the last century. Today, however, power also functions through the envisioning, management, and delivery of reliable futures... The powerful employ futurists and draw power from the futures they endorse, thereby condemning the disempowered to live in the past" (289). In consequence, the very idea of "the future" seems to have been drained of all hope and all potential. This "future" leaves us blank and numb, even as it arrives in the present and radically changes our lives. In his 1983 film *Videodrome*, David Cronenberg imagined a "new flesh" of visceral video embodiment. This "new flesh" was a source of both wonder and terror, as well as a political battleground: "the battle for the mind of North America," we were told, "will be fought in the video arena – the videodrome." But today, Cronenberg's extreme vision has become a banal actuality: this is the real message of "Corporate Cannibal." Grace Jones' modulating electronic flesh is the chronic condition of our hypermodernity, rather than a radical

rupture, or an acute symptom of change.

In other words, now that the posthuman future once prophesied by Afrofuturism has actually arrived, it no longer works as an escape from the domination of racism and of capital. Rather, it serves as yet another 'business scenario' for capitalism's own continued expansion. "As New Economy ideas take hold," Eshun says, "virtual futures generate capital. A subtle oscillation between prediction and control is engineered in which successful or powerful descriptions of the future have an increasing ability to draw us towards them, to command us to make them flesh... Science fiction is now a research and development department within a futures industry that dreams of the prediction and control of tomorrow" (Eshun 2003, 290-291). Capitalism has always depended upon the ever-accelerating extension of *credit*, which is a way of monetizing – and therefore appropriating and accumulating – the future itself. In the last twenty years or so, this stockpiling of the future has reached unprecedented levels, thanks to the way that financial instruments like derivatives have objectified and quantified – and thereby "priced, sold, and circulated" – "risk" in general, understood as the sum of all uncertainties about the future (LiPuma and Lee 2004, 148-150 and passim). Today, we have gone so far in this process that (as Marlene Dietrich says to Orson Welles in *Touch of Evil*) our future is all used up. It has already been *premediated* for us: accounted for, counted and discounted, in advance.[24]

Such is the demoralizing condition that Grace Jones addresses in "Corporate Cannibal." Today, capital predicts, controls, and stockpiles the future – and thereby *uses it up* – through a process of continual modulation. But this is the very process that is at work in the video as well. Jones and Hooker perform a feat of homeopathic magic. They do not claim to escape the mechanisms of the control society; rather, they revel in these mechanisms, and push them as far as possible. Their remedy for the malaise of the digital is a further, and more concentrated, dose of the digital. We

usually regard the postmodern or posthuman condition as a weightless play of surfaces, from which all depth has been evacuated. And, depending upon the circumstances, we may find this depthlessness either terrifying or exhilarating. But "Corporate Cannibal" refuses both of these alternatives. Instead, it blasts open the very surface of the world, in a burst of Weird energy.

I use the word "Weird" here advisedly. Jones' personification of the corporation as a vampiric cannibal is a trope of "Weird fiction." This term was first used in the 1920s, to characterize the writings of H. P. Lovecraft and other contributors to the pulp journal *Weird Tales*. More recently, it has been taken up by China Miéville (2008), and other writers of what has come to be known as the "New Weird" (VanderMeer and VanderMeer, 2008). In both its earlier and more recent incarnations, the Weird conveys a sense of intense anxiety and dislocation, with its "insistence on a chaotic, amoral, anthropoperipheral universe" that is radically unfamiliar and irrecuperable, not to be assigned any sense or meaning (Miéville 2008, 112). At the same time, Weird expression often feels slightly hokey or forced, because it renders something that cannot be described literally and precisely, but only evoked vaguely and incoherently. Miéville associates the Weird of the early twentieth century with "the crisis tendencies of capitalism [that] would ultimately lead to World War I (to the representation of which traditional bogeys were quite inadequate)" (111). He suggests that the New Weird of our present moment responds to "the advent of the neoliberal *There Is No Alternative*," for which "the universe [i]s an ineluctable, inhuman, implacable, Weird, place" (128).

"I'll make you scrounge/ In my executive lounge... I'll consume my consumers/ With no sense of humor": Grace Jones identifies her persona with the alien monstrosity of Capital, and with its barbaric (but slightly tacky) glamour. In so doing, she channels and conducts, condenses and conjures, the maleficent

forces that stand against us in this time of crisis. Such forces are omnipresent, yet impalpable; she makes them visible, audible, and tangible. "I'll make the world explode." Jones renews the Afrofuturist project by turning it inside out, even at the point of its last extremity. More than this we cannot ask of any artist. The dangerous modulations of "Corporate Cannibal" give voice and image to the vertiginous "globalized network society" that we live in today.

# 3 Boarding Gate

Olivier Assayas' 2007 film *Boarding Gate* is a delirious thriller about sex and lust and murder, money and business, drugs and designer clothes, and international finance. Assayas describes the film as part of a loose trilogy that also includes his earlier works *Demonlover* (2002) and *Clean* (2004) (Hillis 2008). All three of these films focus on female protagonists; all are concerned with transnational flows of both people and money, and with cultural exchanges between East and West; and all make extensive use of B-movie plot devices and motifs. But in other respects, these films are quite different from one another. *Clean* is the only one of the three that features a conventional linear narrative, as it follows the efforts of its protagonist Emily (Maggie Cheung) to shake off heroin addiction and regain custody of her son. The other two films, in contrast, are convoluted and circuitous thrillers, with menacing, uncertain endings. *Demonlover* and *Boarding Gate* are both organized, as Claire Perkins puts it, around "a narrative fissure by which the film spirals into a rhetorical puzzle" (Perkins 2009, 4). In both films, linear causality and narrative logic break down, resulting in an impasse that itself becomes the main focus of the narrative. By foregrounding these disruptions, *Demonlover* and *Boarding Gate* shock us into a heightened awareness of the new configurations of social and narrative space that have emerged in the last thirty years or so, along with the rise of digital technologies, and with the post-Fordist, neoliberal reorganization of capitalism. Assayas' avowed aim of "being in touch with the world as it is" leads him to reject what he regards as "a whole world of very conventional storytelling that ends up being [called] sophisticated, highbrow arthouse cinema," and instead "to make a movie that ha[s] a kind of roughness and [i]s not scared of occasionally being over the top" (Hillis 2008).

Despite their pulp, B-movie ambitions, however, *Boarding Gate* and *Demonlover* both remain unavoidably "difficult" films. That is because their aim is to explore, in depth, what Fredric Jameson calls "the bewildering new world space of late or multinational capital" (Jameson 1991, 6). This is something that cannot be done easily or directly. For as Jameson insists, the "global world system" is strictly speaking "unrepresentable," since its flows and metamorphoses continually elude our "existential" grasp (53). It is necessary instead to proceed by abstraction: to "diagram" the space of globalized capital, by entering into, and forging a path through, its complex web of exchanges, displacements, and transfers. Assayas' ambition is therefore cartographical, rather than mimetic. The narratives of *Demonlover* and *Boarding Gate* are unaviodably fractured and fragmented, because the space they explore is non-Euclidean, and not cut to human measure. Assayas surveys the abstract landscape of capital piece by piece and step by step, drawing his camera from one scene into another, building up relations and tracking equivalences.

To put this in another way: Assayas' filmmaking responds to a crucial paradox, or to what we might even call a fundamental Antinomy of neoliberal globalization. The space of transnational capital is at the same time extremely abstract, and yet suffocatingly close and intimate. On the one hand, it is so abstract as to be entirely invisible, inaudible, and intangible. We cannot actually 'see' or 'feel' the virtual "space of flows" (Castells 2000, 407-459) within which we are immersed. For this space is a relational one, largely composed of, and largely shaped by, the arcane financial instruments, and other transfers of "information," that circulate through it. These instruments and flows, and the transactions in the course of which they are exchanged, cannot be "represented" in any form accessible to the human senses; they can only be defined computationally, as the terms of utility functions and partial differential equations.

Assayas' difficult task, therefore, is to translate (or, more precisely, to *transduce*) the impalpable flows and forces of finance into images and sounds that we can apprehend on the screen. His aesthetic problem is the same one that Deleuze ascribes to Francis Bacon: "How can one make invisible forces visible? " (Deleuze 2005, 41; we could also add, audible). Certainly the *effects* of these forces are concrete enough, and susceptible to representation: they range from manic construction booms in big cities to the catastrophic collapse of entire national economies. But Assayas seeks "to render visible these invisible forces" themselves (Deleuze 2005, 43) – in addition to their more readily evident consequences.

If this can be accomplished, it is thanks to the other side of the Antinomy that I have been describing. For at the same time that the space of global capital is abstract, it is also overwhelmingly proximate, and hyperbolically present. It is a "tactile space" (Deleuze 1986, 109), or an "audile-tactile" one (McLuhan 1994, 45) – in contrast to the more familiar visual space of Cartesian coordinates and Renaissance perspective. Visual space is empty, extended, and homogeneous: a mere container for objects located at fixed points within it. But audile-tactile electronic space "is constituted of resonant intervals, dynamic relationships, and kinetic pressure" (McLuhan and McLuhan 1988, 35), and constructed out of "intercalated elements, intervals, and articulations of superposition" (Deleuze and Guattari 1987, 329).

Such a space is a heterogeneous patchwork, continually being curved and folded and stretched. It is traversed by "densifications, intensifications, reinforcements, injections, showerings" and other such processes (Deleuze and Guattari 1987, 328). Movement through this space is therefore not smooth and continuous, but abrupt, nonlinear, discontinuous, and discrete. Tactile space has "lost its homogeneity," Deleuze says, and "left behind its own co-ordinates and its metric relations"

Deleuze 1986, 108-109). In consequence, it must be apprehended – and indeed, it can *only* be apprehended – bit by bit, "fragment by fragment," and from moment to moment, through the constructive action of "linking" one space to another, materially feeling one's way from one space to another (Deleuze 1986,108-109).[25] Such spatial links are not given in advance; they must be created in real time, through the motions of Assayas' camera, in the same way that they are created by "just-in-time" investments of capital.

In order to explore this space of flows, to accurately render both its abstraction and its tactility, and thereby to cleave to the Real of global capital, Assayas is obliged to abandon Bazinian realism, with its long shots, its "composition in depth" (Bazin 2004, 34), and its objective points of view. The reason for this is ontological. Bazin divides the filmmakers of the years 1920 to 1940 between "those directors who put their faith in the image and those who put their faith in reality" (24). Bazin of course champions the latter, and disparages the former; and he sees the increased use of sequence shots and depth of focus in the years following 1940 as marking the definitive triumph of realism over image-based aestheticism. But much has changed in the half century since Bazin's death. The very opposition between reality-based and image-based modes of presentation breaks down in the contemporary world of electronic media and global capital. Today, the most vivid and intense reality is precisely the reality of images. These images are displayed on screens of all sizes, all around us; and, as McLuhan says, they tend to "require participation in depth" (McLuhan 1994, 31). That is to say, they tend to be haptic rather than merely optical; and they are fully imbued with glutinous and tactile qualities. In such a world, it is only by putting his faith in the image that Assayas can express his faith in reality. It is only through a delirious aestheticism, and by embracing the artifice of images and sounds, that his movies are able to "relate physically with an audience," and thereby

actualize their extreme abstractions. Such a "relationship to physicality," Assayas says, is "what is missing today from arthouse cinema" – although horror films have it in abundance (Hillis 2008).[26]

In response to the double imperative of abstraction and tactility, Assayas makes films that are at the same time inhuman in their icy distance, and yet intimate, visceral, and creepy, in the way that they offer us vulnerable body-images, and organize themselves around microperceptions of corporeal affect. In this sense, *Demonlover* and *Boarding Gate* are both ironically humanistic narratives of "how we became posthuman" (Hayles 1999). Or, to put the same point slightly differently, they both attempt to render post-cinematic affects and modes of being, but in a manner that itself remains cinematic. This is Assayas' way of responding to the anxiety so many cinephiles and film theorists have felt in recent years about the advent of post-cinematic, electronic media. Vivian Sobchack compellingly argues, for instance, that electronic media "engage [their] spectators and 'users' in a phenomenological structure of sensual and psychological experience that, in comparison with the cinematic, seems so diffused as to belong to *no-body*... the electronic is phenomenologically experienced not as a discrete, intentional, body-centered mediation and projection in space but rather as a simultaneous, dispersed, and insubstantial transmission across a network or web that is constituted spatially more as a materially flimsy latticework of nodal points than as the stable ground of embodied experience" (Sobchack 2004, 152, 154). But Assayas' paradoxical aim is precisely to render, in embodied, 'cinematic' terms, this post-cinematic regime of dispersed or disembodied experience, whose phenomenology Sobchack so aptly describes. Where Sobchack – much like David Rodowick (2007) – laments the way that "the techno-logic of the electronic" has displaced "the residual logic of the cinematic," leading to a "material and technological crisis of the flesh" (Sobchack 2004, 161), Assayas

39

rather heeds Deleuze's suggestion that, in a time of radically new social and technological forms, "it's not a question of worrying or of hoping for the best, but of finding new weapons" (Deleuze 1995, 178).

*Demonlover* and *Boarding Gate* are united by the project of finding visible, audible, fully embodied, *cinematic* expression for the impalpable forces conducted by post-cinematic media. However, although the two films share a common goal and a common style, they actually *feel* quite different from one another. *Boarding Gate* is more existential than *Demonlover*, and more fully embodied. Where *Demonlover* narrates the dissolution of the "humanist" subject in flows of virtual, abject, posthuman *jouissance*, *Boarding Gate* is rather concerned with what it takes to resist such a dissolution, to survive in the midst of such flows. Assayas himself says that "*Boarding Gate* is a much less theoretical movie. *Demonlover* was like a manifesto or something. It's the one movie I've made that is very much about ideas. [*Boarding Gate*] takes place in the world that *Demonlover* defined, except these are two flesh-and-blood characters…It's much more simple and straightforward in its own way" (Hillis 2008).

*Demonlover*, the more "theoretical" of the two films, envisions the postmodern world as an enormous pornographic video game, with proliferating fractal levels and self-reflexive feedback loops. Every space contains another space within it, and turns out to be itself contained within yet another space. The film's locations, in both physical space and cyberspace, are something like what Deleuze calls *open boxes* (Deleuze 1972, 105-110). Each space has its own particular content; but this content turns out to be the container, or the medium, for some other, radically different content. The film thus fleshes out McLuhan's observation that "the 'content' of any medium is always another medium" (McLuhan 1994, 8). In *Demonlover*, money flows through pornographic video images, which themselves work as incitations to rape and murder. Corporate offices are portals to

bondage dungeons, whose scenarios are streamed live on the Net. Multiple spaces at multiple levels communicate with one another precisely by virtue of the "gap between content and container... the inadequacy [or] the incommensurability of the content" (Deleuze 1972, 108). Rather than separating the actual from the virtual, the film works towards what Deleuze calls their *indiscernibility*, so that they change places, again and again, "in a relation which we must describe as reciprocal presupposition, or reversibility" (Deleuze 1989, 69).

There's plenty of action within the labyrinthine passages of *Demonlover*, but it all leads to a dead end of stasis, imprisonment, and bondage. Not only does the film present a story of dueling corporations seeking to dominate the online porn market; but the corporate intrigue thus portrayed is itself structured like a pornographic video game. *Demonlover* gives us a world in which – as McKenzie Wark puts it, writing of the ways that the logic of gaming has proliferated throughout postmodern social space – "the game has not just colonized reality, it is also the sole remaining ideal... Everything is evacuated from an empty space and time which now appears natural, neutral, and without qualities – a gamespace... Every action is just a means to an end. All that counts is the score" (Wark 2007, 8). In the world of *Demonlover*, individuals are exclusively defined by their place in the game, or by their running score – which is also their spot on the corporate ladder. The competition is unremitting and ruthless. We are always compelled to play for the highest stakes – and we always end up being the losers.

In contrast, *Boarding Gate* presents the world of global capitalism as a loose ensemble of lateral connections among contiguous but separate spaces. In the course of the film, the protagonist Sandra (Asia Argento) moves between corporate offices, loading docks, airports, swank condos, sweatshops, shopping malls, nightclubs, latrines, and workrooms filled with computing equipment. She flees from the outskirts of Paris to

Hong Kong; and by the end of the film, she is ready to move on to Shanghai. Some of the spaces through which Sandra passes are nearly empty, and others are filled with crowds. Some of them are run down, and some are luxurious. But none of them is home; none of them is a place where Sandra might be able to stop for a moment and take a breath – let alone a place where she might actually feel that she *belongs*. Rather, all these places seem to have a built-in air of transience. They evince the sleek, functional anonymity of what the anthropologist Marc Augé calls "non-places," demarcating "a world where people are born in the clinic and die in hospital, where transit points and temporary abodes are proliferating under luxurious or inhuman conditions... where a dense network of means of transport which are also inhabited spaces is developing; where the habitué of supermarkets, slot machines and credit cards communicates wordlessly, through gestures, with an abstract, unmediated commerce" (Augé 1995, 78). In *Boarding Gate*, these locations are more than just background. They seem, if anything, to play a more active role in the narrative than do most of the people who pass desultorily through them. The whole film revolves around the way that these non-places are so vividly tactile, and yet at the same time so oddly empty and "without qualities."

Augé's non-places are also what Deleuze, in his first *Cinema* volume, calls *any-space-whatevers* (Deleuze 1986, 109, 111-122).[27] Such spaces are *"deconnected,"* Deleuze says (120). This isolation, or decontextualization, can be understood in two ways. On the one hand, any-space-whatevers are "defined by parts whose linking up and orientation are not determined in advance, and can be done in an infinite number of ways" (120). As in what Deleuze elsewhere calls a rhizome, "any point...can be connected to any other [point], and must be" (Deleuze and Guattari 1987, 7).[28] But on the other hand, an any-space-whatever can also be understood as "an amorphous set which has eliminated that which happened and acted in it... a collection of locations or

positions which coexist independently of the temporal order which moves from one part to the other, independently of the connections and orientations which the vanished characters and situations gave to them" (Deleuze 1986, 120). In both cases, any-space-whatevers are indeterminate; they are places of "pure potential" without actualization (120). But in the first case the "deconnection" is spatial, while in the second case it is temporal. Under either description, these spaces are so articulated that you can move from any one of them, to any other, and then yet another, without ever arriving at a final destination. As always in the control society, "you never finish anything," but just suffer a series of "endless postponement[s]," as the same problems and conflicts are relayed from one space to the next, without ever being resolved (Deleuze 1995, 179).

Deleuze associates any-space-whatevers with a certain project of modernist abstraction; he discusses the use of these spaces in Rossellini and Bresson, in the films of the French New Wave, and in the experimental cinema of Michael Snow and Marguerite Duras (Deleuze 1986, 121-122). For all these artists, the emptying-out of habitual connections and associations breaks down the established order, and allows new forces of invention to emerge. But even if such an oppositional role for art was plausible in the mid-twentieth-century, it is no longer so today. In the twenty-first-century world we live in, the world of *Boarding Gate*, any-space-whatevers have spread beyond the "undifferentiated urban tissue [with] its vast unused places, docks, warehouses, heaps of girders and scrap iron" evoked by Deleuze (1986, 120), to include as well all those glittering new high-rise constructions and architectural fantasias fueled by economic speculation. As Manuel Castells observes, postmodern business centers are characterized by a strange "architectural uniformity... Paradoxically, the attempt by postmodern architecture to break the molds and patterns of architectural discipline has resulted in an overimposed postmodern

monumentality which became the generalized rule of new corporate headquarters from New York to Kaoshiung during the 1980s," and which has only spread further since. The result is that "architecture escapes from the history and culture of each society and becomes captured into the new imaginary, wonderland world of unlimited possibilities...as if we could reinvent all forms in any place, on the sole condition of leaping into the cultural indefinition of the flows of power" (Castells 2000, 448).

This means that the "deconnection" and blankness of urban spaces is as much a result of intensive capital investment, as it is of capital flight. The ruins of old Detroit, and the new business towers and luxury hotels of Shanghai and Dubai, are two sides of the same coin.[29] In consequence, the powers of invention that emerge from these deconnected spaces can no longer be claimed by an oppositional, heroic modernism. The emergence of "communicative capitalism" (Dean 2005), or "cognitive capitalism" (Moulier Boutang 2007), has led to a mutation in the relation between the virtual and the actual. An any-space-whatever, Deleuze says, is a space of pure virtuality: it "shows only pure Powers and Qualities, independently of the states of things or milieux which actualize them" (Deleuze 1986, 120). And historically, the extraction of surplus value has involved an actualization of the virtual, whether in the form of the conversion of the open potentiality of labor into the quantifiable, commodified abstraction of "labor-power" (Marx 1992, 270ff.), or in that of the "valorization of value" in the "constantly renewed movement" of the circulation of commodities (Marx 1992, 253). Unactualized Powers and Qualities would thus seem to be immune to exploitation; an art that reverts from the actual to the virtual, through what Deleuze calls *counter-actualization* (Deleuze 1990, 150-153), would seem thereby to resist the depredations of capitalism.[30]

But in recent years, these unalloyed Powers and Qualities have themselves increasingly been subsumed by capital, and put

to work. The "unlimited possibilities" arising from "cultural indefinition" are continually being harvested as new sources of profit. Today, surplus value is not only extracted from the virtual by means of its actualization; the inverse process takes place as well. Value is also captured when space is "deconnected," so that the virtual event may be extracted from the state of affairs that incarnates it. Corporations value nothing more than innovation; and they increasingly commodify and market pure virtualities, in the form of events, experiences, moods, memories, hopes, and desires. For this purpose, they construct and colonize any-space-whatevers, whose very vagueness works to insinuate an expectation that anything can happen. Such is our post-cinematic condition: the fantasies that used to be manufactured specifically by the movies can now be found more or less everywhere. This is why Assayas, for all his daring, seems to be making films under a sort of constraint. In an age of ubiquitous recuperation, he cannot hope to display anything like the exuberance, caprice, and freedom of invention of his predecessors in the French New Wave.

In *Boarding Gate*, despite the blankness – and hence the similarity – of the any-space-whatevers through which the camera and the protagonist roam, these spaces are nonetheless all detached from one another. They never intermingle. Each of them seems self-contained, self-reflexive, and monadic. Flows of goods, people, money, and data pass continually through them, moving restlessly from one to another – but without ever leaving any traces behind. Whenever you cross over to a new space, you completely lose touch with the old one. Sandra suffers a break in continuity when she shifts locales; her legal identity is totally made over in the course of the film. It's not that she herself has become a different person; but whenever she moves, she has to get rid of the markers of her social identity – most notably, her mobile phone and her credit cards – and pick up new ones instead. The spaces that Sandra moves through are something

like what Deleuze calls *sealed vessels*: they are separate universes, each with its own concerns and coordinates. They only communicate with one another indirectly, by means of "*transversals*...from one world to another...without ever reducing the many to the One, without ever gathering up the multiple into a whole" (Deleuze 1972, 112). A transversal flow of bodies, goods, or money can cross from any space to any other; but there is no permanent record of these crossings. There is no place for a synoptic overview, no Archimedean point from which it might be possible to grasp all the spaces at once.[31]

Precisely because the world of *Boarding Gate* is a patchwork of local spaces that are "without qualities," and yet sealed off from one another, traditional qualitative and categorial distinctions tend to break down. In the emptiness and pure potentiality of any-space-whatevers, anything can be traded for anything else. The homogeneity of all the containers ensures the translatability of all their contents. Throughout the film, the camera continues to rove nervously back and forth through the space on screen, regardless of whether it is photographing a murder or a business deal, people at work or people going shopping or people running in terror. In this world, everything is interchangeable, or at least exchangeable: sex, money, drugs, business trade secrets, personal identities, and clothing and other consumer goods. Even human actions, qualities, and feelings are subject to promsicuous exchange. Everything flows through the conduits of international air travel, electronic transfers, mobile phone calls, and shipping in cargo containers. Everything is a potential medium of exchange, a mode of payment for something else. And all these exchanges are regulated, not by law, but by contract: import-export contracts, murder contracts, prostitution contracts, and BDSM contracts.

The world of *Boarding Gate* is therefore organized around such activities as prostitution, drug dealing, and murder for hire. These are all forms of freelance work under contract. And Sandra,

the protagonist of *Boarding Gate*, engages in all three of them over the course of the film. She runs drugs as a lucrative sideline of her work for an import/export company; she does a contract killing in the hope that it will help her to escape from a situation in which she feels trapped. And of course, she uses her body as a medium of exchange – as women are so often compelled to do. Though prostitution is stereotypically regarded as the "oldest profession," Assayas suggests that it as a crucial motor and *sine qua non* of what we think of today as the "new economy." Prostitution both constitutes human intimacy as a commercial transaction, and smooths the way for other sorts of commercial transactions. In the backstory of *Boarding Gate*, Sandra earns her keep from her businessman lover Miles (Michael Madsen) by fucking his clients. She then reports back to him, both on what they did in bed, and on whatever information about their business ventures they might have inadvertently revealed. It is unclear whether her knowledge about their sexual habits is ever actually used for blackmail, or whether the information she gathers about their business is really of any commercial value to Miles. But the process clearly greases the wheels of commerce, and helps to seal the deals that Miles has made. It also evidently turns on both Sandra and Miles: an excitement for which he pays her well.

Assayas thus presents "service industries" like prostitution, drug dealing, and murder for hire as quintessential examples of the "affective labor," or "immaterial labor," that – as Michael Hardt and Antonio Negri argue – is central to contemporary capitalism (Hardt and Negri 2001, 289-294). Affective or immaterial labor is any sort of "labor that creates immaterial products, such as knowledge, information, communication, a relationship, or an emotional response" (Hardt and Negri 2004, 108). And such labor has come to have an increasingly crucial role in the organization of neoliberal, globalized capitalism. As Hardt and Negri put it, "what affective labor produces are social

networks, forms of community, biopower... the instrumental action of economic production has been united with the communicative action of human relations" (2001, 293). Instead of seeing the economy as embedded in different sorts of social, cultural, and political institutions and practices, we must now see all forms of society, culture, and politics as themselves embedded within the matrix of the (so-called) "free market." There is no longer any way to distinguish between work and leisure, or between economic activities and other aspects of human life. The predominance of affective labor means that we have moved to what Marx calls the *real subsumption* of labor under capital, as opposed to its merely formal subsumption (Marx 1992, 1019-1038).[32]

I can state the same point in a different way. Affective labor, under the regime of real subsumption, conflates production and circulation. In *Capital*, Marx distinguishes between the fundamental process of production proper, in the course of which surplus value is extracted from living labor; and the secondary, external process of circulation, in the course of which this surplus value is "realized" through the sale of the produced commodities. But the circulation process is entropic and inefficient. Some surplus value is unavoidably lost as a result of what Marx calls the "*faux frais*" of bringing the product to market and supervising its distribution. Under the conditions of real subsumption, however, circulation is no longer external to production. Surplus value can be now extracted at all points of the value chain. As Jonathan Beller puts it, today "the circulation of capital" must itself be "grasped simultaneously as productive and exploitative" (Beller 2006, 115). Production and circulation have become indistinguishable. The very performance of affective or immaterial labor is already an exchange in which value is, all at once, produced, realized, and consumed.[33]

Under such conditions, passion is indistinguishable from economic calculation, and our inner lives are as thoroughly

monetized and commodified as our outward possessions. Libidinal flows are coextensive with financial ones. We manage our personal lives in the same way that businessmen manage the enterprises that they control. The same strategy, the same "art of war," the same calculus of risks, may be applied to erotic conquests and to corporate takeovers. At one point in *Boarding Gate*, Sandra taunts Miles by citing an article in an online business publication that ridicules his failed financial schemes, and calls him "the perfect cliché of bygone times." Sandra uses this appellation so that it refers to Miles' erotic life as well as his financial one. In both realms, he is outdated, he has missed his peak, and he has seen his opportunities vanish. Sandra tells Miles that he suffers from performance problems: he always gets harder planning an erotic or business move than he does when he actually tries to carry it out.[34]

Of course, just because affective or immaterial labor predominates under transnational capitalism, this does not mean that the physical labor of industrial manufacturing has somehow ceased to exist. It continues, more relentlessly than ever – even if it is cybernetically regulated, and hidden away from our affluent eyes. Physical, manufacturing labor, and affective or "symbolic" labor, are not opposed. Rather, they are located at different points along a continuum – or better, along the value chain. Material goods and intangible goods equally rely, for their production, upon the exploitation of labor for hire; they both equally take the form of commodities; and they are both continually being exchanged against one another. The gangsters and power brokers of *Boarding Gate* are involved in all sorts of shady financial dealings, often enforced at gunpoint; but they also own factories in China that manufacture clothes cheaply for transformation into expensive "designer label" goods in the West. As Sandra moves, in the course of the film, from one "sealed vessel" to another, she is really being displaced along the value chain. In the first part of the film, she oversees a port

facility in France where imported goods are unloaded from cargo containers. But later, as she flees for her life in Hong Kong, she weaves her way among sweatshops hidden in nondescript warehouse buildings overlooking busy streets.

Assayas gives us a sensuous, almost tactile, sense of this world of real subsumption, with its radical abstractions, its play of universal equivalences, and its ubiquitous commodification. Everything is shot in what J. Hoberman is not wrong to call a "jagged yet posh faux-vérité style" (Hoberman 2008).[35] The film is set in Paris and Hong Kong; but also in airplanes flying from one city to the other, and in cars, cabs, and limos moving down the streets and highways of both cities and their suburbs. The dialogue is mostly in English, but there are conversations in French and Cantonese as well. The camera floats hypnotically through all of the film's non-places, which always seem tangibly luscious, and yet oddly distanced at the same time. It's like being at an extremely upscale mall, where everything is beautifully arranged, and almost crying out for sensuous contact and absorption. Yet such contact turns out to be impossible. Everything is just a spectacular, empty display. There's nothing that one could actually make use of, or interact with. The *mise-en-scène* of *Boarding Gate* virtually screams: *look, but don't touch.*

There are few still shots in *Boarding Gate*. The camera is always restlessly moving, zooming in and out, reframing, panning laterally and horizontally. Sometimes it circles back on itself, or nervously turns left and right. Nearly everything appears in shallow focus. Rack focus shifts are frequent; they are often used – in place of shot/reverse shot alternations – for moving back and forth between the two speakers in a dialogue. Throughout the film, there are planes that remain blurry, before or behind whatever layer the camera is focused clearly upon. Everything seems to come in layers: glass, machinery, moving crowds. We see layers through the blurs or transparency of other layers. Everything is immaculate, and tastefully patterned: even blood

pooling on the floor after a murder, and even the toilet bowl into which Sandra pukes after witnessing (or performing) such violence. The decor, and the camerawork that presents it to us, are not exactly numbing, even if they are distanced: there is always a sense of cold fever, of icy delirium. This is epitomized by, but not restricted to, the ritzy Hong Kong nightclub with dazzling disco lights that Sandra comes to at a late point in the film, where somebody is equally likely to thrust a karaoke microphone in your face or to spike your drink.

The narrative of *Boarding Gate* is generic or genre-specific: the genre in question being what's best described as the slick Eurotrash thriller, with equal parts glamour and sleaze, paranoia and crass calculation.[36] This genre tends to emphasize surface appearances over deep meanings, and action thrills over plot logic and narrative closure. And Assayas is only too happy to play along; he even raises the stakes, with a series of wild inventions. *Boarding Gate* is filled with what Manohla Dargis, in her lovely review of the movie, calls its "moment[s] of delirium in what has become an increasingly unhinged enterprise," such as when "Kim Gordon…shows up, barking orders in Cantonese" (Dargis 2008). *Boarding Gate* actively calls attention to its digressions and non sequiturs. The film has its share of shootouts and tense escape/chase moments; but it also has 10-minute-long dialogue sequences in which ex-lovers argue fruitlessly about the nature of their dead relationship. The fragmentation, the irresolution, the continual switching back and forth between moments or sequences that are plot-driven, and ones that are instead purely affect-driven, the insistence that genre conventions and expectations can neither be transcended and escaped, nor fulfilled: all these features of *Boarding Gate* reflect – or better, work towards, and help to construct the vision of – a world that is too complex and far-flung to be totalized on the level of any grand narrative (paranoid/conspiratorial or otherwise), and at the same time too intricately interconnected to

be treated linearly, or atomistically.

Another way to put this is to say that, because "the bewildering new world space of late or multinational capital" cannot be represented, it also cannot be contained within the framework of a conventional narrative. Events interpenetrate and feed back upon one another; they have complex, multiple, nonlinear ramifications; they spread out in too many directions at once. Money is the universal equivalent into which, and out of which, anything whatsoever may be exchanged; but for this very reason, finance obscures and tangles the lines of linear cause and effect. We often say that the way to solve a mystery is to "follow the money"; but we also know that money can be easily "laundered," so that the traces of its past metamorphoses are washed away, and it is returned to an immaculate state. Postmodern financial instruments, like CDSs (credit default swaps) and CDOs (collateralized debt obligations) are in effect money-laundering schemes, obscuring debts by scrambling and recombining them, and selling them off in "tranches" so as to wipe them off corporate balance sheets. More generally, financial derivatives are "functionally indifferent" (LiPuma and Lee 2004, 44): they can be used to "price," and thereby to stand in for, the "risk" implicit in any situation whatsoever. This indifference, or infinite substitutability, means that the underlying situations themselves need not have anything in common – aside from the fact that they have all been arbitrarily priced. Things don't need to harmonize, or to fit together. In the world of finance capital, there is no unity or "pre-established harmony"; rather, as Deleuze puts it, "bifurcations, divergences, incompossibilities, and discord belong to the same motley world... It is a world of captures instead of closures" (Deleuze 1993, 81).

In the world of *Boarding Gate*, therefore, it is intrisically impossible to answer the question: "what is actually going on? " Rather, the questions one must ask are: "what is going to happen to me now? "; and "what (if anything) can I do about it? " These

questions are unavoidably narrow in scope, as they refer only to "me" and my immediate prospects – not to the "global world system" as a whole. Also, they can only be asked in the very short term: "what will happen to me in the next week, in the next day, in the next five minutes? " Worrying about long-term prospects and consequences is a luxury that nobody can afford. In a world of "just-in-time" production, one cannot make more than "just-in-time" plans. One's power to negotiate one's circumstances is severely limited, because there is so little that one is able to know. One's actions always have "unintended consequences," and one is always under the sway of circumstances that one cannot foresee, much less control. As the great market ideologist F. A. Hayek puts it: "the knowledge of the circumstances of which we must make use never exists in concentrated or integrated form but solely as the dispersed bits of incomplete and frequently contradictory knowledge which all the separate individuals possess" (Hayek 1948, 77). All these contingencies make "the market" seem like a fatality, a "natural," ineluctable force beyond which there is no appeal.[37]

*Boarding Gate* thus describes a world so fragmented and dispersed that there seems to be no way to get beyond one's own limited perspective as an isolated individual. At the same time, the film reveals the "individual" itself to be an exceedingly precarious construct. The market forces traversing our world are so intense and so disruptive that one's very identity is continually under threat. In a world of affective labor and real subsumption, one is always being called upon to reconfigure one's being into new forms. *Boarding Gate* ominously literalizes this injunction, narrating its protagonist's flight from one identity to another. As becomes clear in the course of the film, instruments like credit cards, mobile phones, and passports are necessary in order for one to have an "identity" at all, as well as for one to be able to act effectively. But of course, these instruments also make it possible for one to be tracked and to be

kept under surveillance. *Boarding Gate* thus envisions a world in which identity is infinitely malleable – but only to the extent that one has the resources to pay for the process of counterfeiting and altering the legal and contractual marks of this identity.

The problem with everything I have said so far is that I have used the impersonal form of "one"; when in *Boarding Gate* this "one" is a particular, indeed a singular, figure: the film's protagonist, Sandra, played by the incredible Asia Argento.[38] Throughout *Boarding Gate*, Argento is dynamic and dangerous, sexy but tough. She clearly embodies a heterosexual-male fantasy of the ultimate *femme fatale*, as alluring as she is menacing, and alluring precisely because she is menacing. In putting Argento's body so continually on display, the film radiates a certain sense of pornographic sleaze – as Assayas himself acknowledges (Hillis 2008). Yet this is only one side of the story. For Argento also mocks her *femme fatale* role, and the whole fantasy surrounding it, with a deep, who-gives-a-fuck irony. This has something to do with her perpetual pout, and with the way she casually tosses off her lines, as if relegating them to some other plane of existence with which she is basically unconcerned. Argento does this even when the lines in question express doubt, passion, or pathos, and when her body language reinforces these affects. In other words, Argento turns acting conventions inside out, at once stylizing and naturalizing her performance. She manages to radiate sexuality in an entirely unselfconscious way; yet this unselfconsciousness is a deeply *knowing* one: "completely without innocence" (as Haraway says of the figure of the cyborg – 1991, 151), and not in the least bit naive. Argento's knowingness both accentuates her sexiness, and allows her to distance herself from it. She is thus able simultaneously to display a method-acting intensity of commitment to her role, and at the same time to put her entire performance into postmodern "quotation marks."[39]

Argento is a post-cinematic celebrity, and she inhabits movie

and video screens in a far different way than older generations of actresses did. A classical female movie star, like Greta Garbo, is an image of purity and perfection. She is an object of infinite desire; she seems "descended from a heaven where all things are formed and perfected in the clearest light" (Barthes 1972, 57). She keeps us away from her at an infinite distance – a distance out of which we worship her. It is no wonder that Garbo concluded her career by withdrawing entirely from public view. Coming to the screen several decades later, Marilyn Monroe is unable to match Garbo's transcendent perfection, or to maintain the same degree of distance. Instead, Monroe supplements her beauty with her performance as a comedic ingenue. Her seeming unconsciousness of her own sexual allure gives us permission, as it were, to approach the mystery of this allure. Even as Monroe retains a definite aura, she also – unlike Garbo – brings this aura down to earth. This descent from the heavens to the earth is what allows Monroe to commodify her image, to multiply it and make it signify – as Andy Warhol so clearly understood.

In contrast to both Garbo and Monroe, Asia Argento no longer retains even the slightest hint of transcendence. She is directly carnal, immediately present in the flesh. And her ferocious intelligence cannot be separated from this carnality. Argento collapses the seductive distance between star and audience, and instead offers us her own hyperbolic presence. Her performance is *excessively* immanent and embodied. Even her irony is too immediate, and too close for comfort. In this way, Argento embraces the very condition denounced by Jean Baudrillard as the "obscenity" and "transparency" of postmodern society. Baudrillard seems caught in the throes of heterosexual panic, as he describes how "the body is already there *without even the faintest glimmer of a possible absence*, in the state of radical disillusion; the state of pure presence" (Baudrillard 1988, 32, and 29-44 passim). Baudrillard hysterically fears this excess; he yearns, instead, for the seductiveness of the

traditional feminine mystique, as exemplified by the old-school Hollywood stars. Seduction, he says, is "simply that which lets appearance circulate and move as a secret" (63-64); it "makes things appear and disappear" (71). Garbo and Monroe are seductive because they are never simply and wholly present; they allure the male viewer's gaze, beyond visibility, into the realm of that which is secret and hidden. Argento, however, short-circuits this dialectic. She frustrates the desire of the male voyeur, precisely by dropping the pretense of being unaware of it. She is self-demystified, self-consciously performative, and all too fully *there*.[40]

As played by Argento, Sandra is both a stoic and an existentialist (oxymoronic as this combination might seem to be). She demonstrates an unrelenting will to survive. But she also has a clear-eyed, unromantic ability to grasp things in their painful, unadorned actuality. She seems entirely detached from any sort of wish-fulfillment fantasy. She both accepts the hostile, unrelenting fatality of the world in which she finds herself, and works on constructing a sustainable place for herself within that world. Since things are changing rapidly all around her, and unexpected contingencies are always coming up, she is forced to improvise from moment to moment. When the cops bust in on a drug deal she is making, or when a rendezvous with her lover turns into a death trap, she has to respond as quickly as possible, simply in order to find a way out.

Sandra therefore takes on all sorts of "professional" roles – from assassin to whore – when she has to, and drops them again as soon as they are no longer needed. In this way, she continually "reinvents" herself. Luc Boltanski and Eve Chiapello describe "reinvention" as the highest imperative of "the new spirit of capitalism" (Boltanski and Chiapello 2007). One must be *"adaptable* and *flexible*, able to switch from one situation to a very different one, and adjust to it; and *versatile*, capable of changing activity or tools, depending on the nature of the relationship

entered into with others or with objects. It is precisely this *adaptability* and *versatility* that make [one] employable" (112). Employability, here, is a *sine qua non*: it is only by fashioning herself as more-than-employable, or as adaptive and flexible even to excess, that Sandra can hope to stay a step ahead of the ever-more-ruthless demands of her employers. And so she throws herself fully into whatever she has to do, while still maintaining an ironic reserve towards the whole process. In this way, Argento's oddly discordant acting style reflects, and entirely meshes with, the demands placed upon her character within the world of the diegesis. Sandra must become a supreme actress, a *virtuoso* of improvised performances, if she is to outrun, and avoid, the horrific fate – to become a pure object devoid of agency, and a sexual plaything for sadists – to which Connie Nielsen's character succumbs in *Demonlover*.[41]

Sandra's virtuosity within the diegetic world of *Boarding Gate* mirrors Asia Argento's own virtuosity as an performer. But Sandra can only experience her performative skill as a grim necessity, not as a source of pleasure or of pride. For flexibility, versatility, and resourcefulness are forced upon her – as they are forced upon all of us – by the very conditions of neoliberal globalization. If you don't adapt to these conditions, you simply won't survive. If you can't sell your virtuosity in the form of labor-power, you will not be employed at all. Sandra's position in the "world space" of transnational capital is radically insecure. She is never able to relax, and she can never take anything for granted. She doesn't have the time for reflection that she would need in order to act meaningfully and on her own initiative. Instead, she is only able to *react*: to devise "just-in-time" responses to immediate threats and problems. Her improvisations are born of desperation. Throughout the film, we see her in unbearable situations. She is fearful; she is nervous; she is exhausted; she is paralyzed in the face of danger; she is consumed with doubt. She pukes with horror and disgust in a

disco toilet; she passes out from a knockout drug; she runs for her life down stairways and through narrow corridors; she compulsively fires her gun, again and again, into the body of a man who is already dead.

These are all typical action film situations, but Assayas transforms them into something else. *Boarding Gate* is built around what Claire Perkins calls a "turn" that "in the terms of Deleuze's work on cinema...represents the invasion of the movement-image by the time-image" (Perkins 2009, 8). In traditional action films, according to Deleuze, "a sensory-motor schema takes possession of the image" (Deleuze 1986, 155). These films move smoothly from perception to action. The protagonist apprehends a certain world-situation, and acts in such a way as to alter it, or correct it. Situation and action are proportionate to one another; the more onerous the dilemma faced by the protagonist, the more resourceful and impressive the action by means of which he or she resolves it. There is a smooth movement from sensory perception to motor response; a stone-faced action hero, like Clint Eastwood's Dirty Harry, is able to remain impassive, and true to himself, because he is always able to discharge his feelings outwardly – with the help, of course, of his .44 Magnum.

But nothing like this happens in *Boarding Gate*. Where Dirty Harry is impassive, Sandra is *oversensitive*. At every point in the film, she is overwhelmed. Nothing she does is adequate to the demands of the situations she finds herself in. Indeed, she can use a gun if she has to; but this doesn't give her any security, or any sense of mastery. That is why Sandra is not an action hero. She belongs, instead, to the world of what Deleuze calls the time-image. Each situation she faces is an experience of intense embodiment and heightened affect. Each of them is "a purely optical and sound situation": that is to say, a situation of existential blockage, in which perception "does not extend into action" (Deleuze 1989, 17). Such a situation exceeds any

possibility of a commensurate response; it is "a matter of something too powerful, or too unjust, but sometimes also too beautiful, and which henceforth outstrips our sensory-motor capacities" (17). In the non-places of transnational capital, "our sensory-motor schemata jam or break" (20), and we are buffeted by forces beyond our control. Instead of being able to act, Sandra *suffers* her encounters. She experiences viscerally, within herself, whatever it is that she cannot accomplish in the world around her. She is *forced to feel* what exceeds all measure of feeling: something "that cannot be felt," but that "also cannot but be felt" (Massumi 2002, 133). Sandra therefore registers *in her body* all the transactions and exchanges – monetary and otherwise – that flow through her and define the space around her. And she then relays these forces to us, in the form of her expressions, her bodily postures, and her movements and gestures.

Olivier Assayas is concerned, above all else, by the "turn" in the course of which the movement-image crosses over into the time-image, and action on a humanly comprehensible scale gives way before the incomprehensible, inhuman flows of transnational finance and digital informatization. This is why *Boarding Gate* is not a pure film of the time-image, but a strange hybrid between genre filmmaking and art-house cinema. Deleuze associates "the crisis of the action-image," and the consequent turn towards the time-image, with the devastation and dislocations caused by World War II (Deleuze 1986, 206 and 196-215 passim). Of course, he says, even to this day "people continue to make [traditional, sensory-motor-oriented genre] films: the greatest commercial successes always take that route, but the soul of the cinema no longer does" (206). The distinction between the movement-image and the time-image thus comes to be equated, somewhat unfortunately, with that between mass market movies and art-house cinema. Assayas, however, incorporates this very distinction within the structure of *Boarding Gate*. Deleuze sees the turn from the movement-image to the

time-image as a definitive break between classicism and modernism. But Assayas suggests that, in the space of transnational capitalism, the break is never definitive, and the turn is never completed. It does not happen once and for all, but instead must be played through over and over again. We are never done with the dissolution of subjective agency into networked feedback effects, with the transcoding of the analog into the digital, and with the "real subsumption" of society into capital and its markets.

All this is epitomized by Sandra's position within the film. Today, as Deleuze says, we are so demoralized that "we hardly believe any longer that a global situation can give rise to an action which is capable of modifying it" (Deleuze 1986, 206). Indeed, in the wake of the triumph of neoliberalism, "the modern fact is that we no longer believe in this world" at all (Deleuze 1989, 171). Sandra too suffers from the waning of hope and desire. She lives a life of the utmost precarity. She finds herself at the mercy of transpersonal forces whose outlines she is unable to trace, whose origins she is unable to discern, and in whose concrete actuality she is not quite able to believe. She experiences existence in "the bewildering new world space of late or multinational capital" as an ongoing catastrophe. Disaster is always looming; and it is always – at best – just barely averted. But Sandra also bears witness to the prospect of living on, of provisionally surviving the catastrophe. She helps restore to us at least "a belief in this world" (Deleuze 1989, 188) – if not quite the sense of how another world might be possible. This may not seem like much; but it shouldn't be scorned either. Just by surviving her condition – which is also ours – Sandra emerges as an exemplary figure. She gives us hope. Sandra's mode of precarious, intermittent, and "just-in-time" subjectivity, however damaged and limited it may be, is the only one still possible in our world of ceaseless modulations of control, and delirious financial and libidinal flows. A point of view like hers is the only sort of "center" to

which we can still refer, in a world so thoroughly decentered, so complex and tortuous, and so utterly devoid of empathy.

Assayas underlines Sandra's point of view by doubling it in a kind of cinematic "free indirect discourse." Pier Paolo Pasolini introduced this term into film theory, importing it from literary studies, in order to make sense of what he called the "cinema of poetry" of the 1960s. According to Pasolini, a film like Antonioni's *Red Desert* (1964) is distinguished by the way that the filmmaker "looks at the world by immersing himself in his neurotic protagonist, reanimating the facts through her eyes" (Pasolini 1988, 179). *Red Desert* is composed almost entirely of what Pasolini calls "free indirect point of view shots" (176-180). These are shots that do not literally reproduce the protagonist's point-of-view, but are also neither omniscient nor objective. Rather, Antonioni transmutes the sensibility of his female protagonist Giuliana (played by Monica Vitti) into his own ostentatiously non-functional cinematic style. The film's own view of the world is tinged, or contaminated, by Giuliana's neurotic alienation, her inability to act, her failure to feel any sense of accomplishment. Antonioni's eccentric camera movements, and his "obsessive framing" of objects of "pure pictorial beauty" (179) bring Giuliana's sensibility into resonance with Antonioni's own "feverish formalism" (180). This is what accounts for the film's "poetic freedom" (180).

Now, Argento's Sandra has very little in common with Vitti's Giuliana. Where Sandra is constrained on every level, Giuliana has all the money, time, and leisure that she might want. Where Sandra is pressured by too much too soon, Giuliana suffers the *anomie* of having nothing to do, and nothing to live for. Where Sandra is enmeshed in a world of corporate intrigue, Giuliana stands entirely apart from the business concerns of her husband. The only similarity between the two characters, and the two films, is that we gain access to both via free indirect discourse. Antonioni registers Giuliana's neurosis, and identifies with it,

through his exacerbated cinematic style. Assayas similarly conveys, and identifies with, the dynamic instability of Sandra's world, and her consequent edginess and distraction and continual need to recalibrate her plans, through his restless camera movements, reframings, and refocusings. Antonioni's "obsessive framing" is matched, and opposed, by what we might call Assayas' equally obsessive deframing (*déecadrage*). In the forty-three years that separate *Red Desert* from *Boarding Gate*, we have moved from an industrial society characterized by massive alienation, to a digitized and ostensibly "post-industrial" one that "require[s] participation in depth" (McLuhan 1994, 31) from everyone. Today, alienation is a quaint luxury that cannot be permitted to anyone any longer. In consequence, Antonioni's poetry of exclusion and idle beauty is replaced by Assayas' poetry of forcible involvement, relentless inclusion, and compulsory monetization. In *Boarding Gate*, Assayas' poetic stylizations respond to the way that the society of cognitive capitalism and immaterial labor continually transforms affect into currency – and vice versa.

In free indirect discourse, Deleuze says, "the camera does not simply give us the vision of the character and of her world; it imposes another vision in which the first is transformed and reflected." In this way, the cinema "attain[s] self-consciousness" (Deleuze 1986, 74-75).[42] In the formal structure of *Boarding Gate*, no less than in Asia Argento's style of performance, and in Sandra's character within the film, we encounter a sort of double consciousness: a reflexivity that does not operate on a meta-level, but is immanent to the situation upon which it reflects. This allows *Boarding Gate* to raise a series of crucial questions. How can we survive the transition from a world of movement to a world of duration? What is the fate of determinate motion in space and time, when all action seems to be swallowed up in the endless expanses of a "space of flows" (Castells 2000, 407-459), and preempted by the synchronicity of a "timeless time" (Castells 2000,

460-499)? What action can still be meaningfully accomplished in the new "world space" of endless circulation and modulation? What cinematic image of achievement can still be generated, in a world where all is time, where "time is money," where money is the "most internal presupposition" of cinema, and where money always implies, as in Marx's formula M–C–M', "the impossibility of an equivalence...tricked, dissymmetrical exchange" (Deleuze 1989, 77-78)? What sort of subjectivity can remain true to itself, in a world where body and mind are measured and defined as flexible investments of "human capital"?

*Boarding Gate* does not offer answers to any of these questions; its accomplishment is precisely to keep them open *as questions*, when the logic of neoliberalism seeks rather to foreclose them. The film ends as Sandra apparently decides not to murder Lester (Carl Ng), her other ex-lover, for whom she abandoned Miles. Lester has cajoled and manipulated Sandra into disrupting and destroying her own life; she is now lost to such an extent that her only escape is to "disappear" into an entirely new and manufactured identity. She must flexibly adapt herself, once again, to a false name, a false nationality, a false passport, and transplantation to an entirely different part of the world. Lester has roundly betrayed Sandra, just as Miles did, in the pursuit of his own financial interests. But Sandra still loves Lester enough, or lusts after him enough, or remembers the sex with him fondly enough – we cannot really tell which – that she finds herself simply walking away, after stalking him and planning to go after him with a knife. I don't think that this represents a lapse in Sandra's otherwise awesome ferocity and determination. It's rather a fateful decision, and a stubborn insistence, that the reign of universal equivalence has to stop: that something needs to remain incommensurable, non-negotiable, unexchangeable, outside the circle of capital. At this moment, in the final shot of the film, the screen itself becomes unreadable: the camera goes from shallow focus to an out-of-focus blur.

# 4 Southland Tales

*Southland Tales* (2007) is the second film by Richard Kelly, whose previous work was the cult hit *Donnie Darko* (2001). *Southland Tales* shares with its predecessor a general air of apocalyptic unease, and a plot that circles around the idea of time travel. In both films, "time is out of joint"; linear, progressive temporality has somehow come undone.[43] But *Southland Tales* is a much more wide-ranging and ambitious movie than *Donnie Darko*; and it features a large ensemble cast, instead of being focused upon a single protagonist. The eponymous hero of *Donnie Darko* sacrifices himself in order to save the world. By accepting his own death, he abolishes an alternative timeline in which his teenage alienation redounds into disaster for everyone around him. Donnie's sacrifice offers us what Gilles Deleuze describes as the cinema's greatest gift: the restoration of our "belief in this world" (Deleuze 1989, 188). *Southland Tales*, however, is set entirely within a catastrophic alternative timeline. There is no way back to suburban normalcy. The End Times are near, as the film makes clear with its frequent quotes from the Book of Revelation. And the drama of sacrifice and redemption in *Southland Tales* points, not towards a restoration of "this world," but towards its nihilistic purgation and transcendence. We are swept headlong, through the raptures of media immersion, into an entropic terminal state – and perhaps also beyond it, out the other side.

*Southland Tales* begins with home video footage of a family Independence Day celebration. The date is July 4, 2005. The footage, filled with random cuts and amateurish swish pans, shows folks, both old and young, just enjoying themselves. But then there's a roar and a flash, followed by a rumbling and a jittering and the sight of a mushroom cloud in the distance. Terrorists have detonated two atomic bombs in Texas. This is the

bifurcation point, the rupture in continuity, the moment when the "straight line" of time becomes a "labyrinth" (Deleuze 1989, 131). We have left the world we know, and entered an alternative timeline: one that diverges irreparably from our own. The homeliness of the film's opening moments will never return. History has been derailed – it has gone mad – and there is no putting it back on track. Cut to computer graphics, voiceover narration, and the hallucinatory mediascape of *Southland Tales*.

The bulk of the movie takes place in Southern California (the "Southland"), three years after this initial attack, in the days leading up to the frenzied Independence Day celebration of July 4, 2008. The "war on terror" has blossomed into a full-fledged World War III. American troops are fighting, not just in Iraq and Afghanistan, but in Syria, Iran, and North Korea as well. The draft has been reinstated; martial law has been declared in some areas. Throughout the United States, police surveillance is ubiquitous, and there is no interstate travel without a visa. All Internet communication is montiored by a government spy facility called US-IDent. The police are authorized to shoot on sight anyone suspected of terrorism. The Republican Party is firmly in control of the country. Electoral politics has been reduced to its essence: televison advertising. International oil supplies have been cut off, and the sinister Treer corporation holds a monopoly on America's alternative energy resources. The only opposition to this state of affairs comes from a comically inept, confused, and internally fragmented "neo-Marxist" underground.

*Southland Tales* is, evidently, deeply concerned with the post-9/11 American security state. The conceit of an alternative timeline allows Kelly to explore, in exacerbated and hyperbolic fashion, our actual current condition of ubiquitous surveillance, restricted civil liberties, and permanent warfare. This regime of control was instituted by the second Bush administration, in the wake of the World Trade Center attacks; it largely remains in

effect today.[44] *Southland Tales* could be described, to a certain extent, as a dark satire in the tradition of Kubrick's *Dr. Strangelove*. It pushes the logic of the security state to absurdist extremes. In the world of the film, there is no right to privacy, and almost no private space. Phonecalls are routinely wiretapped, recorded, and traced. All public activity is captured on video; even the toilets are watched by surveillance cameras. A recurrent image in the film shows the creepy Homeland Security czar Nana Rae Frost (played by Miranda Richardson, channeling Angela Lansbury's performance in *The Manchurian Candidate*), sitting in her command chair at US-IDent headquarters, monitoring the video feeds on multiple screens that cover a large curving wall in front of her. In the world of *Southland Tales*, if you step out of line, or arouse distrust, you are likely to have your home invaded by an armed and masked SWAT team, or to be picked off on the beach by a government sniper. But most people remain oblivious to all these intrusions; they continue to drink, party, and otherwise enjoy themselves on the Venice Beach boardwalk, just as if nothing were amiss.

However, despite these currents of satire, *Southland Tales* is finally best described as a science fiction film. Its overall tone is earnest and urgent, even visionary – more than it is sarcastic or comic. *Southland Tales*, like most science fiction, is not about literally predicting the future. Rather, it is about capturing and depicting the latent *futurity* that already haunts us in the present. At one point in the film, the porn actress Krysta Now (Sarah Michelle Gellar) excitedly remarks that "scientists are saying the future is going to be far more futuristic than they originally predicted." The reason this comment is ludicrous is that "futuristic" is not an objective category, but an anticipatory inflection of the present. *Southland Tales* is indeed futuristic, in that it shows us an otherness, an elsewhere and elsewhen, that is inextricably woven into the texture of the here and now. We usually think of hauntings as traces from the past; but the future

also haunts us with its hints of hope and danger, and its promises or threats of transformation. Especially in times of great social and technological change, we *feel* the imminence of the future in the form of gaps and leaps in temporal progression, and shifts in the horizon of what is thinkable. Of course it is impossible to *know* what changes the future will bring; but the signs of this impossibility – the intimations of instability, the shifts of perspective, and the incipient breaks in continuity – are themselves altogether real. They are part of the conjuncture, part of what shapes the present. If the past *persists* in the present, then futurity *insists* in the present, defamiliarizing what we take for granted. Science fiction highlights this sense of futurity, making it visible and audible. *Southland Tales* is an ironically cinematic *remediation* of the post-cinematic mediasphere that we actually live in. The film's alternative timeline is defined precisely by its *divergence* from the world we know.[45]

*Southland Tales* is more about what I am calling the post-cinematic media regime in general, than it is about the national security apparatus in particular. Terrorism and the "war on terror" are parts of this new media regime, but they are not its basis, nor even its primary focus. At most, they are *catalysts*: they intensify and speed up the emergence of new media forms, and of their corresponding new modes of subjectivity. Surveillance is only one aspect of a broader process; Nana Rae Frost is not the only one monitoring multiple screens, and trying to pay attention all at once to a plethora of media feeds. In fact, all of the characters in the film are doing this, more or less; and so are most of us in the audience. *Southland Tales* surveys and maps – and mirrors back to us in fictive form – the excessive, overgrown post-cinematic mediasphere. The film bathes us in an incessant flow of images and sounds; it foregrounds the multimedia feed that we take so much for granted, and ponders what it feels like to live our lives within it. Video surveillance cameras are ubiquitous, of course, in the world of the film as well as in the

world that we inhabit; but so are many other sorts of recording, broadcasting, and communications devices. Social space is filled to bursting with handheld videocams, mobile phones, portable screens, 24-hour cable news channels, YouTube clips, MySpace pages, automated response systems, and celebrity-tracking papparazzi. Images and sounds are continually being looped for endless replay, or composited together into new configurations. In *Southland Tales*, traditionally 'cinematic' sequences are intermixed with a sensory-overload barrage of lo-fi video footage, Internet and cable-TV news feeds, commercials, and simulated CGI environments. These often appear in windows within windows, so that the movie screen itself comes to resemble a video or computer screen.

Despite the emphasis upon surveillance and security, the mediascape explored by *Southland Tales* is not in the least bit hidden or secretive. It is rather a vast, open performance space, carnivalesque, participatory, and overtly self-reflexive. Not only do we see multiple, heterogeneous screens within the movie screen; we also see the characters in the movie appearing on these screens, creating content for them, and watching them – often all at the same time. If the government isn't recording your actions with hidden cameras, then perhaps someone else is, for purposes of blackmail. But more likely, you are making and distributing videos of yourself, in a quest for publicity and profit. In any case, your mediated image is what defines you. If you aren't already an actor or a celebrity – as most of the characters in *Southland Tales* are – then you probably have a business plan to become one. Every character in the movie seems to be frantically engaged in exhibitionistic display, outlandish performance, and ardent networking for the purpose of self-promotion. The world of *Southland Tales* has become what Jamais Cascio, inverting Foucault, calls the *Participatory Panopticon*: "this constant surveillance is done by the citizens themselves, and is done by choice. It's not imposed on us by a malevolent bureaucracy or

faceless corporations. The participatory panopticon will be the emergent result of myriad independent rational decisions, a bottom-up version of the constantly watched society" (Cascio 2005). The reign of universal transparency, with its incessant circulation of sounds and images, and its "participatory" media ecology in which everyone keeps tabs on everyone else, does not need to be imposed from above. Rather, in the post-cinematic media regime, it "emerges," or "self-organizes," spontaneously from below. The greatest success of what Michel Foucault calls *governmentality* comes about, not when a certain type of behavior is forcibly imposed upon people, but when people can be "incentivized" to impose this behavior willingly upon one another, and upon themselves.

*Southland Tales* does not exempt itself from the frenzied media economy that it depicts. The movie is itself a post-cinematic, transmedia object. Tom Abba describes it as an "extended narrative," in which the story is spread across several media (Abba 2009, 60). Most notably, Richard Kelly published a three-part comic book, or graphic novel, that gives the movie's premises and backstory (Kelly and Weldele. 2007). Many of the plot twists, convolutions, and digressions in *Southland Tales* can only be understand by reading the comic first. This is why the movie's titles divide it into Parts IV, V, and VI; Parts I, II, and III are found in the comic. In addition, when *Southland Tales* was first released, a number of the film's (fictional) characters had websites on MySpace; the movie's (equally fictional) Treer Corporation had its own website as well. There was also a certain amount of spillover between the characters in the movie, and the pop culture celebrities who played them. Sarah Michelle Gellar actually recorded, under her own name, the song "Teen Horniness Is Not A Crime" – which in the film is written and performed (with an accompanying music video) by her character Krysta Now. The song is included on the movie's soundtrack album, and is available for download from the iTunes Music Store.

Of course, this sort of spread among multiple platforms is not unique to *Southland Tales*. It is an increasingly common media strategy today. As Richard Grusin notes, film today is turning into a *distributed medium*: "the film is not confined to the form of its theatrical exhibition but is distributed across other media as well." For instance, "the production, design, and distribution of DVD versions of feature films are part of the original contractual (and thus artistic) intention of these films." Grusin adds that this sort of remediation "marks a fundamental change in the aesthetic status of the cinematic artifact" (Grusin 2007). His point is that the aesthetic experience of a film today may reside just as much in watching the DVD extras, or in exploring the associated websites, as it does in watching the film itself. For that matter, the media experience may well reside in children's playing with toys that are modeled after figures from an animated film, and given away as part of a cross-platform promotional strategy. The aesthetics of distributed media cannot be separated from their marketing. For its part, *Southland Tales* not only supplements itself with a variety of intertextual materials in other media, but also folds the practice of multimedia distribution and dispersion into the narrative of the film itself. Most notably, Krysta Now seeks to leverage her semi-celebrity as a porn starlet not only by recording songs and making a music video, but also by starring in her own talk-show-cum-reality-television series, and by selling her own energy drink.

What this means is that, although *Southland Tales* is very much a *movie*, it is also profoundly post-cinematic in both form and content. I say that it remains a movie, in the sense that it is big and spectacular, and that it was clearly intended to be viewed in a movie theater, on an enormous screen.[46] However, its audiovisual flow is entirely post-cinematic, and of a piece with the video-based and digital media that play such a role within it. The compositional logic of *Southland Tales* is paratactic and additive, having little to do with conventional film syntax. The

film is filled with inserts; it overlays, juxtaposes, and restlessly moves between multiple images and sound sources. But it does not provide us with any hierarchical organization of all these elements. Many of the film's most arresting images just pop up, without any discernible motivation or point of view. For instance, around the five-minute mark, shortly after a title reading "Los Angeles," there is a shot of a G. I. Joe doll, advancing on knees and elbows along a wet sidewalk, then firing a rifle. It is nighttime. We see the toy in sharp focus and in close-up, while behind it the full extent of the boulevard, lined by palm trees, stretches out-of-focus into the deep background. The sounds emitted by the toy are accompanied, on the soundtrack, by Moby's soothing ambient music, and by a voiceover newscast reporting that celebrity-turned-soldier Pilot Abilene (Justin Timberlake) has been wounded in Fallujah by friendly fire. The film never returns to this toy figure; it has no function in the narrative. Of course, the film is filled with references to soldiers, and to wounded veterans like Pilot Abilene; but is that enough to motivate the appearance of the toy? The image of G. I. Joe is just *there*. It grabs our attention because it is anomalous and unexpected; it is evocative in a way that we cannot quite pin down. The film bequeaths us this moment, and then moves on to something else. G. I. Joe is just one figure in the movie's ceaseless flow.[47]

Kelly's repetitive *compositing* of images and sounds is almost the polar opposite of Eisensteinian montage. For Eisenstein, "montage is conflict" (Eisenstein 1949, 38). Contradictory images interact precisely by clashing with one another; out of this clash, a higher order image – or even a concept, which no single, isolated image could possibly express – is generated dialectically. In this way, the whole is greater than the sum of its parts. "From the collision of two given factors *arises* a concept," Eisenstein says (37); "from the superimposition of two elements of the same dimension always arises a new, higher dimension" (49). As

Deleuze summarizes the process, Eisensteinian montage features an ascending "organic spiral" composed of dialectical leaps (Deleuze 1986, 33); "the image must, effectively, change its power, pass to a higher power" (35). From this point of view, Eisenstein explicitly and scornfully rejects any "understanding of montage as a *linkage* of pieces" (Eisenstein 1949, 37), or "as a means of description by placing single shots one after the other like building blocks" (48), or like "bricks, arranged in series" (37).

However, Kelly's images and sounds do not interact dialectically. They really do seem to be linked together merely in the manner of bricks or building blocks. At best, the connections among shots, or among elements within a shot, are only allusive and indirect. Early in the film, for instance, as a voiceover newscast informs us that the Republicans have captured supermajorities in both Houses of Congress, a video clip embedded in the screen shows a pair of elephants fucking. Presmuably this is a snarky reference to the elephant as a symbol of the Republican Party. In any case, the clip shares space on the screen with a number of computer graphics; these include corporate logos for the newscasts's sponsors, Panasonic, Bud Light, and Hustler. (This is a brilliant list, including as it does three crucial commodities that are bought and sold in the age of affective labor: electronics, intoxicants, and sex). At a much later point in the movie, the Baron von Westphalen (Wallace Shawn), head of the ubiquitous Treer Corporation, shows a commercial for his new gas-free automobile, the Saltair. The ad is a CGI sequence that shows one of these cars approaching, mounting, and sexually thrusting into another one. (A phallic appendage extrudes out of the first car, and penetrates the exhaust pipe of the second). This evidently literalizes, and thereby satirizes, the sexual subtext that permeates so much automobile advertising. In addition, the humping automobiles recall the humping elephants; but we are not given any rationale for this connection. All these correspondences and connections form something like

an affective constellation; but they are too dispersed, and too indefinite and arbitrary, to work in the focused and organized way that Eisensteinian montage theory demands. Rather, these links are *weak ties*, such as we are accustomed to find on the Internet.[48]

The film critic Jim Emerson has a sense of what's at stake here, in his disapproving review of *Southland Tales* (originally entitled "Is It Even a Movie? "): "There's an obvious channel-surfing aesthetic to mimic 'information overload,' but nothing's on, anyway. One shot could just as easily be followed by any other shot – they aren't cut together with any verve or intelligence, so the effect is flat and linear... What's missing is resonance – a quality that's hard to define" (Emerson 2007).[49] Emerson dislikes the film because, as he accurately observes, it is not edited according to any traditional cinematic logic. Not only does *Southland Tales* not follow the method of dialectical montage; it also doesn't follow Hollywood continuity rules for organizing a narrative in such a way as to maximize narrative flow and impact.[50] Emerson is acutely aware of what's going on in *Southland Tales*; it's just that what he objects to is not a bug but a feature. The looseness or arbitrariness of its montage is in fact the very *point* of the movie. Kelly's shots refuse to coalesce into any sort of higher, synthetic unity. They never make the leap from affect to concept, or from their flatness to "a higher power," or to "a new, higher dimension." This is because the images and sounds of *Southland Tales* do not even *clash* in the first place. Rather, they coexist in their very distance from one another, their "incompossibility."[51]

In other words, Kelly's images and sounds are wildly disparate, and yet they all exist on the same plane. They do not fit together in any rational way; they are so miscellaneous, and so scattered, that they do not even conflict with one another. At the same time, none of these images or sounds is privileged over any other; no image source or sound source is treated as more

authentic than any other. In particular, there is no hierarchy of representations; the images on a screen are just as real, and just as efficacious, as the objects from which those images are supposedly derived. In the terms used by Deleuze and Guattari, the film refuses any "supplementary dimension," and operates only "with the number of dimensions one already has available" (Deleuze and Guattari 1987, 6). In this way, *Southland Tales* exhibits an entirely *flat ontology*.[52] This is what accounts for the fact that, on the one hand, the editing of the film seems "flat and linear" (as Emerson complains); while at the same time narrative sequences proliferate deliriously, bifurcate, and fold back upon one another, in a manner that is anything but "linear." In *Southland Tales*, chains of cause and effect both multiply and break down entirely, in defiance of traditional narrative logic. Nothing in the film makes sense in terms of linear causality, or in terms of action grounded in character, or even in terms of dialectical contrast. The onward flow of the film, as it zigzags towards catastrophe, is rather a matter of juxtaposition, dreamlike free association, and the proliferation of self-referential feedback loops.

For example, consider an almost impossibly convoluted narrative sequence in the first half of the movie. It concerns a pair of hip, "underground" performance artists, Dion (Wood Harris) and Dream (Amy Poehler). He is black, and she is white. They are a couple in real life, and collaborators in all their performances. They disguise themselves with facial prosthetics so that they will not be recognized. In this disguise, they pretend to be a viciously arguing newlywed couple. Their plan is to simulate a scenario in which they are murdered by a racist cop. Another collaborator, pretending to be the cop, will break in on them, as if responding to a domestic violence call. He will shoot them with blanks, and they will pretend to be hit, while a hidden accomplice presses a button in order to make fake blood spurt out. All this will be recorded on video, and released to the media and on the Net as

something that really happened. It's an agit-prop political action, being staged in order to discredit USIDent, and to blackmail some leading Republican politicians.

The fake racist cop is Ronald Taverner (Seann William Scott), who is impersonating his identical twin brother Roland Taverner (also played by Scott). Roland actually is a police officer, who has been kidnapped and is being held prisoner by the neo-Marxists. Ronald is accompanied by the amnesiac actor Boxer Santaros (Dwayne Johnson). Boxer has written a screenplay in which he plays the role of a psychotic police officer; he wants to accompany an actual officer on his rounds, in order to research the role. Boxer takes along a video camera, with which he records everything that happens; Dion and Dream's plan is for the fake double murder to be recorded on this camera. As Ronald and Boxer drive along, Ronald tries to get into character, by making a racist comment, on camera, to Boxer (who, like the actor playing him, is black). However, when Boxer responds with confusion and disbelief, Ronald backs off and says that he was only joking.

The whole fake-murder scenario goes awry, however, when a second supposed racist cop, Bart Bookman (Jon Lovitz), barges in on the scene of Dion and Dream's argument. At first, Dion and Dream continue screaming at one another, using their brilliant "improv" skills; but then, in fear of Bookman's threats, they break character and reveal themselves as the notorious performance artists they really are. Bookman doesn't care; he fires real bullets and kills them. As they fall, the hidden accomplice still pushes the special-effects button at the sound of gunfire, in order to spill the prearranged prosthetic blood. Ronald and Boxer flee the scene in a panic. In a subsequent scene, we learn that Bookman is also an impersonator rather than an actual cop; he's yet another neo-Marxist agent. He has killed Dion and Dream, and confiscated the video camera that recorded the double murder, in service to yet another confused agenda

that also seems to involve both political activism and blackmail for cash. In further developments, however, the videotape of the incident is itself mistaken for a different video, and stolen to further yet another political-intervention-cum-blackmail scheme.

The Dion-and-Dream subplot is only one small portion of *Southland Tales*; nearly everything else in the movie could be unpacked in similarly obsessive detail. My point in recounting the episode at such length is simply to give a sense of how dense and overstuffed the movie is. *Southland Tales* is filled with conspiracies and counter-conspiracies, with character impersonations and character doublings, with staged events and spontaneous events and reenactments of all these events, and with multiple digital recordings and simulations. And each of these can be interpreted in numerous, often contradictory ways. The film teases us, for instance, with the possibility of an allegorical reading. Thus, Dion and Dream may be identified with the Two Witnesses who play an important role in the Book of Revelation (11:3ff), and in subsequent Christian eschatological thought.[53] Finally, however, we are compelled to take the film's incidents and characters as *literally* as possible. Jim Emerson is once again accurate – albeit for the wrong reasons, and with a negative judgment that I do not share – when he complains that "the whole thing is so literal that everything has a banal explanation" (Emerson 2007). For the film's sheer density of incidents and references baffles our efforts to "translate" what we see and hear into something more abstract, more metaphorically palatable and easily manageable. The obsessive details of the movie are piled on, and left for fans to untangle and argue over, in a manner that is usually found only in long, multi-episode television and comic book serials. Kelly compresses several TV seasons' worth of episodes and plot twists into 145 minutes. *Southland Tales* may be long for a movie; but regarded as an implicit television series, it is almost brutally compressed and foreshortened.

If Kelly's juxtapositions of images and sounds do not fit into any tradition of cinematic montage, this is because they are organized according to the vastly different logic of digital compositing. The historical shift from montage to compositing – which occurred in Hollywood during the 1990s – is explored in great detail by Lev Manovich (2001, 136-160). Even if, "most often, the composited sequence simulates a traditional film shot" (137), nonetheless the fundamental assumptions of digital compositing are opposed to those of the analog cinema. The final output of electronic simulation may resemble the final output of mechanical reproduction, but these are generated in entirely different ways.[54] According to Manovich, "digital compositing exemplifies a more general operation of computer culture – assembling together a number of elements to create a singuler seamless object" (139). This means that the cutting-and-pasting of elements that are synchronically available in a database replaces the suturing of shots that unfold diachronically. "Where old media relied on montage, new media substitutes the aesthetics of continuity. A film cut is replaced by a digital morph or digital composite" (143). In contrast to the complexly hypotactic organization of twentieth-century modernist media forms, digital multimedia production "follows the principle of simple addition. Elements in different media are placed next to each other without any attempt to establish contrast, complementarity, or dissonance between them" (143). In short, "montage aims to create visual, stylistic, semantic, and emotional dissonance between different elements. In contrast, compositing aims to blend them into a seamless whole, a single gestalt" (144).

Digital compositing implies a continuity and equality among its elements. The assembled images and sounds all belong to a single "smooth space" – as opposed to the hierarchically organized "striated space" of montage (to use Deleuze and Guattari's distinction – 1987, 474-500). However, this does not

mean that the result of compositing is always "seamless," in the way that my previous quote from Manovich suggested. Manovich himself concedes that, when "hybrid spaces" are created, "television normally relates these spaces semantically but not visually." When we see a newscaster with a video clip behind her, for instance, the two spaces are visually "disjointed, as they share neither the same scale nor the same perspective. If classical cinematic montage creates the illusion of a coherent space and hides its work, electronic montage openly presents the viewer with an apparent visual clash of different spaces" (Manovich 2001, 150).

This suggests that the combination of moving images is governed by two pairs of oppositions, or unfolds along two axes. On the one hand, the mimetic, hypotactic, and striated space of cinematic montage may be opposed to the simulacral, paratactic, and smooth space of digital compositing. On the other hand, the *effects* aimed at by these procedures may range from the seamless unity of the multiple elements to their more or less explicit disjunction. On the side of analog cinema, both the standardized causal logic of the Hollywood continuity system and the Bazinian long-take style, with its "ambiguity" and "uncertainty" (Bazin 2004, 36) may be contrasted with Eisenstein's aggressive montage. On the side of digital simulation, the "perceptual realism" aimed at by films like *Jurassic Park* and *Forrest Gump* may be contrasted with the hypermediated juxtaposition of incompatible elements in a film like *Southland Tales*. Classical Hollywood films, and more recent blockbusters by the likes of Spielberg and Zemeckis, both create illusions of continuous action – albeit by very different means. *Potemkin* and *Southland Tales*, on the other hand, both foreground the heterogeneity of their construction – although Eisenstein's dialectical contradictions work very differently than Kelly's incompossibilities.[55]

One problem with Manovich's account of digital editing is

that it is focused almost entirely on visual images. It ignores the role of sound in digital media. But *Southland Tales*, like so many post-cinematic works, is weighted more to the sonic than to the optical. It assumes a world that, as McLuhan says, is "audile-tactile," and no longer centered on the eye (McLuhan 1994, 45). With digital media, we find ourselves "back in acoustic space" (McLuhan and Fiore 1967, 63). Digital compositing involves sounds as well as images; it even reduces the difference between them, since both sensory modalities are processed through the same digital code. But also, the very multiplication and fragmentation of visual sources leads to a certain destitution of the eye, and a consequent shift of emphasis towards the ear. Cartesian perspectival space gives way to "a discontinuous and resonant mosaic of dynamic figure/ground relationships" (McLuhan and McLuhan 1988, 40). *Southland Tales* repeatedly emulates the computer screen or cable television news screen, in which multiple windows compete for attention. In such conditions, my eyes no longer 'know' where to look. The media experiencer can no longer be figured as a "spectator," standing apart from and overlooking a homogeneous visual field. Rather, he or she must parse multiple, windowed image sources as rhythmic patterns and as information fields. "In this electric age we see ourselves being translated more and more into the form of information"; perceptual impressions are "translated into information systems" (McLuhan 1994, 57). These systems, with what Manovich calls their "database logic," composed as "collections of individual items, with every item possessing the same significance as any other" (Manovich 2001, 218), cannot be ordered by vision alone. This is why their very presentation demands the foregrounding of the other senses, most notably hearing.

Michel Chion, the great theoretician of film sound, is equally sensitive to the role of "sound on screen" in post-cinematic media (1994). In traditional analog cinema, the images are

primary. The coherence of a film comes mostly from its mise en scène, cinematography, and editing. The soundtrack serves as a support for the images, giving them emotional resonance and a guarantee of (seeming) naturalism. That is to say, sound provides what Chion calls *"added value"*; it "enriches a given image" in such a way as to give the false impression that "this information or expression 'naturally' comes from what is seen, and is already contained in the image itself" (Chion 1994, 5). Film sound is therefore a *supplement* (in Derrida's sense of the term): it subliminally supports the primacy of an image that nonetheless would not mean or feel the same without it.

But all this changes in post-cinematic media like television and video. Sound now operates overtly instead of covertly. Instead of sound providing "added value" to the image, now a visual element is "nothing more than an *extra image*," working "to illustrate or rather decorate" whatever is spoken on the soundtrack (Chion 1994, 158). In this way, "television is illustrated radio"; for "sound, mainly the sound of speech, is always foremost in television. Never offscreen, sound is always *there*, in its place, and does not need the image to be identified" (157). In television news especially, spoken commentary weaves together and makes coherent what otherwise would seem to be an utterly random stream of images. For televisual images have no intrinsic logic of their own; they are only strung together through the guidance provided by the sound. This does not necessarily mean that images will tend to disappear; more often, it leads to their mad proliferation. When images are governed only by speech, a regulatory principle entirely external to them, they are no longer constrained by any intrinsic logic. This allows them to multiply without limit.

Music video operates according to a related, but slightly different, logic. Chion says that, because music videos are anchored in pre-existing songs, they feature "a joyous rhetoric of images" (Chion 1994, 166). Music video paradoxically "liberates

the eye. Never is television as visual as during some moments in music videos, even when the image is conspicuously attaching itself to some music that was sufficient in itself" (166). Images are freed precisely because they are entirely superfluous. They do not provide any added value to a song that is already self-sufficient. But they also do not have to advance a narrative, since the music video "does not involve dramatic time" (166). Instead, "the music video's image is fully liberated from the linearity normally imposed by sound" (167). The visual track is wedded to the soundtrack in that it establishes certain "points of synchronization, where the image matches the production of sound in some way." But "the rest of the time," outside of these synchronization points, the image track ignores the sound and "goes its separate way" (167).

Chion notes that "cinephiles especially attack music videos as eye-assaulting; they dislike the stroboscopic effect of the rapid editing." However, this is only "because they are judging the editing according to cinematic criteria" that are no longer valid (Chion 1994, 167). In fact, "the rapid succession of shots creates a sense of visual polyphony and even of simultaneity" (166), despite the fact that we only see one image at a time. Chion, writing in 1990, notes that the literal simultaneity of multiple images on a single screen, or of frames within the frame, tends to be rare in film – and even in video, where it is technically easier to accomplish (166). But of course, this situation has changed in the last twenty years. *Southland Tales* has no trouble with multiple frames or windows, and images within images, because these have become so familiar a feature of our contemporary media environment.

*Southland Tales* uses sound precisely in the ways that Chion describes as characteristic of post-cinematic media. In the film, just as in television news, speech guides us through an otherwise incomprehensible labyrinth of proliferating images. The voiceover narration provided by Pilot Abilene (Justin

Timberlake) is "always *there*, in its place," even when Abilene himself is offscreen, or when the voice is not issuing from his demented onscreen image. Abilene's commentary is tonally flat and detached;[56] it includes backstory information, evocations of various characters' states of mind, and readings from the Book of Revelation. This neutral, all-encompassing voice accounts for, and thereby makes possible, the "apparent visual clash of different spaces" evoked by Manovich – a clash which cannot be resolved on the visual level alone. In traditional Hollywood film, the offscreen voice often acquires a transcendent or God-like authority.[57] In contrast, the flat voice of the television newscaster suggests a bare accumulation of facts, which cannot be made subject to any transcendent judgment. Justin Timberlake's voiceover in *Southland Tales* is similarly blank and dispassionate. It reduces the film's images to the status of data, or pieces of information, that can be combined in innumerable ways, without concern for the traditional constraints of film syntax. Everything in *Southland Tales* is spoken in the same way, "said in a single and same sense" (Deleuze 1994, 42); and this Deleuzian *univocity* is the indifferent background that allows differences and incompossibilities to emerge.

Stylistically, Kelly's images tend towards a televisual flatness. They usually feature conventional character positioning: either centered two-shots, or shot/reverse-shot setups. But this deliberate visual blandness is what allows for the stacking of images within images, as well as for the frequent irruption of bizarre tableaux and hallucinatory visual displacements. I have already mentioned the car commercial, and the G.I. Joe doll on the Venice Beach boardwalk. But there's also the freakish entourage of the Baron von Westphalen; and the dazzling three-minute-long sequence shot that weaves through the crowd celebrating Independence Day aboard the Baron's "mega-zeppelin"; and the vision of Pilot Abilene turning round in his gun turret, with his disfigured face, his maniacal grin, and an

insane glint to his eye; and the scene in which Ronald Taverner gestures in front of a mirror that only returns his reflection with a delay of several seconds. All these are possible only because, as Chion says, in a televisual mode "the image [i]s something extra" (Chion 1994, 159). The overfullness of *Southland Tales'* soundtrack – which includes, in addition to Abilene's voiceover, a scattering of CNN-style news reports, and Moby's brooding, ambient musical score – allows for the unmooring of the film's images, a scattering of the weightless detritus of more than a century of moving pictures.

With its tendency to congeal action into self-contained set pieces, *Southland Tales* also frequently approaches the condition of music video. At certain points in the film, the already fractured narrative comes to a complete halt. "Dramatic time" is suspended, giving way to an "audiovisual passage" whose temporality is dictated by a pop song that dominates the soundtrack.[58] Indeed, the most memorable sequence in the film is precisely such a passage. The sequence features Pilot Abilene – which is to say, Justin Timberlake – dancing and lip-synching to the Killers' hit song from 2005, "All These Things I've Done." There is no fast cutting, but the cinematography is entirely subordinated to the rhythms of the song. Within the diegesis, the scene is motivated as Abilene's drug-induced hallucination, the result of injecting himself with a powerful psychedelic called Fluid Karma. But really, it breaks out of the diegesis altogether, and addresses the film's audience directly. The sequence is a delirious, but utterly cold and abstract, sexual fantasia; it is best regarded, perhaps, as a post-cinematic, videocentric revision of Busby Berkeley's big production numbers from Warner Brothers musicals of the 1930s. The scene is utterly extraneous as narrative, but it works as a kind of affective focal point, bringing to a head the feelings of displacement and distraught confusion that have drifted throughout the film, and touched nearly all the characters. In an interview, Kelly even calls the sequence "the

heart and soul of the film" (Peranson 2007).

In this sequence, Abilene/Timberlake stumbles about in a game arcade, as dry ice smoke swirls from the floor. He is wearing a blood-stained T-shirt. He exhibits a ravaged beauty: the symmetry and perfect sculpting of his features is disrupted by the scar lines that traverse one side of his face, traces of his injury in Fallujah from friendly fire. As he progresses through the arcade, he flips the dog tags around his neck while lip-synching the repeated line: "I've got soul, but I'm not a soldier." But the lip-synching is not maintained consistently; at times, he stops doing it, even as the song continues. Abilene/Timberlake drinks beer, and pours it over his head like a frat-boy party dude. He moves forward, staring into the camera, except when he seems too befuddled to focus his attention anywhere. At one point, he gives the camera (and us) the finger, and then smirks as he passes out of the frame. All the while, Abilene/Timberlake is surrounded by a bevy of Busby Berkeley-esque nearly-identical women wearing platinum-blonde, curly wigs and skimpy nurses' uniforms. They are "sexy" in a tawdry and tacky way, with the fake smiles we expect to see on TV. They gyrate and kick their legs, as Abilene/Timberlake entertains their attentions briefly, and then pushes them out of the way. The dance continues, with dreamlike motions, even as the song fades from the soundtrack, to be replaced by Moby's low, ambient drone.

The sequence as a whole is dominated by Justin Timberlake's charismatic presence. You can't forget the celebrity behind the character he plays. This is all the more so, in that the rock grandiloquence of The Killers is so distant from the r&b-inflected pop of Timberlake's own musical recordings. This discordance only draws our attention still more acutely to Timberlake as a media construct, or celebrity persona. For here, as in so many places in American popular culture today, Timberlake displays a charisma that seems incompatible with – and yet that somehow arises seamlessly out of – his bland-as-white-bread, blue-eyed-

soul presence. Justin Timberlake seems to be a "man without qualities," hyperbolically bland and ordinary; and yet this everydayness generates a powerful aura. He radiates a smothering sexual heat, especially when he appears in music videos by female r&b singers (Rihanna, Ciara, and even Madonna).[59] In *Southland Tales*, this sexual energy is turned inside-out, or diverted into a solipsistic dementia. But it retains the odd, haunting sense of something not-quite-there: as if it were not reduced, but rather intensified, by the process of being hollowed out, turned into an empty shell of itself. It's not for nothing that Pilot Abilene incessantly quotes, in addition to the Book of Revelation, the final lines of T. S. Eliot's "The Hollow Men" – only inverted so that "the world ends/ Not with a whimper but a bang."

In any case, Pilot Abilene's music video hallucination is at once utterly depraved, and yet also oddly impersonal. It is flat, self-contained, and without resonance, as if it were being performed in a special chamber designed to muffle and absorb anything that might exceed the literal, or that might lead us to connotations beyond the obvious. The scene is nearly unspeakably ridiculous, at the same time that it is creepily menacing, and yet also exhilarating. When you shoot Fluid Karma, Abilene says just before injecting himself, "you talk to God without even seeing Him. You hear His voice, and you see His disciples. They appear like angels under a sea of black umbrellas. Angels who can see through time." In other words, speech is severed from vision. You hear what you are unable to see; and what you see (the fake-porno nurses as angels) is the always-inadequate representation, or messenger, of a divine futurity that you can never quite apprehend. For Richard Kelly, as for Philip K. Dick, if you let the forces of the cosmos stream through you, then you will find yourself channeling chintzy advertising specials and reality shows. Watching Timberlake strut and lip-sync among the fake-porno nurses, it's almost as if

time had stopped for the duration of the song, looping back upon itself in order to intensify, by a sort of positive feedback, the film's overall sense of apocalyptic imminence: of something catastrophic not so much happening, as always being about to happen. Justin Timberlake dramatizes the state of teetering on a precipice without actually falling over; or better, of falling over but never finishing falling over, never quite hitting the ground.

What I have been saying about the Justin Timberlake music video scene applies, in large, to the movie as a whole. *Southland Tales* is overloaded to the point of hallucination; yet at the same time it depicts a culture drained of vitality, and on the brink of death. The movie exuberantly envisions the entropic dissipation of all energy, and the implosion of social and media networks into a flat, claustrophobic, degree-zero banality. This end-point looms continually before us, but it is never quite reached. It is as if the film were always holding something back; or as if it were running repeatedly through a holding pattern, like an airplane circling the airport without landing. Timberlake/Abilene repeatedly tells us that we are watching the end of the world. But this end is continually being deferred. Even in the last moments of the film, when we finally get the "bang" that we have been promised all along, it is unclear what (if anything) has actually been accomplished. It may be the Apocalypse foretold by the Book of Revelation, or it may be just another media show. We usually say in such cases that "time will tell"; but in the world of *Southland Tales*, there is precisely no time left to tell.

Indeed, time has been depleted in the world of *Southland Tales*, just like every other natural resource. The psychedelic drug Fluid Karma allows you to travel or "bleed" through time. But this drug is just a byproduct of the new energy source, also called Fluid Karma, that has freed America from its dependence on oil. Fluid Karma is produced by the Baron von Westphalen and his Treer Corporation; they manufacture it by capturing the motion of the ocean tides, a seemingly limitless source of energy. But of

course, there is no such thing as a "perpetual motion machine" (which is how the Baron describes Fluid Karma). The extraction of the ocean's energy results in a kind of tidal drag that slows down the rotation of the earth. This leads in turn to a gradual running-down of time itself, and a rift in the spacetime continuum. The leaking-away of time – its asymptotic approach to an end that it never fully attains – is both a major theme of *Southland Tales*, and the principle behind its formal organization of sounds and images.

Deleuze describes modernist cinema as an art of the *time-image*. Post-World-War-II art cinema offers us an image of "time itself, 'a little time in its pure state' " (Deleuze 1989, 17). In the modernist cinema's direct image of time, sheer duration is affirmed in its own right, and liberated from any subordination to narrative. But *Southland Tales*, as a post-cinematic work, is about the exhaustion of this image of time – or perhaps I should say, the exhaustion of temporality itself. This is evidenced by the way that digital media do not seem able to "communicate duration" – as David Rodowick complains, quoting Babette Mangolte (Rodowick 2007, 163). Just as the movement-image gave way to the time-image, so now the time-image gives way to a new sort of audiovisual or multimedia image: one lacking "the sense of time as *la durée*" Rodowick 2007, 171).[60] What Rodowick sees as sheer loss, however – a reduction to "the 'real time' of a continuous present" (171) – needs to be regarded in an affirmative sense as well. If we have lost a certain humanist pathos of lived duration, in return we have gained the sheer profusion and density of 'real-time' innovation and invention. Post-cinematic works like *Southland Tales*, with their imploded temporality, "don't bother to be concerned about the way they combine devices that might be opposed in the abstract" (Chion 1994,167). Few works go further than *Southland Tales* in exploring the potentialities, both for good and for ill, of the new media regime that is now emerging before our eyes and ears.

The hypermediated reconfiguration of time and space that *Southland Tales* offers us is a creative response, not just to the demands of new digital technologies, but also to the social and cultural conditions of what Mark Fisher calls *capitalist realism* (Fisher 2009). As Fisher puts it, echoing both Fredric Jameson and Slavoj Žižek, today "it is easier to imagine the end of the world than it is to imagine the end of capitalism"(2). Even as we shudder with apocalyptic premonitions, we are haunted by "the widespread sense, not only that capitalism is the only viable political and economic system, but that it is now impossible even to *imagine* a coherent alternative to it." In such a world, the future is no longer open. We have an inescapable sense that "the future harbours only reiteration and repermutation. Could it be that there are no breaks, no 'shocks of the new' to come? " (Fisher 2009, 3). For all processes, and all relations, have been captured in the form of saleable commodities. This is the real meaning of Hegel's and Kojève's "end of history" (Fukuyama 1993). Capitalism not only "subsumes and consumes all of previous history" (Fisher 2009, 4); it preemptively appropriates and commodifies all futurity as well. The world can end, but it cannot change; or better, the only change it can know is the "capitalistic fashion-novelty" derided by Ernst Bloch: "sheer aimless infinity and incessant changeability; – where everything ought to be constantly new, everything remains just as it was... a merely endless, contentless zigzag" (Bloch 1995, 201, 140). In the world of capitalist realism, duration implodes; it shrinks down to a dimensionless, infinitesimal point. Time is emptied out, or whittled away. The task for a critical art today is not to mourn this loss, but to discover what possibilities the new situation offers.

*Southland Tales* accomplishes such a task through its manic multiplication of new-media strategies. Every characteristic of the post-cinematic media regime, under the conditions of capitalist realism, is accelerated to the breaking point. We see this

in Richard Kelly's experiments with narrative and cinematic form; but also in the film's treatment of subjectivity, and in the way it uses celebrities. Most of the actors in *Southland Tales* are pop culture icons of one sort or another. Some of them are best known for their roles in previous films, while many of them made their name in other media. In every case, however, their acting in *Southland Tales* cuts sharply against their familiar personas. I have already mentioned the odd, pivotal role that Justin Timberlake plays in the film. But there's also Dwayne Johnson (a.k.a. The Rock), whose Boxer Santaros is a befuddled amnesiac; Johnson shows a vulnerability, and a continual fearfulness, utterly at odds with his past roles as a professional wrestler, and as an action hero. Sarah Michelle Gellar will never escape her identification as *Buffy the Vampire Slayer*; but nothing could be more un-Buffy-like than her hilarious performance here as the perky, upbeat, humorless, self-promoting, and incorrigibly naive porn starlet Krysta Now. And Seann William Scott, who radiates existential anguish in his role as the doubles Ronald and Roland Taverner, is best known for his performance as the irrepressibly crass Stifler in the *American Pie* movies. In all these cases, the violent contrast between the character in the diegesis, and the well-known persona of the celebrity who is playing that character, leads to a kind of cognitive dissonance.

For instance, Dwayne Johnson's character, Boxer Santaros, is amnesiac and literally beside himself; we ultimately learn that this amnesia is a consequence of space/time displacement, together with the murder of his "other" self. Boxer is a rich and famous Hollywood star with Republican Party connections (much as Dwayne Johnson himself is in "real life"); he is even married to Madeleine Frost (played by Mandy Moore in yet another bit of celebrity counter-casting), the bitchy, fashion-victim daughter of a key Republican Senator. But Boxer doesn't remember anything of his past life. This means that, although everyone else in the world of the film recognizes him, he does

not recognize himself. Amnesia takes away his knowledge of his own stardom; but it also turns him into even more of an actor, since anything he does makes him feel like he is playing a fictional character. His only possible mode of being is therefore to play it by ear, straining to imagine himself into whatever role he finds himself having been cast for. No wonder Boxer keeps slipping into the role of a character in an apocalyptic screenplay that he is supposed to have written – though he doesn't remember writing it either, but only reading it.

Dwayne Johnson gives a brilliant performance as this sort of a performer. You can see him trying on the various roles, being touched by fear and anxiety and surprise, and above all by a sort of bemused puzzlement – but always braving it out and trying to act in the way the situation demands. Is it possible to be a Method actor, inhabiting your role, when you don't have any personal memories to call upon in order to think yourself into that role? Is it possible to be a Method actor, drawing upon personal memories in order to inhabit the role of somebody without any such personal memories? Boxer Santaros' hyperperformative, or improvisational, simulation of interiority is the only model of subjectivity that *Southland Tales* gives us. The "split subject" of an earlier Hollywood era (the particularity of the diegetic character, doubled by the unchanging, recognizable persona of the star who played that character) opens up into a potentially endless hall of mirrors. Boxer Santaros is an extreme version of the *flexible personality* demanded by what Luc Boltanski and Eve Chiapello (2007) call "the new spirit of capitalism." On the one hand, such a personality must be capable of participating, with total energy and enthusiasm, in whatever project engages him at the moment. On the other hand, he must also have "the ability to disengage from a project in order to be *available*" for a new one. "Even at the peak of engagement, enthusiasm, involvement in a project," the flexible personality must be "prepared for change and capable of new investments" (Boltanski and Chiapello 2007, 112). Who

could meet these schizophrenic demands better than an amnesiac actor?

But there's more to Boxer Santaros, and to the other characters in *Southland Tales*, than just this radical lability. Boxer, and Pilot Abilene, and Ronald and Roland Taverner, and even Krysta Now, also possess what I can only call a powerful and moving *sincerity*. Such an attribute might seem entirely out of place, in a "postmodern" world, with no depths, where everything is reduced to the status of a one-dimensional caricature, and where "personality" is entirely a matter of self-promotion and of continual adaptation to changing circumstances. But sincerity is precisely *not* a question of depth, or of authenticity, or of some fundamental inner quality of being.[61] Sincerity merely implies a certain *consistency* in the way that a being acts and presents itself, without presupposing anything about the basis of this consistency. Graham Harman defines sincerity as the way that "a thing always just is what it is" (Harman 2005, 143).[62]

In this sense, we must say that Boxer Santaros is altogether sincere. What is being expressed sincerely, throughout *Southland Tales*, is precisely the diffuseness and discomfort of this character, together with its difference from the usual screen persona of Dwayne Johnson, together with the difference between that usual persona and the actual, empirical person who Dwayne Johnson is. None of these uncertainties and differences are smoothed over, and none of them are posed as "contradictions" to be dialectically resolved. Instead, they are just *presented*, and transformed into spectacle, in their full messiness and intractability. In the midst of his multimedia barrage, Kelly also "fill[s] the screen," as Amy Taubin rightly puts it, "with tenderness, longing, [and] despair" (Taubin 2007). Boxer Santaros never figures out who he truly is; but the pathos is overwhelming when, towards the end of the film, he gets up to dance on a big disco floor, and is joined both by his girlfriend Krysta Now and by Madeleine Frost, the wife he has forgotten.

In purely narrative terms, the moment is absurd. But after two hours in which their characters have argued, plotted with and against one another, and generally gone around in circles, this final conjunction of Dwayne Johnson, Sarah Michelle Gellar, and Mandy Moore has a force of conviction that makes it almost sublime.

*Southland Tales* doesn't offer us a way out from the nightmare of "capitalist realism," or the neoliberal "end of history." But in its crazy ambition, its full engagement with contemporary media, and its terrible sincerity, it is one of those rare works that dares to be "as radical as reality itself." In its demented fabulation, it reflects upon our actual situation, while at the same time inserting itself within that situation, rather than taking a pretended distance from it. Kelly's "science fiction" is scientifically and technologically unsound, and could best be described as delirious – but that is precisely why it is directly relevant to a world in which "the boundary between science fiction and social reality is an optical illusion" (Haraway 1991, 149).

# 5 Gamer

Mark Neveldine and Brian Taylor's *Gamer* (2009) is brilliant in the way that only a sleazy exploitation movie could be. It is fast, cheap and out of control – the product of directors who cheerfully describe themselves as "pretty A.D.D." (Quigley 2009). Neveldine/Taylor's earlier *Crank* films already pushed the motifs of the action genre beyond all boundaries of taste and plausibility. But *Gamer* ups the ante considerably, in terms of both choreographed violence and conceptual edge. It's an audacious movie; and one that, in the service of this audacity, isn't afraid to risk seeming ridiculous or stupid. *Gamer* may well be, as Jeanette Catsoulis of *The New York Times* rather snarkily put it, "a futuristic vomitorium of bosoms and bullets" (Catsoulis 2009). But this description needs to be read as praise rather than opprobrium. For *Gamer* is one of those rare films that truly dares to be "as radical as reality itself." Precisely because of its exaggerations and funhouse distortions, it says more about the world we actually live in today than nearly any other recent American film that I have seen. *Gamer* remains a few steps ahead of any possible critical reflection that one might try to apply to it – including, of course, my own.

In terms of genre, *Gamer* is an action/exploitation feature. But it is also a science fiction film. *Gamer* is set in the near future, "some years from this exact moment" (as an opening title tells us), in a world whose technology is extrapolated from our own. In this way, *Gamer* explores the incipient futurity – or, at the very least, the incessant pressure of technological change – that is so big a part of our experience today. Capturing this experience in the medium of film is inherently problematic. Of course, film has long since been displaced by newer media – television, video, and a whole panoply of computer-based forms – as the "cultural dominant" of our society.[63] But in recent years, with the rapid growth of digitization and of networking, we seem to have

passed some sort of threshold. The ontological basis of film seems to be under threat, as was not the case even in the late twentieth century. Film theorists have begun to worry, and to mournfully proclaim – as they never did in the age of broadcast television – that cinema has become an art of the past (Rodowick 2007).

Neveldine/Taylor respond to this situation without nostalgia, and without regret. Instead of ironically recycling cinema's glorious past,[64] they hyperbolize the contemporary media landscape. They make a movie that itself subsumes and reflects upon post-cinematic forms – computer games in particular. In *Gamer*, spectacle, virtualization, and "entertainment" in general have been pushed to their logical extremes. Everyone in the world, it seems, is addicted to MMORPGs (massively multi-player online role-playing games). But these games are themselves viscerally "real," in a way that is not (or not yet) the case today. The basic science-fictional extrapolation of the movie is to envision a form of gaming in which players control the actions, not of virtual figures on a screen, but of real, physical, flesh-and-blood bodies: human "actors" or avatars. In this way, *Gamer* combines, and updates, the two most prominent popular entertainment forms of the early 21st century: online gaming and reality television. Conceptually, *Gamer* explores these forms of entertainment in order to think about freedom and enslavement in what Gilles Deleuze called the control society (Deleuze 1995, 177-182), or in a world that – as McKenzie Wark (2007)describes it – has become increasingly indistinguishable from gamespace.

There are two games that dominate the world of *Gamer*: Society and Slayer. In both of these games, the human avatars who actually perform the physical actions of the game have no free will. They no longer control their own bodies and motor actions; rather, they take orders from the gamers "playing" them. Artificial nanocells are introduced into the avatars' brains; these cells reproduce, replacing the original, organic nerve cells with

synthetic ones. Once you have undergone this procedure, you have an IP address in your head, and your body obeys whatever commands are transmitted to that address by the player who controls you. You say what they want you to say, and move the way they want you to move. Of course, this relationship only works one way. The controllers see and hear their avatars on multiple screens, and live vicariously through them. But under normal conditions, the avatars cannot see their controllers, and cannot learn anything about them.

Society is a hilariously sleazy live version of the popular (and extensively media-hyped) "3D virtual world community" Second Life (http://secondlife.com). In Society, players guide their avatars through scenarios of drug consumption, partying and clubbing, and (most of all) down 'n' dirty sex. Avatars rollerskate through crowded plazas, crashing into one another; they grope one another in crowded dance clubs; they accost one another with corny pickup lines in bars. The gamespace of Society is visually garish: overlit, with hypersaturated colors, raunchy costumes, and lurid, tacky interior decorations that egregiously shout out their own "bad taste." Often tags are superimposed on the images of the avatars, giving their characters' fictive names – just as is actually the case in Second Life. Our first view of Society's gamespace is set to the satirical novelty song "Bad Touch" by Bloodhound Gang, which just about says it all: "You and me baby ain't nothin' but mammals/ So let's do it like they do on the Discovery Channel."

The avatars in Society move jerkily and abruptly; their actions and speech are interrupted by pauses that seem to go on just a bit too long. This is a result of what the movie calls the *ping*: the gap in time between order and execution. The ping is due both to network latency, and to the sheer fact of one person's body and brain having to process and execute a command given by another. The "speed of thought" (Gates 2000) is not truly instantaneous. Indeed, *Gamer* is one of the rare futuristic

narratives to acknowledge technical glitches and breakdowns, instead of presenting a seamless vision in which they no longer exist. Thanks to the ping, the avatars in Society display what Bergson saw as the very basis of comedy: "an effect of automatism and of inelasticity" impinging upon the vitality and spontaneity of the organic (Bergson 1914, 18). In this way, the movie never lets us forget that the avatars are just proxies for their players.

But *Gamer* also shows the relationship of player to avatar more directly, by cutting back and forth between Angie (Amber Valletta), who works as a sexbot in Society, and her controller Gorge (Ramsey Moore). Angie is ridiculously dressed in a white fur wrap, blue hot pants, pink platform boots, and an orange wig; if the camera isn't close up in her face, it is usually placed so as to accentuate her ass. Angie is compelled by her player to radiate perkiness and sexiness, even as we know that she actually feels put upon and distressed. This is all conveyed through ambiguious gestures and facial expressions, in an acting style that is cognitively dissonant almost to the point of schizophrenia. For his part, Gorge is a morbidly obese, wheelchair-bound man. We usually see him in extreme closeup, sweating profusely, consuming munchies, and licking his slobbering lips as he moves Angie into one degrading situation after another. Gorge is the *reductio ad absurdum* of the cliché of the gamer as a pervert, and a nerd with absolutely no social skills.[65]

Society is all about sex as spectacle; but actually, sex is subordinated to economics. The financial structure of the game is simple, and brilliantly neoliberal: you can either be a consumer by paying to actively play, or be a worker by being paid to be played. As Ignatiy Vishnevetsky (2009) observes, *Gamer* is "the sort of movie that imagines what the working class would have to do in its fantasy scenario." This is something that is all-too-conveniently left out of most visions of a transhumanist Singularity (Kurzweil 2005), or of an *Exodus To the Virtual World*

of computer games (Castronova 2007). On the one hand, Society's consumers can be as nasty as they want to be, without having to face any legal or moral consequences. They get a pornographic experience that is still vicarious, and therefore safe for them; but that is also more intense, and more "real," than any mere computer simulation could ever be. On the other hand, Society's avatars receive wages in return for giving up control over their own bodies. They represent the *ne plus ultra* of what Michael Hardt and Antonio Negri describe as the quintessential mode of production in today's network society: *affective labor*, the "labor that produces or manipulates affects such as a feeling of ease, well-being, satisfaction, excitement, or passion" (Hardt and Negri 2004, 108).

This has important economic consequences. The sim-actor directly produces moods, feelings, and experiences as commodities, rather than mediating such subjective, impalpable states through the production of physical goods. In working this way, the avatar is not just selling the use of his or her "labor-power" for a certain number of hours – as was the case in classical capitalism as described by Marx. In addition to this, he or she is also selling his or her "life" itself as a commodity. Such a "biopolitical" mode of exploitation would seem to combine the worst aspects of slavery and of wage labor; nonetheless, it is increasingly the norm – as Hardt and Negri argue – in our contemporary world of post-Fordism, "real subsumption," and immaterial production. Today, profits are extracted from the whole texture of our lives, not just from the specific hours we pass working in a factory or an office. *Gamer* allegorizes, or exemplifies, this fact.

The same point can be made in a slightly different way. Today – in contrast to the situation that Marx outlined in the nineteenth century – "surplus value" is extracted from the process of circulation (especially media circulation), as well as from the direct process of production. Marx described the labor-power

expended in circulation as the *faux frais* (false expenses, or overhead costs) of the capitalist mode of production; but post-Fordist corporations have found a way to make the work involved in circulation directly productive, so as to extract a surplus from it as well. Indeed, we might say that value is even extracted, today, from the act of consumption itself, which is now a kind of labor in its own right. In classical capitalism, the moment of consumption is the moment when value is destroyed: the object is removed from the commodity chain because it is no longer being exchanged, but is instead actually put into use, and used up (so that use-value finally takes priority over exchange-value). But in a world of virtual consumption, and of *ludocapitalism* or play-as-work (Dibbell 2006, 299), this is no longer the case. In *Gamer*, even the player's most private and solitary *jouissance* – as Gorge, for instance, gets off on his living avatar's being penetrated by a character who calls himself "Rick Rape" (Milo Ventimiglia), or as he is turned on as a result of witnessing, through her eyes, a bloody murder that takes place right in front of her – is equivalent to a capture of energy and attention.

When Hardt and Negri speak of "immaterial labor," they mean that the commodity produced is not a physical object. But this is not to deny the materiality of the production process itself; which is to say, of the physical and mental labor (the expense of time and energy) that is required in order to generate this immaterial result. The material labor expended in immaterial production is aptly figured by the labor (sexual and otherwise) of the avatars or bodies that are physically present in the world of the game, and compelled to perform the actions from which their players derive enjoyment. But as the players reap this enjoyment, they themselves are performing labor in their own turn. Not only are they actually paying for the "right" to help in constructing a profitable spectacle;[66] they are also providing massive amounts of economically-valuable data through the technology's

surveillance of everything that streams over the network. As Jonathan Beller puts it, "we valorize the organization of society in our very bodies as we add value to the media by watching it and make ourselves over in socially acceptable forms" (Beller 2006, 138-139). In this manner, Beller adds, *to look is to labor...* Increasingly, part of the value of the commodity, be it a painting or a Hollywood star, comes from the amount of (unpaid-for) visual attention it has absorbed" (181). Beller is here describing the logic of value in 20th-century film and television. But *Gamer* suggests that this logic is further extended and intensified by the interactive or participatory media that are today in process of supplanting film and television.

Slayer, the second mass entertainment spectacle in *Gamer*, pushes this logic of exploitation and control even further. Slayer is a real-time combat game, with avatars physically present in the gamespace. The soldiers who appear in the game – the Slayers – are convicts on death row; as an alternative to immediate execution, they are allowed to "volunteer" for combat as meat puppets controlled by gamers. They actually have live weapons; they kill and get killed on a regular basis. In Slayer, just as in Society, the player controls the avatar. The player decides when and in what direction to fire a gun; but the avatar is the one who actually pulls the trigger. As one Slayer puts it: "I'm the hand; someone somewhere else is the eye." The player vicariously experiences the joy of combat; but the Slayer must actually face the physical consequences. This means that the Slayer game, even more than Society, entirely turns upon the time delay of the *ping*, the gap of some milliseconds between order and execution. For "the slice of a second out there is the difference between living and dying."

The premise of Slayer is that, if an avatar survives thirty rounds of battle, then he or she will be pardoned and freed. But of course, this never actually happens. The game is rigged; everyone dies before reaching such a point. People convicted of

lesser crimes may similarly "choose" to enter the combat zone; they only have to survive one round in order to be pardoned and freed. But this is also impossible to accomplish. For these lesser avatars – known as "genericons" – only appear in the game as NPCs (non-player characters); they are not controlled by actual players, but just by simple computer routines. This means that they are relegated to being cannon fodder; they are not allowed to exercise even their most basic reflexes of self-preservation. All they can do is idiotically repeat the same actions over and over, regardless of the mayhem that surrounds them. Thus Freek (John Leguizamo) holds a broom, and keeps on sweeping the same small area of floor, until he is (unsurprisingly) brought down by crossfire.

Slayer also goes further than Society in terms of its underlying economic logic. In Slayer, income is generated, not just from the gamers who pay to control the soldier characters, but also from millions of pay-per-view subscribers who watch the combat live on TV or the Web. As a result, both players and avatars become worldwide celebrities; though the latter, confined in lock-up, remain unaware of their fame. The "real world" of *Gamer* is saturated with billboards and electronic screens displaying the figure of Kable (Gerard Butler), the soldier in Slayer who has survived the most rounds of combat. The film also revels in its reaction shots of crowds of yuppies, in cities around the world, viewing the Slayer action on enormous screens. These spectators – or at least the American ones – have an ugly air of entitlement. They cheer each spectacular display of violence. But they react with baffled anger when something goes wrong with the live feed, due to technical problems or sabotage by hackers. They are furious that anyone would presume to interfere with their enjoyment.

The money stream from Slayer not only brings in enormous profits, but also subsidizes the out-of-control costs of the American prison system. This aspect of *Gamer's* scenario is

scarcely even satire. After all, in the United States today, more money is spent on incarceration than on education. The prison population has risen sharply, thanks to "zero-tolerance" policies on drug use and other forms of petty and victimless crime. In order to defray the high costs of punishment, prisons are increasingly being privatized, and prisoners are put to work at extremely low wages. *Gamer* simply pushes these trends to their logical conclusion. In the world of the film, imprisonment – with enforced labor and a high mortality rate – seems to be the only alternative, for the working class, to selling their bodies on Society. Today, prisoners are compelled to perform unremunerated and unskilled labor for the industrial and service sectors. In the future envisioned by *Gamer*, they are called upon to do unpaid work for the military-entertainment complex instead. Slayer thus answers the demands of both neoliberal governance and media proliferation. Prisoners are forced to work, in order to pay the costs of their own punishment. At the same time, they help to accelerate and intensify the frenzy of media circulation, and hence to facilitate the increased extraction of value that results from "the accruing of human attention on the image"(Beller 2006, 231).

What most distinguishes Slayer, however, is its visual presentation. The Slayer gamespace is radically different from that of Society. Slayer is presented in such a way as to emulate the look and feel of combat computer games. It is shot in grimy, desaturated colors; and it takes place in a cluttered urban landscape, strewn with debris, filled with the motion of people and vehicles, and lit up by frequent explosions. The gameplay is presented with vertiginously moving handheld cameras.[67] There are odd, canted angles, frequent swish pans and jump cuts, continual changes of perspective, and sequences of destruction lovingly presented in slow motion. Much of the action is filmed from over Kable's shoulder, just like in a video game, as he runs through the battered landscape, or as he turns abruptly in place,

searching for hidden enemies. Most of the time we do not see the action directly on the movie screen, but experience it at second remove, filtered as a video feed. Sometimes there is even an overlaid heads-up display, as in actual computer games. From time to time, interference patterns ripple across the screen.

It is worth lingering for the moment on the question of how Neveldine/Taylor's visual presentation of Slayer compares to the look and feel of actual computer combat games. Alexander Galloway, tracing the "Origins of the First-Person Shooter" (Galloway 2006, 39-69), argues that combat games differ fundamentally from action movies, both in their point of view and in their presentation of space. In games, I tend to see the gameworld directly through my avatar's eyes. In film, to the contrary, I do not actually share the protagonist's vision. I see the world of the film *along with* the protagonist, but I do not look directly through his or her eyes. To put the point in more formal terms, the first-person POV subjective shot is central to many computer games, where it works to increase the player's identification and involvement. But the subjective shot is rarely used in the movies, where it has an oddly disturbing and disidentifying effect. "In film, the subjective perspective is marginalized and used primarily to effect a sense of alienation, detachment, fear, or violence, while in games the subjective perspective is quite common and used to achieve an intuitive sense of motion and action in gameplay" (40). That is to say, "where film uses the subjective shot to represent a problem with identification, games use the subjective shot to *create* identification" (69).[68]

Galloway points out that games, unlike movies, directly associate vision with physical movement through space, and with motor actions such as firing a gun. This is why games are able to make such effective use of the subjective shot. From a first-person perspective, the gamer is able to explore a "fully rendered, actionable space" (Galloway 2006, 63) – something that

the film spectator, deprived of keyboard and joystick, cannot do. In cinema, the camera's autonomous exploration of space is generally dissociated from the perspective and the movements of any particular character.[69] A further consequence of this distinction is that "game design explicitly requires the construction of a complete space in advance that is then exhaustively explorable *without montage*" (64; emphasis added) – something that is almost never the case in film. Cinematic space is necessarily fragmented, because it is, at best, a *selection* (by means of framing and editing) from the continuum of the real.[70] In film, camera angles and shots are all determined in advance; the depicted space is a function of cinematography and editing. In games, to the contrary, the space must be rendered fully ahead of time, so that the gameplayer is able to roam through it at will.

The visual and formal difference between first-person shooter games and action movies, therefore, is a consequence of the difference in position between the gameplayer and the movie spectator. The gamer perforce must act, or provide input; but even when the filmviewer 'identifies' with the action on screen, he or she is incapable of contributing to it, or of having any effect upon it whatsoever. In order to convey something like the 'look and feel' of a computer game, Neveldine/Taylor have to reject the actual elements of video game construction, and provide cinematic equivalents for these elements instead. In place of the shooter game's first-person POV, they offer us the POV of a restlessly moving camera, which tracks the protagonist from continually varying angles. The camera's perspective feels like an embodied one, because it is highly mobile, and always in the thick of the action. But far from giving us Kable's own POV, the camera always shows him to us 'objectively,' in action within the frame. Similarly, Neveldine/Taylor do not seek to replicate the spatial continuity of actual video games; instead, they present a space that is broken up by aggressive, jumpy, and discontinuous editing. It is only by thus fragmenting visual space through

hyperbolic, hyperactive A.D.D-style montage that a film like *Gamer* can avoid being contemplative, and instead communicate a sense of visceral involvement that matches up to what computer combat games are able to provide.[71]

In this way, *Gamer* foregrounds the continual *remediation* that is so pervasive a feature of our media landscape today (Bolter and Grusin 2000). It is not just the case that newer media remediate older media, and adopt those older media as their content ("the 'content' of any medium is always another medium" – McLuhan 1994, 8). The process also works the other way. Older media remediate newer ones, incorporating into their texture the very forms and forces that have made them obsolete. *Gamer* is quite overtly and knowingly a post-cinematic movie. It is cinema for a time after the death of cinema; or cinema that – *pace* Rodowick – is revitalized precisely by its own decline and disappearance. This also means that there is no hierarchy between what the film depicts within its diegesis, and what the film *does* as a media object in its own right. The diegetic simply replicates the extradiegetic, and vice versa; in contrast to standard modernist practice, there is no sense here of any metalevel from which the film might reflexively comment upon its own content and practice. Rather, *Gamer* offers us a *flat ontology*, in which all media and all processes of remediation have the same status and the same degree of actuality. In the world of the film, no less than in this present world in which we encounter the film, nothing is direct or "unmediated," and nothing exists outside of the mediasphere. In particular, Society and Slayer are themselves surrounded and reinforced by other forms of media. For one thing, advertisements for the two games are ubiquitous within the world of *Gamer*. For another, these games are also the primary focus of television news broadcasts, which are seen throughout the film, and which seem to have no other subject of interest. In this way, the film's exposition is handled largely by infographics flashing across media screens.

*Gamer* begins – after the opening company credits, some video signal-zapping and the title text "some years from this exact moment..." – with enhanced images of striking sites from around the world. There are postmodern downtowns with skyscrapers, but also favelas and even ancient ruins. Vehicular and foot traffic whizzes by in accelerated motion. Quite wittily, these scenes are apparently cribbed from the movie *Baraka* (Ron Fricke, 1992), which drew contrasts between the peaceful rhythms of indigenous peoples ostensibly at home with the natural world, with the violent accelerations of life in the overdeveloped world.[72] *Baraka* is a film, according to its director, that "plunges into nature, into history, into the human spirit and finally into the realm of the infinite," in order to develop the theme of "humanity's relationship to the eternal."[73] Neveldine/Taylor hijack Fricke's footage in order to depict a social order whose values are nearly the opposite of those espoused by Fricke: a world in which any supposed "balance of life" has been obliterated by consumerism, and nothing remains stable for more than a second. The only constants in these opening shots are the things added to the source material by Neveldine/Taylor: enormous billboards and electronic signs advertising Society and Slayer. The signage first appears, dreamily, reflected in a puddle of water; then, hard-edged, aggressively pasted over every possible surface. All the while, Marilyn Manson's cover of the Eurythmics song "Sweet Dreams (Are Made of This)" plays on the soundtrack ("Some of them want to abuse you/ Some of them want to be abused..."), reminding us of our status as either predators or prey in this updated-for-the-new-millennium version of Social Darwinism. We have been warned.

After this opening sequence, we meet the talkshow host Gina Parker Smith (Kyra Sedgwick), who will apparently do anything in order to get a story. She has scored by arranging an exclusive interview with the billionaire software genius Ken Castle,

inventor of the brain nanotechnology that makes Society and Slayer work. Castle, despite (or rather because of) his teasing reclusiveness, is a pure creature of media: the world's greatest celebrity as well as its richest man. His games have made him wealthier than Bill Gates, as a montage sequence of magazine covers tells us. Castle is played by Michael C. Hall, best known as the star of the Showtime TV series *Dexter*. But whereas Hall is introverted and tormented in *Dexter*, in *Gamer* he is extroverted and slimy. A condescending, self-congratulatory smirk never leaves his face, not even when he is sucking on his trademark lollipop. Castle clearly thinks that he is smarter than everybody else – and he revels in this fact. He is slickly mediagenic and "charming" (in a way that can only be described as if "in quotation marks"), like a sleazy lounge lizard who has suddenly realized all his most extravagant, megalomaniacal dreams, and can make anybody do whatever he wants (as indeed he can, both because of his money, and literally, because of his technology). His insinuating voice, with a slight "hillbilly" twang, is a pure media manipulation effect – a performance with nothing whatsoever present behind it. Castle's folksy populism, and his steely contempt for his inferiors (which pretty much means everybody apart from himself) are two sides of the same coin. In embodying the character of Castle, Hall pretty much steals every scene he's in – as the actors playing bad guys in genre pictures often tend to do.

Castle is an extrapolation, if not directly of Bill Gates or Steve Jobs, then certainly of the nerd-turned-entrepreneur, control-freak billionaire type that they exemplify. Indeed, Castle might well be described as the living personification of "the new spirit of capitalism", with its emphasis upon flexibility, innovation, and entrepreneurial initiative, and upon networking rather than vertical command (Boltanski and Chiapello 2007). This new spirit places a hipster veneer upon what still ultimately remains a form of authoritarian management. Its premise is that networked

manipulation works more effectively than a hierarchical chain of command ever did. In other words, Castle is the "human face" of software-based capital, or of affective capital, in the society of control. For this is precisely a form of governance, or regime of accumulation, that requires a "human face," in order to exemplify its new managerial style. In the 1960s, IBM was seen as the ultimate soulless corporation; its bureaucratic computers were the negation of everything human. Today, to the contrary, it's impossible to imagine Apple without Steve Jobs – his minimalist, perfectionist aesthetic, and his showmanship, are essential components of the personal computing, communicating, and entertainment devices that Apple sells. Castle plays a similar role, as the face behind Society and Slayer.

Castle is the human face of the new capitalism, therefore. Except for one thing: Castle himself is not quite human any longer. We learn near the end of the film that he has turned himself into a cyborg, replacing 98% of his own brain with his synthetic nanocells. The difference between Castle and the avatars in Society and Slayer, however, is that Castle's artificial nerve cells are able to transmit orders and exert control, whereas everyone else's nanocells are engineered only to receive orders and to compel obedience. "I think it, you do it," Castle says. With his nanotech, he is able to make people "buy what I want them to buy, vote how I tell them to vote, do pretty much damn well anything I figure they ought to do" – without their even being aware of it. The control of other peoples' minds and bodies in gamespace is only a prelude to, or a test run for, the control of other peoples' minds and bodies in all other areas of life as well. Gaming – like other media forms and aesthetic forms before it – is a kind of cutting-edge space in which to experimentally implement, and to explore in advance, the social arrangements (of power and resistance, or of capital accumulation and of the friction that interferes with that accumulation) that are subsequently deployed throughout all of society.

*Gamer* has been criticized by some reviewers and bloggers because – in typical genre fashion – it shifts our attention away from the total system of control, and focuses it instead on just one evil individual. Its narrative implies, therefore, that defeating this one individual – as happens, of course, at the very end of the movie – is enough to make things right and free everyone. In this way, the movie would be guilty of leaving the system itself intact. But I think that such a reading is itself too simple: it ignores the way that the figure of Castle precisely embodies and condenses the "system itself", that is to say, the whole regime of flexible accumulation (or of what we might prefer to call expropriation with a smirk, or a smile). One way that today's media "personalities" differ from nineteenth-century fictional characters, or from twentieth-century selves with interiority, is that media personalities today function so directly as personifications, or embodiments, of impersonal, impalpable, and unrepresentable forces. Indeed, this is not anything really new; for Marx, already, the individual capitalist "in actual fact is nothing but personified capital" (Marx 1993, 963). But such a situation of possession and personification is far more widespread today than it was in Marx's own time. Where the nineteenth century, in both its fictions and its social life, generally presented characters with Lukacsian typicality (and this is the form of fictional character that most Marxist cultural critics, trapped in their own nostalgia, still tend to prefer), and the twentieth century emphasized depth psychology and interiority, the twenty-first century rather presents "personalities" as shells within which social forces are (temporarily) contained, or as screens and interfaces through which these forces exert themselves upon, and affect, the world. In *Gamer*, Castle's brain interface is a way of embedding commodity relations directly in the flesh; and he himself is the cybernetic, neoliberal regime of control and accumulation, embedded directly in the flesh. Just as, according to Deleuze and Guattari, philosophers must develop

"conceptual personae" in order to dramatize, and thereby fully work out, their ideas (Deleuze and Guattari 1994, 61-83), so capital today must generate *entrepreneurial personae* in order to fully realize the accumulation of capital at which it aims. In this sense, the genre tendency to personify social forces in individual figures is a necessary procedure; and a genre film like *Gamer* is accurate to condense its social commentary into such figures.

In terms of its narrative, *Gamer* is entirely a genre film: everything that happens in the course of the plot is something that we have seen before, and that we have come to expect from other movies. In Hollywood terms, *Gamer* could be described as *Running Man* meets *The Matrix*. The movie presents an oppressive virtual reality, within which a macho protagonist has to fight his way out of a situation in which everything has been rigged against him. The working-out of this plot is entirely formulaic; everything happens just as expected, up to and including the requisite happy ending and triumph of the macho figure over the bad guy. However, Neveldine/Taylor's adherence to these genre norms is so perfunctory as almost to be sarcastic. *Gamer* has all the usual plot twists, depictions of masculine impassivity, loud explosions, displays of jiggling breasts, and hyped up macho insults that one might expect. At one point, Kable is threatened by the demented killer Hackman (played by the football-player-turned-actor Terry Crews), who appears before him nude and dripping in blood. It's no accident that this "mad dog" character is black; as is also, at the other extreme, the leader of the heroic underground hacker resistance: the "Humanz Brother" (played by Chris Bridges, the rapper Ludacris, evidently channeling Laurence Fishburne in the *Matrix* trilogy). This scrupulous adherence to cliché, even to the point of offensiveness, underlies the way in which genre norms seem to be little more than a framework upon which Neveldine and Taylor are able to hang their delirious inventions. Or better, it is as if the film's normativity (in terms of plot, character, gender,

and so on) itself expresses, and exposes, the way that neoliberal ideology explicitly excludes any possibility of meaningful social change. As Margaret Thatcher famously put it, "There Is No Alternative"; any alteration of social arrangements is literally unthinkable. *Gamer*'s strict adherence to genre norms is its way of deliberately figuring (and thereby calling our attention to) this foreclosure.[74]

In *Gamer*'s backstory, Kable has been framed for murder. Specifically, he has been forced by Castle – impelled against his own will – to kill his best friend, in an early test of nano-powered mind control. Now he is in jail, and he fights in Slayer. And, thanks to his performance in the game, he has become an international media star – though in his confinement he isn't aware of this. Kable only needs to survive a few more rounds of battle in order to win his freedom. And so, of course, in traditional genre movie fashion, we the audience find ourselves rooting for him; we even "identify" with him. It's no wonder that the covers of the DVD and BluRay boxes for *Gamer* show Gerard Butler as Kable in full combat mode, holding an assault rifle. That's precisely what these action movies are about. But it's worth noting that our attitude towards Kable is directly figured within the movie itself – since it is the very condition of celebrity that the movie dramatizes. If we are rooting for Kable, we are doing this together with all those rowdy yuppies who watch the combat on a live feed. Our extradiegetic position as spectators of *Gamer* is mirrored by just about everyone (aside from Castle and his flunkies) within the world of the diegesis.

However, what it means to "identify" with the protagonist of a movie is definitely in need of redefinition here. After all, within the diegesis Kable is not an autonomous agent – just as, from an extradiegetic perspective, fictional movie characters are never autonomous agents. When Kable fights in Slayer, he is actually being "run" by 17-year-old Simon (Logan Lerman), a narcissistically self-involved gameplayer whose every gesture

expresses his affluent, privileged background. Simon can pretty much do whatever he wants; but evidently, this is only the case because his (unseen) father has paid for his high-tech, full-spectrum 360-degree gaming and media room, as well as for his Slayer account. Simon himself has gotten a certain degree of Web celebrity, thanks to his skillful and successful "playing" of Kable. But, of course, it's all just a game to him, since Kable's body is the one actually at risk.

In between Slayer sessions, Simon munches on pistachio-butter-and-jelly sandwiches, as he lies around in his media room. Here again, as was the case with Gorge, Neveldine/Taylor deliberately flirt with negative media stereotypes of gamers. Simon casually enters into video-chat conversations with girls who flash their tits at him, or otherwise proposition him – or in some cases insult him – over the Web. He also casually buys heavy-duty assault weaponry online (rejecting anything that strikes him as too "gay", i.e., not destructive enough). Within Slayer, Simon's relation to Kable is expressed by shots in which the two appear side by side, at full-body length, in the combat zone; we see Kable's moves miming Simon's own gaming gestures, creating the effect of a sort of dance. This contrasts with the way Gorge and Angie never appear in the same shot, but are only linked by cuts between their faces in close-up.

However, as the film goes on, the relation between Kable and Simon changes. The underground hacker group, the Humanz, makes it possible for the conversation between them to work both ways, so that Kable can talk to Simon, and hear back from him, rather than just taking implicit orders from him. Eventually, Simon is reluctantly persuaded to set Kable free from control, so that he can act in Slayer for himself; at this point, Simon is reduced to the role of a passive movie spectator, instead of an (inter)active gamer. Now he is somebody who (like us) is simply along for the ride. All in all, the play of identification and distance in the film is immensely complicated. We need to

triangulate between our own attitude towards Kable, our own attitude towards Simon, the attitudes of audiences in the diegesis towards both Kable and Simon, and the changing relationship between Kable and Simon themselves. In this way, *Gamer* negotiates between the cinematic media regime, and the post-cinematic media regime centered on computer games. The gamer's identification with an avatar via remote control is quite different from the filmviewer's identification with an onscreen character via empathic mirroring. But both regimes work through the paradoxes of *vicarious involvement at a distance.*[75]

I have already mentioned that *Gamer* is set "some years from this exact moment." This phrase is apt, and indeed precise, because of the way that it envisions futurity as a kind of intensified present. The movie's ever-so-slight extrapolation from the real world of 2009 is to posit a future in which we experience an even greater heightening of real-time immediacy, of the "here and now," than we do today. That is to say, *Gamer* is hyperbolically *actualist*, or *presentist*. The movie's action takes place, not so much over a span of time, as in a series of "exact moments," of heightened and intensified, hypermediated Nows. Each sequence of the film is a thin sliver of pure present. Time has been shorn of its existential *thickness*. Retentions and protensions are reduced to the bare minimum; memories and desires only exist in an extremely compressed and foreshortened way. Bergson would say that here the past subsists only in its most "contracted" state. *Gamer* would thereby seem to confirm David Rodowick's claim that digital cinema cannot convey Bergsonian (or Proustian or Deleuzian) duration: "the sense of time as *la durée* gives way to simple duration or to the "real time" of a continuous present... the filmic conception of the shot as a 'block of duration,' or as a spatially whole and irreducible element of filmic expression, has been significantly challenged" (Rodowick 2007, 171-172). But where Rodowick, with his "nostalgia for the analogical world" (174), laments this situation

as an existential and aesthetic loss, Neveldine/Taylor rather seek both to understand the political implications of the situation, and to explore the new possibilities that it offers.

In the world of *Gamer*, memory is so flattened and reduced as to be drained of all emotional resonance. It only exists as so much computer data, accessible more easily by security forces and large corporations than it is by ourselves. This condition is literalized at one point in the film, when the Humanz hook up Kable to a computer, so that his blocked traumatic memories – of the murder Castle forced him to commit, and about which he explicitly affirms that he doesn't have anything to say – can be played back to onlookers in the form of a surveillance video. Is there any better figuration for the ways in which the obsessive storing and cataloging of personal memories – through computer archives of photos and videos, lifeblogs, and other such prosthetic devices – is inseparable from a certain commodification (or "alienation," in the strict Marxist sense rather than the looser existential one) of the past, and of our "mental privacy" itself?[76]

As for desire – or even simple anticipation of the future – it is entirely instrumentalized in *Gamer*, and reduced to a question of mere technique. Kable's actual name is Tillman: but his name has been changed, against his will, to a flashy tag for media-publicity purposes. In the real-time combat game setting of Slayer, as Kable/Tillman struggles to make it through a round of play, all he can afford to feel (let alone think about) is how to avoid the dangers of the next thirty seconds or so. Where can I hide? In which direction should I shoot? Can I get my controller to turn me around when I need to? The only desire at work here is the one to survive; the only anticipations are those required for immediate short-term planning. Any further temporal horizon is unthinkable. Memory and anticipation are both exceedingly weak, when compared to a real-time situation of confinement and battle. Either Kable is fighting for his life; or else he is

trapped in the confines of his dark and narrow cell; or else he sits, blank and adrift, in the white-out of the dazzlingly sun-lit desert. In none of these situations is there any opportunity for wide-ranging reflection, or for expansion beyond the confines of the most immediate present.

Tillman tries hard to remember his wife (Angie, whom we have met in Society), and their daughter. He has been separated from them as a result of his incarceration; and we are reminded, time and again, that his hope of rejoining them is the only thing that keeps him going. (This is, of course, an entirely genre-typical setup). And yet Tillman can barely call his wife's and daughter's images to mind. We get a few brief memory flashbacks of his daughter walking in the grass – images that are quite vague, because they are almost fuzzed-out by bright sunlight. Tillman doesn't even have a photo of his loved ones, until one is surreptitiously passed to him in his cell. When he looks at the photo, we get what seems to be another flashback: an apparent memory of Tillman driving a car, smiling at his wife beside him, as she presses his arm, on which is tattooed the phrase "I am always there for you." But these shots reappear at the very end of the film, when Tillman has finally defeated Castle and regained his freedom. This tells us that the sequence was not a flashback, but a flashforward.[77] The insert does not represent memory, but rather anticipation. Or more accurately, this flashforward isn't subjective at all. Although the sequence conforms to a film grammar that is generally used to denote subjective association, in fact the future moment presented here cannot be attributed to the mind of Kable/Tillman, nor to that of any other character within the diegesis. The anticipation belongs, we might say, solely to the film itself.[78] As such, it conforms to an ontology that is not defined by an experience of duration, but only by the quantitative accumulation of images. None of these images are truly anchored either in the past or in the future; rather, in their heightened presentness, they can potentially be deployed in any

order whatsoever.[79]

The presentism or actualism recorded and embodied by *Gamer* – together with its consequent instrumentalism – of course results from the media glut that we already experience on a daily basis. Our social life is so overpacked and overstimulated and hypermediated, that we can only feel it in the immediate instant. Indeed, as Richard Grusin and Jay David Bolter argue, the spacetime parameters of our contemporary social life are defined by a continual play between hypermediation and immediacy (Bolter and Grusin 2000). The affective tone of *Gamer*, as well as of the "real world" in which it was released, is that of a society-wide attention deficit disorder (the "A.D.D." that Neveldine/Taylor attribute to themselves). The past and future are hazy, because they seem utterly out of reach. Futurity, no less than pastness, is brutally compressed and foreshortened. As it is for Tillman, so it is for all of us. Too much is going on Right Here, Right Now, for us to be able to focus on anything from Before or After.

However, *Gamer* also makes the point that the immersive, real-time network that it depicts is not altogether seamless. The closure cannot be complete. "This exact moment" is never entirely self-contained. Systems of control "work only when they break down, and by continually breaking down" (Deleuze and Guattari 1983, 8). Indeed, the movie pays special attention to moments of incompletion and interruption. There are always glitches, loopholes, and exceptions. I have already mentioned the *ping*: the delay of several hundred milliseconds between the moment that the player gives a command, and the moment that the avatar actually executes the command. The ping is, as it were, built into the game; it is not a bug, so much as a necessary feature of the very mechanisms of interactivity and control.[80] But in addition to the ping, there is always the broader possibility of network breakdown and failure. This is what allows the Humanz to make their subversive interventions. In order to spread their

message, they interrupt news broadcasts, commandeer the screens on which Slayer is playing, and even cause Society to crash and go offline.

The most important thing about the Humanz is that their own counter-technology is incomplete and ad hoc. They cannot directly destroy Castle's control system, but only circumvent it by parasitizing it, and by mobilizing its own techniques against it. For instance, there is no way to eliminate the nano-cell implantations that colonize the avatars' brains; but the Humanz are able to block the particular transmissions that give the avatars their orders. They can slow down and hijack network signals; and they can ferret out encrypted information, and transmit things that were supposed to remain private. Thus they are able to broadcast worldwide the final encounter between Kable and Castle, in the course of which (as is required by the rules of the genre) the billionaire reveals the full extent of his nefarious plans. In contrast to Castle's slick, state-of-the-art presentations, the Humanz's own media transmissions are low-fidelity and full of static and other interference; it is as if an over-the-air television signal were being received by a poorly tuned and inadequately sensitive antenna.

The lesson of all this is clear. In the world of *Gamer*, there is no going back on the network and its circuits of celebrity and control. There is no possibility of reverting to an earlier, supposedly clearer and more honest, state of affairs. The only way out is the way through. The only possible oppositional stance is one of embracing these new control technologies, generalizing them, and opening them up without reserve. Neveldine/Taylor depict, within the diegesis of *Gamer*, the very strategy that they themselves adopt in order to promote the film, as a media object or commodity in the real world. They fully embrace the logic of entertainment, and spectatorial involvement, that is the target of their satire. They make no bones about the fact that *Gamer* is an "exploitation" film whose aim is to

draw audiences in, rather than "alienating" them through cognitive estrangement. For in the cynical early twenty-first century, cognitive estrangement no longer works (if indeed it ever did) as a viable strategy for subversion. Self-reference, irony, and formal alienation-effects have all become widely used, and accepted, as marketing tools. What's needed, rather, is an approach that ups the ante on our very complicity with the technologies and social arrangements that oppress us.[81]

Neveldine/Taylor are acutely aware of this; in consequence, they never exhibit moral concern, or adopt an overtly critical stance. If anything, they insist upon placing themselves in the same degraded moral universe as that of our crassest, and most outrageous, media objects: games like *Grand Theft Auto*, shows-turned-movies like *Jackass*, and any number of reality television shows. Not only are there lots of "bosoms and bullets" in *Gamer*, but often the violence and sex are played for cheap laughs and sight gags. For instance, at one point in a Slayer session, we see a woman in a hijab. She is an NPC who does nothing but cross the street, over and over again, entirely oblivious of her surroundings. Kable rescues her from certain death, by pushing her away from the spot where a bomb is about to land and detonate. But barely an instant after thus being rescued, the woman starts to cross the street again; and this time she is flattened by – of all things – an oncoming ice cream truck. Kable (or rather, Simon playing Kable) mutters something on the order of "oh well, at least I tried." He then turns back to the combat at hand. The scene is simply left like that, for us to laugh at (or not). There is no effort to undermine, or to pull us away from, what Slavoj Žižek would call the "obscene enjoyment" of such a moment. *Gamer* takes the neoliberal world order entirely for granted, with its overt cynicism and calculated rejection of empathy. If There Is No Alternative, Neveldine/Taylor seem to be saying, we may as well revel in the sheer excess of the situation.

The overall form of *Gamer* resonates with its generic and

technological content. The movie exemplifies the way in which, as Seb Franklin puts it, "a composite of film editing and computer programming is the emblematic cultural mode of the present day" (Franklin2010). *Gamer* combines the logic of computer games with that of the contemporary action movie; or better, it demonstrates the process by which the latter has increasingly been subsumed by the former. According to Franklin, "the function of editing in narrative film production has undergone a significant change since the 1980s" (Franklin 2009a). In the last two decades, producers like Jerry Bruckheimer, and directors like Tony Scott and Michael Bay, have offered us digital-cinematic spectacles in which editing, however fast and frenetic, is almost entirely subordinated to the imperatives of programming. "In the digital age the narrative function of commercial film editing has moved from what could be deemed an interpretive mode (where montage necessitates a comparison of two distinct series of image on the part of the viewer) to an executive mode where cuts are used to create the pace that extensive demographic research and data collection suggests is essential to contemporary market satisfaction... this mode directly corresponds to the centrality of execution (or action) to the cultural modes of the digital computer" (Franklin 2009a).

In other words, contemporary film editing is oriented, not towards the production of meanings (or ideologies), but directly towards a moment-by-moment manipulation of the spectator's affective state. Computer code is a "language" (if we can still call it that) that does not generate signification, but rather directly impels action. For code is not composed of signifiers, but of commands. The use of an "executive" sort of editing marks an unprecedented turn in the history of cinematic form. Eisenstein championed associative and intellectual montage. Classical Hollywood, quite differently, deployed continuity editing in order to tell its stories as intensely and efficiently as possible. And even that great partisan of mise-en-scène over editing,

André Bazin, has no problem with "a finely broken-down montage," as long as it shows "respect for the spatial unity of an event at the moment when to split it up would change it from something real into something imaginary" (Bazin 2004, 50). Despite their vast differences, all these classical filmmakers and theorists are in agreement that montage is meaningful, in the precise sense that it adds a "supplementary dimension" (Deleuze and Guattari 1987, 6) to the shots that it combines, thus allowing the image to "change its power, pass to a higher power" (Deleuze 1986, 35).

But recent films like Michael Bay's *Transformers* series no longer seem to be invested in meaningful expression, or narrative construction, at all. They don't even show a concern for accurate continuity. As Bay himself blithely puts it, "I think you have to make movies for the general public and not the details... When you get hung up on continuity, you can't keep the pace and price down. Most people simply consume a movie and they are not even aware of these errors" (Anonymous 1999). All that matters is the "pace" and "price" of the movie, and how well viewers can be led to "consume" it. This means that contemporary high-end movies are cynically instrumentalized, far beyond the dreams of old-school Hollywood avarice. In the words of Bruce Reid, Bay's movies "not only flaunt every reasonable expectation of believability and internal consistency, they make no sense. Edits seem random, every rule of film grammar is tossed out the window, and the headlong rush of movement forward is all" (Reid 2000). In theory, such a mode of filmmaking should not work; and yet it evidently does, as Bay's high box office grosses prove. Today, Michael Bay is the new D. W. Griffith (or the anti-Griffith), as he mixes and matches shots with no concern for traditional articulations of spatial and temporal continuity.

If meaningfulness is no longer a criterion, what does determine editing rhythms in the contemporary Hollywood

blockbuster? Franklin explains that film "is transformed through multiple, rapid edits in order to generate pace and hence user excitement, demonstrated by market research to be prerequisites for commercial success in the blockbuster market since the early nineties" (Franklin 2009b). For almost a century, theorists have been concerned with what Walter Benjamin famously described as the "shock effect of film" (Benjamin 2003, 267). But today, this "shock effect" is in process of being quantified and instrumentalized. This is done in order to determine the precise editing rhythms that will generate a maximum audience response. There would seem to be a paradox in the fact that editing has become ever faster and more pronounced in recent Hollywood movies, even though, conceptually speaking, digital technologies have led to "a decrease in the centrality of montage to film" (Franklin 2010) – as Franklin, Galloway (2006, 64-65), Rodowick (2007, 170-171), and Lev Manovich (2001, 141-145) all maintain. But both sides of this seeming contradiction are explained by the switch from "interpretive" to "executive" editing. In today's media landscape, editing no longer *signifies*, but it does *work*, perhaps more than ever. Consequently – to paraphrase Deleuze and Guattari – if we wish to grasp the operation of post-cinematic forms "we will never ask what a [media work] means, as signified or signifier"; rather, "we will ask what it functions with, in connection with what other things it does or does not transmit intensities" (Deleuze and Guattari 1987, 4).

As Franklin indicates, the investigation and quantification of "user excitement" is currently carried out by means of focus groups. Filmmakers use market research in the same way that politicians do. But a more direct mode of calibration and control is now on the horizon. According to Scott Brown of *Wired*, we are currently entering "the age of 'neurocinema,' the real-time monitoring of the brain's reaction to movies, using ever-improving fMRI technology… in theory, studios could use fMRI

to fine-tune a movie's thrills, chills, and spills with clickwheel ease, keeping your brain perpetually at the redline... Neurocinema helpfully speeds up a process Hollywood began years ago, namely the elimination of all subjectivity in favor of sheer push-button sensation" (Brown 2010). Of course, neurocinema may well be nothing more than a techno-fantasy, something that will never be successful in practice. But recent scientific studies already suggest that, over the past 75 years, the relative shot lengths of Hollywood films have approached ever more closely to the physiological optimum for mental attention (Cutting, DeLong, and Nothelfer 2010). From a science-fictional point of view, it is highly indicative, and indeed symptomatic, that the ambition to produce a neurocinema exists at all, and that there are companies actually trying to put it into effect. It is only a slight jump from neurocinema to the mind-control scenario of *Gamer*. There is almost no boundary between giving customers what they want, and inducing them to want what you give them. Much like Castle, "Michael Bay, with access to my innermost circuitry, can really get in there and noogie the ol' pleasure center... I'll soon be reporting levels of consumer satisfaction previously known only to drug abusers. My moviegoing life will, literally and figuratively, be all about the next hit" (Brown 2010).

All this can be restated in more conventionally formalistic terms. David Bordwell has outlined the formal characteristics of what he calls "intensified continuity" (Bordwell 2002). This is the post-1960s visual style, in both American and international commercial cinema, that involves "more rapid editing... bipolar extremes of lens lengths... more close framings in dialogue scenes...[and] a free-ranging camera" (16-20). More or less confirming Franklin's observation, Bordwell notes that such a style "aims to generate a keen moment-by-moment anticipation. Techniques which 1940s directors reserved for moments of shock and suspense are the stuff of normal scenes today" (24). Yet, even

as he catalogues these departures from classical Hollywood norms in painstaking detail, Bordwell insists that, "contrary to claims that Hollywood style has become post-classical, we are still dealing with a variant of classical filmmaking" (24). Everything that Hollywood does today is still done "according to principles which crystallized in the 1910s and 1920s" (24). Indeed, "far from rejecting traditional continuity in the name of fragmentation and incoherence, the new style amounts to an *intensification* of established techniques" (16). In effect, Bordwell sees these changes in the way that films are formally constructed as merely epiphenomenal. The means may have changed, but the ends of storytelling remain. "Viewers remain in the grip of the action" as they always did (25). The New Hollywood of the 1970s is just like classical Hollywood, only more so. For Bordwell, it would seem, the more things change, the more they stay the same.

Nonetheless, when it comes to the filmmaking of the past ten or fifteen years, Bordwell changes his tune somewhat. While in 2002 he seems largely unconcerned by the presence of occasional "incoherent action scenes" in intensifed-continuity films (Bordwell 2002, 24), later in the decade he gets much more worried. Like so many other classically-oriented cineastes, he deplores the way that "the clarity and grace of motion seen in classic Westerns and comedies, in the work of Keaton and Lloyd and Ford and Don Siegel and Anthony Mann, gave way to spasmodic fights and geographically challenged chases. At first, the chief perpetrators were Roger Spottiswoode and Michael Bay. Now it's nearly everybody, and journalistic critics have recognized that this lumpy style has become the norm." In action sequences, filmmakers have become "reluctant to face the concrete, moment-by-moment facts of the fight" (Bordwell 2008). And in fact this use of fast cutting in order to avoid concreteness can be found everywhere: "we tend to think that only high-octane action sequences are cut quickly, but today's dialogue

scenes are cut fast too" (Bordwell 2007).

If anything, I would be inclined to put Bordwell's point even more strongly. Sometime within the last twenty years, coincident with the full adoption of digital technologies in Hollywood, a critial threshold has been passed. We have reached the point where the mere "intensification of established techniques" has mutated into something entirely different. The dialecticians would call this a transformation of quantity into quality. In more contemporary language, we might say that intensified continuity has "jumped the shark." In any case, we now encounter a new stylistic norm in which – as Bordwell puts it – "Hollywood action scenes became 'impressionistic,' rendering a combat or pursuit as a blurred confusion. We got a flurry of cuts calibrated not in relation to each other or to the action, but instead suggesting a vast busyness. Here camerawork and editing didn't serve the specificity of the action but overwhelmed, even buried it" (Bordwell 2008). What Bordwell implies, but can't quite bring himself to say explicitly, is that, when intensified continuity is pushed to this absurd, hyperbolic point, it does indeed result in a radical aesthetic "regime change." The New Hollywood of the 1970s may just have "intensified" the conventions of continuity editing; but the Hollywood of today has exploded them, and reached the point of what I will call a stylistics of *post-continuity*.

Most high-budget blockbusters today follow this new stylistics. In Bay's *Transformers* films, in the *Bourne* films by Doug Liman and Paul Greenglass, and in the recent works of Tony Scott, a preoccupation with immediate effects trumps any concern for broader continuity – whether on the immediate shot-by-shot level, or on that of the overall narrative. As Franklin says, "the plot (or user experience) of fiction film in the age of ubiquitous computing is executed as much as it is narrated" (Franklin 2009b). But arguably, post-continuity stylistic tendencies are displayed with the greatest intensity and verve not in blockbusters, but in exploitation films like those of

Neveldine/Taylor. This may be because, as Carol Clover put it nearly two decades ago, exploitation film "operates at the bottom line," while in contrast this bottom line tends to be "covert or mystified or sublimated" in more mainstream filmmaking (Clover 1992, 20). In the changed economic environment of Hollywood today, *Gamer* is by no means as low-budget, and as external to industry norms, as were the horror films of the 1970s and 1980s that Clover discusses. Nonetheless, if the post-continuity style of executive editing involves an exacerbated form of the cynical manipulation of the audience, then Neveldine/Taylor can be credited for the purity and extremity of their cynicism; Scott and Bay, in contrast, lack even the courage of their cynical (non-)convictions. Neveldine/Taylor gleefully emulate the greatest excesses of Scott and Bay, except that they provide us with a brutally compressed, miniaturized version of everything that is overblown and grandiose in the work of the latter. In embracing the logic of post-continuity style, Neveldine/Taylor explore its extreme possibilities and ultimate consequences in a way that more upscale directors never dare to do.

Even a quick look demonstrates how extreme *Gamer* is, in its push towards post-continuity. The movie offers us a continual cinematic barrage, with no respite. It is filled with shots from handheld cameras, lurching camera movements, extreme angles, violent jump cuts, cutting so rapid as to induce vertigo, extreme closeups, a deliberately ugly color palette, video glitches, and so on. The combat scenes in Slayer, in particular, are edited behavioristically more than spatially. That is to say, the frequent cuts and jolting shifts of angle have less to do with orienting us towards action in space, than with setting off autonomic responses in the viewer. But even in their non-action sequences, Neveldine/Taylor usually avoid traditional continuity-based setups.

Consider, for instance, the scene, in an early part of the film,

where Freek talks to a silent Kable, telling him that his composure is "spooky." We do not see all of the actors' faces, but only extreme closeups, from skewed angles, in which portions of their faces nearly fill the screen. There's an alternation between shots concentrating on Freek, and those that show him talking, still in tight close-up, behind Kable's face in profile. In these latter shots, there are even rack-focus shifts from Freek's face to Kable's, so that we end up with Kable's face focused but in shadow, while behind it Freek's face is front-facing but blurry. All this is intercut with soft-focus flashbacks to Kable's memory of his wife and child, and then with a hard-edged flashback to the murder of Kable's friend (played in reverse, and without Kable appearing in the image as the triggerman). It is only at the end of this sequence that we get an establishing shot of Kable and Freek sitting at the base of an enormous concrete structure in the desert; and this is so extreme a long shot that the figures of Kable and Freek are quite tiny. Bordwell notes that, under the regime of intensified continuity, there is a continual "pressure toward closer views... Mouths, brows and eyes become the principal sources of information and emotion"; also, in such sequences, "the scene's most distant framing may well come at the very end, as a caesura" Bordwell 2002, 20). Neveldine/Taylor are clearly emulating this pattern, but (like Tony Scott sometimes) they do it to excess. Strictly speaking, such a presentation doesn't violate continuity rules; but the extreme fragmentation makes it hard for us – even in a scene as quiet as this one – to ground or locate the speakers.

This scene in the desert can be contrasted with the sole sequence in the film in which Neveldine/Taylor do adhere to an entirely classical shot-reverse shot pattern. I refer to the sequence in which Angie speaks to a male social-work bureaucrat, attempting to regain custody of her and Tillman's child. The bureaucrat sits at a desk in the middle of an absurdly large and empty room. There are long shots, at the beginning and end of

the sequence, of Angie walking towards this desk, and then walking away. The click of her heels on the floor is highly amplified, and we hear it even before she enters the frame. In between Angie's arrival and her departure, we get an alternation, following the rhythm of the conversation, of the two speakers. Each of then is presented, entirely by the book, either in a head-and-shoulders medium closeup, or in a head-and-torso shot over the shoulder of the other speaker. Of course, the conversation goes nowhere. Angie is quite anguished at the loss of her child, who has been taken away from her by an adoption agency. The bureaucrat, for his part, wavers back and forth between maintaining a "professional" demeanor as he refuses Angie's request, and letting his obvious contempt for her (as an "actress" or avatar in Society, and as the wife of a convicted killer) shine through. At one point, he even bursts into "inappropriate" laughter, then quickly controls himself again. Because of the way the sequence is shot, and how it differs from everything else in the movie, the futility of making a human appeal to a bureaucrat, or of appealing to the instituted power system for any sort of justice at all, is equated with the futility and emptiness of the classical shot-reverse shot convention itself. This editing pattern is a formalist cliché, inherited from the era of classical Hollywood. Today, it is entirely empty, because it implies a human reciprocity that no longer exists in the commodified, mediatized world that the movie reflects back to us.

There are scenes of this sort throughout *Gamer*, in which Neveldine/Taylor foreground, and thereby reflect back upon, the implications of their own cinematic procedures. This is not a modernist sort of reflexivity, however. It is more on the order of a pragmatic, or procedural, demonstration.[82] Neveldine/Taylor continually vary the stylistics of their film, depending upon the requirements of each particular scene. Rather than aiming for consistency, they promiscuously make use of whatever tactics and techniques come to hand. *Gamer* freely exhibits both classical

stylistic devices and post-cinematic/post-continuity ones; of course, such indiscriminate mixing itself implies a post-continuity aesthetic. Neveldine/Taylor call attention to their technical extravagance, indulging in the "overt narration" and "flamboyant displays of technique" that Bordwell finds to be typical of recent Hollywood films (Bordwell 2002, 25). In interviews, too, the directors "emphasiz[e] the equipment they use to set up and capture their shots rather than mustering some pretense to 'depth' " (Neveldine 2010). In sum, Neveldine/Taylor focus upon the executive and procedural implications of the techniques they employ, without laying claim to any underlying importance. They force us to pay attention to *how it works*, instead of *what it means*. For this very reason, *Gamer* is not a self-reflexive movie, but rather a *procedural* and *demonstrative* one. By executing a series of technical procedures, it points up the ways in which these procedures are embedded within, and extend themselves into, particular sorts of social interactions and relations. Every cinematic mode of expression, and every piece of technical equipment, is part of a politico-economic mechanism of control.[83]

Doubtless, the procedural and demonstrative impact of *Gamer* must be attributed, not to any directly polemical intent on the part of Neveldine/Taylor, but rather to the constraints of their relatively low budget, and to their experimental techniques (e.g., working with new equipment that is still in beta) and their guerrilla-filmmaking tactics.[84] The necessities of exploitation cinema lead to a brutally compressed and foreshortened post-continuity style – in contrast to the bloated self-indulgence of "A-list" directors like Michael Bay. As Deleuze and Guattari argue, the "cramped space" of "minor" cultural forms "forces each individual intrigue to connect immediately to politics" (Deleuze and Guattari 1986, 17).[85] This means, not that Neveldine/Taylor make a minimalist film without flourishes, but rather that – in a sense – they make a film that is *only* flourishes. They don't have

the time or the budget – or the attention span – to be perfectionists. They are not weighted down, as higher-budget movies tend to be, by demands for plot rationalization and secondary elaboration. They cannot cover over their proceduralism with a veneer of plausibility and good sense. In consequence, they make a film that appears wildly mannerist. They follow procedural and executive logic as far as they can – however crazy and aberrant the results may be.

Consider, for instance, the absurdist action sequence in which Kable escapes from the Slayer gamespace. First he drinks down an entire bottle of vodka; then he pukes and pisses into the gas tank of an "ethanol only" truck, in order to (literally) fuel his escape. In their audio commentary on the *Gamer* DVD, the directors laugh about the extravagance of this scene; of course it would have been far simpler for Kable simply to pour the vodka directly into the gas tank. But the ridiculous excessiveness of Kable's procedure is itself the comedic point of the sequence. Everything turns upon a "machinic...synthesis of heterogeneities" (Deleuze and Guattari 1987, 330) that includes Kable's body as a crucial element. The handheld camera wobbles, and even spins upside down, as it shows Kable stumbling drunkenly through the gamespace. Throughout the sequence, the film footage is repeatedly interrupted by quick bursts of distorted video signal. Simon is composited into the gamespace, as he complains to Kable running free of his control. Best of all, when Kable finally reaches the truck, we see a POV shot from the interior of the gas tank, as it receives Kable's alcohol-laden puke. Embodiment, flow, the human-virtual interface, and the human-machine interface are all yoked violently together in the course of one short montage sequence. In little more than two minutes of screen time, Neveldine/Taylor effectively demolish the old idea that cyberculture, or virtual reality, has anything to do with disembodiment. Instead, they propose a new vision of hybrid and prosthetic technologies: what I am tempted to call a

scatalogical, micturitional psychokinetics.

All this leads us into the concluding sequences of *Gamer*, in which Kable/Tillman finally triumphs over Castle. I cannot better Vishnevetsky's evocation of these scenes, starting with "the chiaroscuro of the mansion scene, which puts more or less everyone who's ever cited Jacques Tourneur as an influence to shame... The scene [then] transforms, over the course of a few minutes, into a song-and-dance number and then a fight (but of course the musical is the ancestor of the action movie), then a bit of sci-fi special effects and finally a confrontation on a basketball court" (Vishnevetsky 2009). These sequences all take place in Castle's castle (as it were), his mansion which is a cross between a high-tech wonderland (something that even Michael Jackson might have envied), and a fortified bunker. The continually-changing chiaroscuro lighting, instead of concealing a woman-transformed-into-a-panther, prepares Tillman for, and sets off, a brightly-lit vision of his missing daughter, whom it turns out has been kidnapped by Castle. Tillman thinks that she is really there, but it's only a 3D laser projection (of "pornographic" image quality, Castle says). Tillman then fights off Castle's goons, and knocks them out one at a time, as under mind control they dance in lockstep to Sammy Davis Jr.'s version of "I've Got You Under My Skin," lip-synced by Castle. In the final confrontation, Castle tries to force Tillman, through mind control, to kill his own daughter with a knife. Tillman resists, and asserts his freedom by finally turning the knife on Castle himself. Only this isn't really a victory for free will over conditioning, since we see via montage that Tillman is only able to do this because Simon has come back online to control him as well. Is "freedom" anything more than a choice among battling compulsions whose source is elsewhere? This is not the only moment in the film when Neveldine/Taylor's science-fictional extrapolation touches on the dilemmas of contemporary neuroscience.

*Gamer* fulfills all genre expectations, even up to the defeat of

the bad guys and the (apparent) liberation of the world from post-Fordist mechanisms of control. Nonetheless, Neveldine/Taylor don't exactly leave us with exalted hopes. We never quite leave gamespace behind; when Tillman finally kills Castle, one of the latter's henchmen acknowledges him with a curt "well played, Kable." And the last shot of the film, before the credits, shows Tillman, with his wife and daughter, driving into the dark mouth of a deep tunnel. The screen cuts to black, and we see the flashing message from an old-style arcade video game: "GAME OVER – INSERT COIN." The message is echoed by a familiar monotone robot voice. The film itself has gamed us; we are still trapped in the world it depicts.

Neveldine/Taylor do accomplish one thing, however. They trace out for us the system of audiovisual entertainment that is one major facet of the control society within which we increasingly find ourselves enmeshed today. They don't "critique" this control society – if anything, they gleefully embrace it. But they offer us something that is arguably better than critique: they provide a kind of cognitive and affective map of contemporary gamespace. They point up its extensiveness, its affordances, its limitations, and the degree of our unavoidable complicity with it. *Gamer* strongly resonates with McKenzie Wark's assertion that "only by going further and further into gamespace might one come out the other side of it" (Wark 2007, 224).[86]

# 6 Coda

"Corporate Cannibal," *Boarding Gate, Southland Tales* and *Gamer* have almost nothing in common – except for the fact that they all belong to, and they all express, a common world. This is the world we live in: a world of hypermediacy (Bolter and Grusin 2000, 33-34) and ubiquitous digital technologies, organized as a "timeless time" and a "space of flows" (Castells 2000, 407-499), through which "divergent series are endlessly tracing bifurcating paths" (Deleuze 1993, 81). Such a world cannot be *represented*, in any ordinary sense. There is no stable point of view from which we could apprehend it. Each perspective only leads us to another perspective, in an infinite regress of networked transformations – which is to say, in an infinite series of metamorphoses of capital. We find ourselves in a chronic condition of crisis; the "state of exception" (Agamben 2005) has itself become the norm. The repeated experience of disruption, or "creative destruction" (Schumpeter 1943, 81-86), is a necessary part of capital's own perpetual self-valorization and rejuvenation: it will go on, whatever the human cost. "Corporate Cannibal," *Boarding Gate, Southland Tales* and *Gamer* all bear witness to this state of affairs.

We live in a world of crises and convulsions; but this does not mean that our world is anarchic, or devoid of logic. If anything, the contemporary world is ruthlessly organized around an exceedingly rigid and monotonous logic. For everything in the postmodern world is subject to the tendential movement of "real subsumption."[87] All impulses of desire, all structures of feeling, and all forms of life, are drawn into the gravitational field, or captured by the strange attractor, of commodification and capital accumulation. There is no difference, in this respect, between images and sounds on the one hand, and more palpable objects and markers of identity on the other. Everything moves

along the same vectors of modulation, digitization, financialization, and media transduction. The movement is all in one direction; and yet it is also without finality. "The circulation of money as capital is an end in itself, for the valorization of value takes place only within this constantly renewed movement. The movement of capital is therefore limitless" (Marx 1992, 253). The proliferation and dissemination of images and sounds, together with other material and immaterial goods, is an endless process of circulation, with no content other than the self-reflexive reiteration of the mark of capital itself, in the form of trademarks and brand names. In the words of Marshall McLuhan, it is "a medium without a message, as it were, unless it is used to spell out some verbal ad or name" (McLuhan 1994, 8). In McLuhan's time, "General Electric" was spelled out in light bulbs; by 1990, "IBM" was spelled out in atoms. Today, everything seems to come with a corporate logo and a brand name.

Another way to put this is to say that the very experience of real subsumption is what makes our world a common one. It doesn't matter which particularities are being subsumed; but only that they are all subsumed in the same way. The regime of capital today is indeed, as Deleuze and Guattari put it, channelling Nietzsche, "a motley painting of everything that has ever been believed" (Deleuze and Guattari 1983, 34). We live in a world of extreme diversity and multiplicity: but the basic *condition of possibility* for this profusion is the functioning of money, or credit, as a single standard of value or "universal equivalent" (cf. Marx 1992, 162). The proliferation of variations, and of consumer choices, is underwritten by a more fundamental homogeneity. Money and credit make it possible for anything to be exchanged with anything else. In the realm of digital media, binary code functions in a similar manner. For this code is a universal equivalent for all data, all inputs, and all sensory modalities. Everything can be sampled, captured, and transcribed into a string of ones and zeroes. This string can then

be manipulated and transformed, in various measured and controllable ways. Under such conditions, multiple differences ramify endlessly; but none of these differences actually *makes a difference*, since they are all completely interchangeable.[88]

It is easy enough to deplore this situation on moralistic or political grounds, as high-minded cultural theorists from Adorno to Baudrillard have long tended to do. And it is tempting to wax nostalgic, and mourn the passing of a more vital, and more temporally authentic, media regime, as film theorists as diverse as David Rodowick (2007) and Vivian Sobchack (2004) have recently done. But such responses are inadequate. They are too wrapped up in their own melancholic sense of loss to grasp the emergence of new relations of production, and of new media forms. They miss the aesthetic poignancy of post-cinematic media, with their "peculiar kind of euphoria" and "mysterious charge of affect" (Jameson 1991, 16, 27). Also, these critiques denounce the symptoms of cultural malaise – Horkheimer and Adorno's "instrumental reason," or Žižek's "decline of symbolic efficiency" – without paying sufficient attention to the processes of exploitation and expropriation that generate such symptoms.[89] And they look toward the illusory comforts (or at least the relative explicability) of older modes of production, instead of taking the full measure of capitalism's "constant revolutionising of production, uninterrupted disturbance of all social conditions, everlasting uncertainty and agitation" (Marx and Engels 1998, 54).

In order to come to grips with social and technological change, we need a "constant revolutionising" of our methods of critical reflection as well. In this regard, cultural theory lags far behind actual artistic production. Creative works like "Corporate Cannibal," *Boarding Gate, Southland Tales* and *Gamer* are several steps ahead – in relation to both technology and political economy – of all our attempts (mine included) to place them, theorize them, or account for them. These multimedia

works are *prophetic*, in the way that Jacques Attali once proclaimed music as being: "Music is prophecy. Its styles and economic organization are ahead of the rest of society because it explores, much faster than material reality can, the entire range of possibilities in a given code. It makes audible the new world that will gradually become visible, that will impose itself and regulate the order of things" (Attali 1985, 21).[90] Today, post-cinematic works are directly engaged in this sort of proleptic exploration.

Writing a third of a century ago, Attali opposed the audible to the visible, and championed the deterritorializing force of "noise" against the reterritorializing effects of the visual image. At the time, he was right to put things in this way. The entire twentieth century was characterized, as McLuhan argued, by a shift away from visual (perspectival, linear) space, and towards an "acoustic space" that is "dynamic, always in flux, creating its own dimensions moment by moment" (McLuhan 1997, 41). This means, among other things, that sound – rather than image – was the leading edge of change, the modality in which new cultural forms first emerged. It is no accident that, in the last decades of the century, music was the first aesthetic realm to display the radical mutations, in both production and consumption, that emerged from new digital technologies. Today, however, in the twenty-first century, these changes have become ubiquitous. They have fully taken hold in the realm of moving images, and indeed in every aspect of our lives. We now live in the midst of an *audiovisual continuum*. With so many different articulations of sounds and images, and with digital transcoding as the common basis for all of them, it no longer makes sense to posit a global opposition between the audible and the visible. The prophetic function of art, its ability to "explore...the entire range of possibilities in a given code," no longer has a privileged relation to any particular sensory modality, or to any particular art form.

This is why works like "Corporate Cannibal," *Boarding Gate*,

*Southland Tales* and *Gamer* are so important. In their engagement with new technologies and new media forms, no less than in their explicit content, they explore the *possibility space* of globalized capitalism, mapping this space both cognitively and affectively. They trace the lines of force that generate and shape the world space of capital; they follow its tendential movements towards limitless expansion; and, conversely, they try to locate its sticking points, its intermittencies and interruptions.[91] Grace Jones as "corporate cannibal" consumes everyone and everything she meets, following the inner logic of capital itself. She hopes thereby to "make the world explode." That is to say, she makes a dangerous wager: she bets on the extreme possibility that capital's own virulent nihilism might lead to its downfall. For her part, Sandra in *Boarding Gate* follows the "lines of flight" that contemporary finance capital seemingly makes available to us. She learns, however, that every escape is also a new trap. Continually outrunning the dangers that threaten her, she manages – just barely – to survive. But at the end of the film, she moves beyond mere survival, to something like a moment of decision. The wager here is that such a defection from the logic of capital can be sustained in spite of everything. *Southland Tales* pushes the logic of media saturation to the point of apocalyptic self-destruction, while leaving uncertain the prospect of a subsequent renewal. Richard Kelly's wager is that sheer hypermediated excess can push the logic of the "society of the spectacle" to the point of exhaustion and breakdown. Finally, Neveldine/Taylor wager on the game of wagering itself, pushing it to the end despite their knowledge that it is fixed. None of these works discovers an "outside" to capitalism; and none of them offers anything like revolutionary hope. But they all insist, at least, upon exhausting, and thereby perhaps finding a limit to, the totalizing ambitions of real subsumption.

Thus "Corporate Cannibal," *Boarding Gate*, *Southland Tales* and *Gamer* all explore the labyrinthine nightmare of the

contemporary world system. They all operate on the premise that the only way out is the way through. The world of real subsumption is a world without transcendence; the only way, therefore, to get 'beyond' this world is to exhaust its possibilities, and push its inherent tendencies to their utmost extremity. This means that these works produce their own version of what Benjamin Noys has called *accelerationism*: "an exotic variant of *la politique du pire*: if capitalism generates its own forces of dissolution then the necessity is to radicalise capitalism itself: the worse the better... What the accelerationists affirm is the capitalist power of dissolution and fragmentation." Accelerationism therefore aims "to exacerbate capitalism to the point of collapse" (Noys 2010). Rather than deploring our actual state of (semi-permanent) crisis, the accelerationists imply that capitalist crisis has never gone far enough, and that *this* is why they have so far only served to re-energize and reboot the movement of capital accumulation, rather than (as Marx at one point hoped) exploding it altogether.[92]

Noys is quick to point out the obvious deficiencies of accelerationism as a political strategy. On the one hand, its virulent radicalism – at least on the level of rhetoric – is not matched by any suggestions as to how the convulsive death of capitalism might actually lead to liberation, rather than to barbarism, massive destruction, or some other form of universal catastrophe. On the other hand, accelerationism risks a paradoxically conservative return to "the most teleological forms of Second International Marxism" (Noys 2010): that is to say, to the complacent evolutionist belief that, in and of themselves, the economic "laws" of capitalist development will inevitably and automatically lead to the supersession of capitalism by socialism. This sort of optimism is scarcely even thinkable today – although some traces of it persist in Michael Hardt and Antonio Negri's argument that globalization, real subsumption, and biopower are themselves inadvertently creating the necessary (if not sufficient)

preconditions for communism and the self-rule of the multitude.[93]

In spite of all this, my argument comes down to the assertion that accelerationism is a useful, productive, and even necessary aesthetic strategy today – for all that it is dubious as a political one. The project of cognitive and affective mapping seeks, at the very least, to explore the contours of the prison we find ourselves in. This is a crucial task at any time; but all the more so today, when that prison has no outside, but is conterminous with the world as a whole. As Jameson suggests, today we suffer from an "increasing inability to imagine a different future"; we find ourselves trapped by "the universal ideological conviction that no alternative is possible, that there is no alternative to the system" (Jameson 2005, 232). What we need at such a moment, he adds, is precisely "a meditation on the impossible, on the unrealizable in its own right…a rattling of the bars and an intense spiritual concentration and preparation for another stage which has not yet arrived" (232-233). I am not sure that the accelerationist strategy of emptying out capitalism through a process of exhaustion is really what Jameson has in mind here; but I think that such a strategy does respond, in depth, to the condition that Jameson so cogently describes. When we are told that There Is No Alternative, that it is not possible even to conceive "alternative arrangements of daily life" (Clover 2009, 2), then perhaps there is some value in the exhaustive demonstration that what we actually have, right here, right now, is not a viable alternative either. In this way, accelerationist aesthetics points to the "disruption," or the radical "break," without any positive content, which is all that remains for Jameson of the Utopian gesture today (Jameson 2005, 231-232).

Writing in the age of cinema, Walter Benjamin suggested that the value of film resided in its "shock effect…which, like all shock effects, seeks to induce heightened attention" (Benjamin 2003, 267).[94] In a similar way, in the post-cinematic age emerging

today, media works like the ones that I have been discussing can be valued for what could perhaps be called their *intensity effect*. They help and train us to endure – and perhaps also to negotiate – the "unthinkable complexity" of cyberspace (Gibson 1984, 51), or the unrepresentable immensity and intensity of "the world space of multinational capital" (Jameson 1991, 54). This is accomplished through the accelerationist strategy of plumbing the space of capital to its vertiginous depths, and tracking it into its furthest extremities and minutest effects. Just as film habituated the "masses" of Benjamin's time to the shocks of heavy industry and dense, large-scale urbanization, so post-cinematic media may well habituate Hardt and Negri's "multitude" to the intensities arising from the precarization of work and living conditions, and the unleashing of immense, free-floating and impersonal, financial flows.[95]

The result of such an accelerationist exploration of the spacetime of capital should be, as Jameson puts it, "to endow the individual subject with some new heightened sense of its place in the global system," so that "we may again begin to grasp our positioning as individual and collective subjects" (Jameson 1991, 54). Beyond this, Jameson expresses the hope that cognitive mapping (to which I would add affective mapping as well) may help us to "regain a capacity to act and struggle which is at present neutralized by our spatial as well as our social confusion" (54). I am not bold enough to claim that "Corporate Cannibal," *Boarding Gate, Southland Tales* and *Gamer* have in fact accomplished anything like this. And I certainly do not claim – as scholarship in the field of "cultural studies" is sometimes wont to do – that these media works, or my discussion of them, or the reception of them by others, could somehow constitute a form of "resistance." I do not think it is possible to make such a leap, because aesthetics does not translate easily or obviously into politics. It takes a lot of work to make them even slightly commensurable.[96]

This difficulty of translation is precisely why an accelerationist aesthetics makes sense, even if an accelerationist politics does not. "It is the business of the future to be dangerous," Whitehead said (Whitehead 1925/1967, 207); and one important role of art is to explore the dangers of futurity, and to "translate" these dangers by mapping them as thoroughly and intensively as possible. This is not easy, since there is always a risk that the work will get lost within the spaces that it endeavors to survey, and that it will become yet another instance of the processes that it is trying to describe. "Corporate Cannibal," *Boarding Gate*, *Southland Tales* and *Gamer* all take on this risk; and these works' accomplishments, as well as their limitations, are up to the full measure of their ambitions. This is what makes them exemplary works for a time when – despite the astonishing pace of scientific discovery and technological invention – the imagination itself threatens to fail us.

# Works Cited

Abba, Tom (2009). "Hybrid Stories: Examining the Future of Transmedia Narrative." In: *Science Fiction Film and Television* 2.1, pp. 59–76.

Adorno, Theodor (1997). *Aesthetic Theory*. Trans. Robert Hullot-Kentor. Minneapolis: University of Minnesota Press.

Agamben, Giorgio (2005). *State of Exception*. Trans. Kevin Attell. Chicago: University of Chicago Press.

agentorange (2010). DVD release finally puts Gamer under my skin. URL: http://www.quietearth.us/articles/2010/01/14/DVD-release-finally-puts-GAMER-under-my-skin.

Anders, Charlie Jane (2009). *Michael Bay Finally Made an Art Movie*. URL: http://io9.com/5301898/michael-bay-finally-made-an-art-movie.

Anonymous (1999). Armageddon DVD Review. URL: https://michaelbay.com/articles/articles/014.html.

Attali, Jacques (1985). *Noise: The Political Economy of Music*. Trans. Brian Massumi. Minneapolis: University of Minnesota Press.

Augé, Marc (1995). *Non-Places: Introduction to an Anthropology of Supermodernity*. Trans. John Howe. New York: Verso.

Barabási, Albert-László (2003). *Linked: The New Science of Networks*. New York: Basic Books.

Barthes, Roland (1972). *Mythologies*. Trans. Annette Lavers. New York: Hill and Wang.

— (1981). *Camera Lucida: Reflections on Photography*. Trans. Richard Howard. New York: Hill and Wang.

Bataille, Georges (1985). *Visions of Excess: Selected Writings 1927-1939*. Trans. Allan Stoekel, with Carl R. Lovitt and Donald M. Leslie, Jr. Minneapolis: University of Minnesota Press.

Bateson, Gregory (2000). *Steps to an Ecology of Mind*. Chicago: University of Chicago Press.

Baudrillard, Jean (1988). *The Ecstasy of Communication*. Trans.

Bernard and Caroline Schutze. New York: Semiotext(e).

— (1993). *Symbolic Exchange and Death*. Trans. Mike Gane. London: Sage Publications.

Bazin, André (2004). *What Is Cinema? Vol. 1*. Trans. Hugh Gray. Berkeley: University of California Press.

Becker, Gary (1978). *The Economic Approach to Human Behavior*. Chicago: University of Chicago Press.

Beller, Jonathan (2006). *The Cinematic Mode of Production: Attention Economy and the Society of the Spectacle*. Hanover: Dartmouth University Press.

Benjamin, Walter (2003). *Selected Writings. Vol. 4 (1938-1940)*. Ed. Howard Eiland, Michael W. Jennings. Trans. Edmund Jephcott, and Others. Cambridge: The Belknap Press of Harvard University Press.

Bergson, Henri (1914). *Laughter: An Essay on the Meaning of the Comic*. Trans. Cloudesley Brereton and Fred Rothwell. New York: Macmillan.

Bloch, Ernst (1995). *The Principle of Hope*. Trans. Neville Plaice, Stephen Plaice, and Paul Knight. Cambridge: MIT Press.

Bogost, Ian (2006). *Unit Operations: An Approach to Videogame Criticism*. Cambridge: MIT Press.

— (2007). *Persuasive Games: The Expressive Power of Videogames*. Cambridge: MIT Press.

Boltanski, Luc and Eve Chiapello (2007). *The New Spirit of Capitalism*. Trans. Gregory Elliott. New York: Verso.

Bolter, Jay David and Richard Grusin (2000). *Remediation: Understanding New Media*. Cambridge: MIT Press.

Bordwell, David (2002). "Intensified Continuity: Visual Style in Contemporary American Film." In: *Film Quarterly* 55.3, 16–28.

— (2007). Intensified Continuity Revisited. URL: http://www.davidbordwell.net/blog/?p=859.

— (2008). A Glance at Blows. URL: http://www.david bordwell.net/blog/?p=3208.

Brown, Scott (Jan. 2010). Scott Brown on How Movies Activate

Your Neural G-Spot. URL: http://www.wired.com/magazine /2010/01/pl_brown_ gspot/.

Bruno, Giuliana (2002). *Atlas of Emotion: Journeys in Art, Architecture, and Film.* New York: Verso.

Cascio, Jamais (2005). The Rise of the Participatory Panopticon. URL: http://www.worldchanging.com/archives/002651.html.

Castells, Manuel (2000). *The Rise of the Network Society. 2nd ed. Vol. 1. The Information Age: Economy, Society, and Culture.* Cambridge: Blackwell.

Castronova, Edward (2007). *Exodus to the Virtual World: How Online Fun Is Changing Reality.* New York: Palgrave Macmillan.

Catsoulis, Jeanette (Sept. 2009). "Bullets, Buttocks and Button Pushing." In: The New York Times. URL: http://movies. nytimes.com/2009/09/05/movies/05gamer.html?ref=movies.

Cavell, Stanley (1979). *The World Viewed: Reflections on the Ontology of Film.* Cambridge: Harvard University Press.

Chion, Michel (1994). *Audio-Vision: Sound on Screen.* Trans. Claudia Gorbman. New York: Columbia University Press.

Clover, Carol (1992). *Men, Women, and Chainsaws: Gender in the Modern Horror Film.* Princeton: Princeton University Press.

Clover, Joshua (2006). "futuresex/lovesounds." URL: http://jane dark.com/2006/10/futuresex_lovesounds.html.

— (2009). *1989: Bob Dylan Didn't Have This To Sing About.* Berkeley: University of California Press.

Dargis, Manohla (2007). "Apocalypse Soon: A Mushroom Cloud Doesn't Stall 2008 Electioneering." Nov. 2007. URL: http://movies.nytimes.com/2007/11/14/movies/14sout.html.

— (2008). "Sex, Blood and Exotica in an Anti-Thriller Thriller." Mar. 2008. URL: http://movies.nytimes.com/2008/03/21/movies/21gate.html.

Davis, Erik (2008). "'Roots and Wires' Remix: Polyrhythmic Tricks and the Black Electronic." In: *Sound Unbound: Sampling Digital Music and Culture.* Ed. Paul D. Miller. Cambridge: MIT

Press, 53–72.

Dean, Jodi (2005). "Communicative Capitalism: Circulation and the Foreclosure of Politics." In: *Cultural Politics* 1.1.

DeLanda, Manuel (2002). *Intensive Science and Virtual Philosophy*. New York: Continuum.

Deleuze, Gilles (1972). *Proust and Signs*. Trans. Richard Howard. New York: Braziller.

— (1984). *Kant's Critical Philosophy*. Trans. Hugh Tomlinson and Barbara Habberjam. Minneapolis: University of Minnesota Press.

— (1986). *Cinema 1: The Movement-Image*. Trans. Hugh Tomlinson and Barbara Habberjam. Minneapolis: University of Minnesota Press.

— (1988). *Foucault*. Trans. Sean Hand. Minneapolis: University of Minnesota Press.

— (1989). *Cinema 2: The Time-Image*. Trans. Hugh Tomlinson and Robert Galeta. Minneapolis: University of Minnesota Press.

— (1990). *The Logic of Sense*. Trans. Mark Lester. New York: Columbia University Press.

— (1993). *The Fold: Leibniz and the Baroque*. Trans. Tom Conley. Minneapolis: University of Minnesota Press.

— (1994). *Difference and Repetition*. Trans. Paul Patton. New York: Columbia University Press.

— (1995). *Negotiations 1972-1990*. Trans. Martin Joughin. New York: Columbia University Press.

— (2005). *Francis Bacon: The Logic of Sensation*. Trans. Daniel W. Smith. Minneapolis: University of Minnesota Press.

Deleuze, Gilles and Felix Guattari (1983). *Anti-Oedipus: Capitalism and Schizophrenia*. Trans. Robert Hurley, Mark Seem, and Helen R. Lane. Minneapolis: University of Minnesota Press.

— (1986). *Kafka: Toward a Minor Literature*. Trans. Dana Polan. Minneapolis: University of Minnesota Press.

— (1987). *A Thousand Plateaus: Capitalism and Schizophrenia.* Trans. Brian Massumi. Minneapolis: University of Minnesota Press.

— (1994). *What Is Philosophy?* Trans. Hugh Tomlinson and Graham Burchell. New York: Columbia University Press.

Dery, Mark (1994). "Black to the Future: Interviews with Samuel R. Delany, Greg Tate, and Tricia Rose." In: *Flame Wars: The Discourse of Cyberculture.* Ed. Mark Dery. Durham: Duke University Press, pp. 179–222.

Dibbell, Julian (2006). *Play Money: Or, How I Quit My Day Job and Made Millions Trading VIrtual Loot.* New York: Basic Books.

Eisenstein, Sergei (1949). *Film Form: Essays in Film Theory.* Trans. Jay Leyda. New York: Harcourt, Brace and Company.

Emerson, Jim (2007). "Southland Tales: No sparkle, no motion." Dec. 2007. URL: http://blogs.suntimes.com/scanners/2007/12/ southland_tales_is_it_even_a_m.html.

Eshun, Kodwo (1998). *More Brilliant Than the Sun: Adventures in Sonic Fiction.* London: Quartet Books.

— (2003). "Further Considerations on Afrofuturism." In: *CR: The New Centennial Review* 3.2 (Summer 2003), pp. 287–302.

Fisher, Mark (2006). I, the Object. URL: http://k-punk.abstractdynamics.org/archives/008729.html.

— (2009). *Capitalist Realism.* London: Zero Books.

Foucault, Michel (1979). *Discipline and Punish: The Birth of the Prison.* Trans. Alan Sheridan. New York: Vintage.

— (2008). *The Birth of Biopolitics: Lectures at the College de France, 1978-1979.* Trans. Graham Burchell. New York: Palgrave Macmillan.

Frampton, Daniel (2006). *Filmosophy.* London: Wallflower Press.

Franklin, Seb (2009a). "The Cut and the Code: Towards a Digital Economy of Film Editing." Unpublished text.

— (2009b). "The Major and the Minor: on Political Aesthetics in the Control Society." PhD thesis. University of Sussex.

— (2010). The Cut: theory and counter-theory of digital form.

URL: http://www.sussex.ac.uk/english/profile124042.html.

Freedman, Carl (2000). *Critical Theory and Science Fiction*. Middletown: Wesleyan University Press.

Fukuyama, Francis (1993). *The End of History and the Last Man*. New York: Harper Perennial.

Fuller, Matthew (2005). *Media Ecologies: Materialist Energies in Art and Technoculture*. Cambridge: MIT Press.

Galloway, Alexander R. (2006). *Gaming: Essays on Algorithmic Culture. Minneapolis*: University of Minnesota Press.

Gates, Bill (2000). *Business @ the Speed of Thought: Succeeding in the Digital Economy*. New York: Warner Books.

Gibson, William (1984). *Neuromancer*. New York: Ace Books.

Granovetter, Mark (1973). "The Strength of Weak Ties." In: *American Journal of Sociology* 78.6, 1360–1380.

Grusin, Richard (2004). "Premediation." In: *Criticism: A Quarterly for Literature and the Arts* 46.1, pp. 17–39.

— (2007). "DVDs, Video Games, and the Cinema of Interactions." In: *Multimedia Histories: From the Magic Lantern to the Internet*. Ed. by James Lyons and John Plunkett. Exeter: University of Exeter Press, 209–221.

Haraway, Donna (1991). *Simians, Cyborgs, and Women: The Reinvention of Nature*. New York: Routledge.

Hardt, Michael and Antonio Negri (2001). *Empire*. Cambridge: Harvard University Press.

— (2004). *Multitude: War and Democracy in the Age of Empire*. New York: Penguin.

— (2009). *Commonwealth*. Cambridge: The Belknap Press of Harvard University Press.

Harman, Graham (2005). *Guerrilla Metaphysics: Phenomenology and the Carpentry of Things*. Peru, Illinois: Open Court.

— (2007). "On Vicarious Causation." In: Collapse: Philosophical Research and Development 2, pp. 187–221.

— (2009). *Prince of Networks: Bruno Latour and Metaphysics*. Melbourne: re.press.

Harvey, David (2006). *Spaces of Global Capitalism: Toward a Theory of Uneven Geographical Development*. New York: Verso.

Hayek, F. A. (1948). *Individualism and Economic Order*. Chicago: University of Chicago Press.

Hayles, N. Katherine (1999). *How We Became Posthuman: Virtual Bodies in Cybernetics, Literature, and Informatics*. Chicago: University of Chicago Press.

Hermitosis (2008). "Interview: How Nick Hooker Turned Grace Jones Into A Corporate Cannibal." URL: http://hermitosis.blogspot.com/2008/09/nick-hooker-turned-grace-jones-into.html.

Hillis, Aaron (2008). "Olivier Assayas on *Boarding Gate*". URL: http://www.ifc.com/news/2008/03/oliver-assayas-on-boarding-gat.php.

Hoberman, J. (2007). "Revelation." Oct. 2007. URL: http://www.villagevoice.com/2007-10-30/film/revelation/.

— (2008). "The One Reason To See *Boarding Gate*". Mar. 2008. URL: http://www.villagevoice.com/2008- 03- 18/film/the- one- reason- to- see- boarding-gate/.

Hooker, Nick (2009). "Grace." Email to the author, January 17, 2009.

Jameson, Fredric (1991). *Postmodernism, Or, The Cultural Logic of Late Capitalism*. Durham: Duke University Press.

— (2005). *Archaeologies of the Future: The Desire Called Utopia and Other Science Fictions*. New York: Verso.

Jenkins, Simon (2009). "As they did Ozymandias, the dunes will reclaim the soaring folly of Dubai." Mar. 2009. URL: http : / / www . guardian . co . uk/commentisfree/2009/mar/20/dubai-decline-middle-east.

Kara (2009). Comic-Con 2009: Interview with Mark Neveldine, Brian Taylor, and Terry Crews. URL: http://screencrave.com/ 2009- 07- 29/interview- gamer-mark-neveldine-brian-taylor-terry-crews/.

Kaufman, Eleanor (1998). "Introduction." In: *Deleuze and Guattari:*

*New Mappings in Politics, Philosophy, and Culture*. Ed. by Eleanor Kaufman and Kevin Jon Heller. Minneapolis: University of Minnesota Press, pp. 3–13.

Keathley, Christian (2006). *Cinephila and History, Or, The Wind in the Trees*. Bloomington and Indianapolis: Indiana University Press.

Kelly, Richard and Brett Weldele (2007). *Southland Tales: The Prequel Saga*. Los Angeles: Graphitti Designs and View Askew.

Kershaw, Miriam (1997). "Postcolonialism and Androgyny: The Performance Art of Grace Jones." In: *Art Journal* 56.4, pp. 19–25.

Krasniewicz, Louise (2000). "Magical Transformations: Morphing and Metamorphosis in Two Cultures." In: *Meta-Morphing: Visual Transformation and the Culture of Quick-Change*. Ed. Vivian Sobchack. Minneapolis: University of Minnesota Press.

Kurzweil, Ray (2005). *The Singularity is Near*. New York: Viking.

Latour, Bruno (1988). *The Pasteurization of France*. Cambridge: Harvard University Press.

LiPuma, Edward and Benjamin Lee (2004). *Financial Derivatives and the Globalization of Risk*. Durham: Duke University Press.

Lyotard, Jean-François (1993). *Libidinal Economy*. Trans. Iain Hamilton Grant. Bloomington: Indiana University Press.

Manovich, Lev (2001). *The Language of New Media*. Cambridge: MIT Press.

Marx, Karl (1992). *Capital: A Critique of Political Economy. Vol. 1*. Trans. Ben Fowkes. New York: Penguin.

— (1993). *Capital: A Critique of Political Economy. Vol. 3*. Trans. David Fernbach. New York: Penguin.

Marx, Karl and Friedrich Engels (1998). *The Communist Manifesto*. New York: Signet Classics.

Massumi, Brian (2002). *Parables for the Virtual: Movement, Affect, Sensation*. Durham: Duke University Press.

McDowell, Colin (2005). "Goude Heavens." In: *The Times*,

November 6, 2005. URL :
http://women.timesonline.co.uk/tol/life_and_style/women
/style/article583890.ece.

McLuhan, Marshall (1994). *Understanding Media: The Extensions of Man*. Cambridge: MIT Press.

— (1997). *Media Research: Technology, Art, Communcation*. Ed. Michael A. Moos. Amsterdam: G+B Arts International.

McLuhan, Marshall and Quentin Fiore (1967). *The Medium is the Massage*. New York: Bantam.

McLuhan, Marshall and Eric McLuhan (1988). *Laws of Media: The New Science*. Toronto: University of Toronto Press.

Miéville, China (2008). "M. R. James and the Quantum Vampire." In: *Collapse* (May 2008), 105–128.

Moulier Boutang, Yann (2007). *Le capitalisme cognitif: La nouvelle grande transformation*. Paris: Editions Amsterdam.

Mulvey, Laura (2006). *Death 24x a Second: Stillness and the Moving Image*. London: Reaktion Books.

Neveldine, Robert (2010). "Re: Gamer." Personal communication.

Noys, Benjamin (2010). *The Persistence of the Negative: A Critique of Contemporary Continental Theory*. Edinburgh: Edinburgh University Press.

Pasolini, Pier Paolo (1988). *Heretical Empiricism*. Ed. Louise K Barnett. Trans. Ben Lawton and Louise K. Barnett. Bloomington: Indiana University Press.

Patterson, Orlando (2006). "Our Overrated Inner Self." URL: http://select.nytimes.com/2006/12/26/opinion/26patterson.htm l.

Peranson, Mark (2007). "Richard Kelly's Revelations: Defending *Southland Tale*s." URL : http://www.cinema-scope.com/cs27/int_peranson_kelly.html.

Perkins, Claire (2009). "Lost in Decryption: Female Subjectivity in the Films of Olivier Assayas." In: *Cinemascope* 5.12. URL: http://www.cinemascope.it/Issue%2012/INDEX_N12.html.

Piechota, Carole (2009). "Touching Sounds: The Audiovisual

Passage in Contemporary Cinema." Prospectus for doctoral dissertation.

Polanyi, Karl (2001). *The Great Transformation*. Boston: Beacon Press.

Prato, Greg (2009). "Grace Jones." URL: http://www.allmusic.com/cg/amg.dll?p=amg\&sql=11: 3ifexqe5ldse~T1.

Prigogine, Ilya and Isabelle Stengers (1984). *Order Out of Chaos: Man's New Dialogue With Nature*. New York: Bantam.

Prince, Stephen (1996). "True Lies: Perceptual Realism, Digital Images, and Film Theory." In: *Film Quarterly* 49.3, pp. 27–37.

Quigley, Adam (2009). Interview: Writers/Directors Neveldine and Taylor Talk Gamer. URL: http : / / www . slashfilm . com / 2009 / 09 / 04 / interview - writersdirectors- neveldine- taylor- talk- gamer- what- happened- with- jonah- hex - and - how - crank - 2 - was - their- nickelodeon - green - goop - moment - for- america/.

Reid, Bruce (2001). "Defending the Indefensible: The Abstract, Annoying Action of Michael Bay." URL: http://www.thestranger.com/seattle/Content?oid=4366.

Reynolds, Simon (1998). *Generation Ecstasy: Into the World of Techno and Rave Culture*. Boston: Little, Brown, and Company. — (2005). *Rip It Up And Start Again: Post-punk 1978-1984*. London: Faber and Faber.

Rodowick, David (2007). *The Virtual Life of Film*. Cambridge: Harvard University Press.

Royster, Francesca T. (2009). "'Feeling like a woman, looking like a man, sounding like a no-no': Grace Jones and the performance of Strange in the Post-Soul Moment." In: *Women and Performance* 19.1 (Mar. 2009), 77–94.

Schumpeter, Joseph (1943). *Capitalism, Socialism, and Democracy*. London: George Allen & Unwin Ltd.

Shaviro, Steven (2003a). *Connected, or, What It Means to Live in the Network Society*. Minneapolis: University of Minnesota Press.

— (2003b) "Straight From the Cerebral Cortex: Vision and Affect in Strange Days." In: The Cinema of Kathryn Bigelow: Hollywood Transgressor. Ed. by Deborah Jermyn and Sean Redmond. London: Wallflower Press, pp. 159–177.

— (2004). "The Life, After Death, of Postmodern Emotions." In: *Criticism: A Quarterly for Literature and the Arts* 46.1, 125–141.

— (2007). "Emotion Capture: Affect in Digital Film." In: *Projections* 2.1, 37–55.

— (2008). "Money for Nothing: Virtual Worlds and Virtual Economies." In: Virtual Worlds. Ed. by Mary Ipe. Hyderabad: Icfai University Press, pp. 53–67.

— (2009). "The Singularity is Here." In: *Red Planets: Marxism and Science Fiction*, ed. Mark Bould and China Miéville, London: Pluto Press, 103-117.

Shores, Correy (2009). "Deleuze's Analog and Digital Communication; Isomorphism; and Aesthetic Analogy." URL: http://piratesandrevolutionaries.blogspot.com/2009/01/deleuzes-analog-and-digital.html.

Silverman, Kaja (1988). *The Acoustic Mirror: The Female Voice in Psychoanalysis and Cinema*. Bloomington and Indianapolis: Indiana University Press.

Simondon, Gilbert (2005). *L'individuation à la lumière des notions de forme et d'information*. Grenoble: Million.

Smelik, Anneke (1993). "The Carousel of Genders." URL: http://www.let.uu.nl/womens_studies/anneke/carous.htm.

Sobchack, Vivian (2004). *Carnal Thoughts: Embodiment and Moving Image Culture*. Berkeley: University of California Press.

Spivak, Gayatri Chakravorty (1985). "Scattered Speculations on the Question of Value." In: *Diacritics* 15.4, 73–93.

Steuer, Eric (2007). "*Darko* Director Richard Kelly Explains the Long Wait for *Southland Tales*." URL: http : / / www. wired . com / entertainment / hollywood/magazine/15-11/pl_screen.

Stivale, Charles (2006). Duelling Augé's - Pascal and Marc. URL:

http://www.langlab.wayne.edu/CStivale/D-G/DuellingAuge.html.

Suvin, Darko (1979). *Metamorphoses of Science Fiction.* New Haven: Yale University Press.

Taubin, Amy (2007). "Southland Tales." Nov. 2007. URL: http://www.richard-kelly.net/news/news.php?id=424.

Taylor, Astra (2005). *Zizek! The Movie.*

Thrift, Nigel (2008). *Non-Representational Theory: Space | Politics | Affect.* New York: Routledge.

Trilling, Lionel (1972). *Sincerity and Authenticity.* Cambridge: Harvard University Press.

Tuttle, Harry (2007). Unspoken Cinema: Minimum Profile. URL: http://unspokencinema.blogspot.com/2007/01/minimum-profile.html.

VanderMeer, Ann and Jeff VanderMeer, eds. (2008). *The New Weird.* San Francisco: Tachyon Publications.

Vertov, Dziga (1984). *Kino-Eye: The Writings of Dziga Vertov.* Trans. Kevin O'Brien. Berkeley: University of California Press.

Videography (2009). High Score: 4K Win for 'Gamer'. URL: http://videography.com/article/87592.

Virno, Paolo (2004). *A Grammar of the Multitude.* Los Angeles and New York: Semiotext(e).

Vishnevetsky, Ignatiy (2009). Now in Theaters: "Gamer" (Neveldine/Taylor, USA). URL: http://www.theauteurs.com/notebook/posts/977.

Wark, McKenzie (2007). *Gamer Theory.* Cambridge: Harvard University Press.

Watts, Duncan J. (2004). *Six Degrees: The Science of a Connected Age.* New York: W. W. Norton.

Whitehead, Alfred North (1925/1967). *Science and the Modern World.* New York: The Free Press.

— (1929/1978). *Process and Reality.* New York: The Free Press.

Williams, Eric (1994). *Capitalism and Slavery.* Chapel Hill: University of North Carolina Press.

# Endnotes

1. Strictly speaking, Deleuze and Guattari say that the work of art "is a bloc of sensations, that is to say, a compound of percepts and affects" (1994, 164).

2. I am implicitly drawing upon Jonathan Beller's account of what he calls "the cinematic mode of production," or the way that cinema and its successor media "are deterritorialized factories in which spectators work, that is, in which we perform value productive labor" (2006, 1). The cinema machine extracts surplus labor-power from us, in the form of our attention; and the circulation and consumption of commodities is effected largely through the circulation and consumption of moving images, provided by film and its successor media. Beller gives a highly concrete account of how media forms and culture industries are central to the productive regime, or economic "base," of globalized capitalism today. However, I think that he underestimates the differences between cinematic and post-cinematic media: it is these differences that drive my own discussion here.

3. My terminology here is somewhat differently from that of Michael Hardt and Antonio Negri, who have done the most to develop the concept of affective labor. For Hardt and Negri, "unlike emotions, which are mental phenomena, affects refer equally to body and to mind. In fact, affects, such as joy and sadness, reveal the present state of life in the entire organism" (2004, 108). This seems wrong to me, precisely because there is no such thing as "mental phenomena" that do not refer equally to the body. The division between affect and emotion must rather be sought elsewhere. This is why I prefer Massumi's definition of emotion as the capture, and reduction-to-commensurability, of affect. It is this reduction that, among other things, allows for the sale and purchase of emotions as commodities. In a certain sense,

emotion is to affect as, in Marxist theory, labor-power is to labor. For labor itself is an unqualifiable capacity, while labor-power is a quantifiable commodity that is possessed, and that can be sold, by the worker. Hardt and Negri's own definition of affective labor in fact itself makes sense precisely in the register of what I am calling labor-power and objectified emotions: "Affective labor, then, is labor that produces or manipulates affects such as a feeling of ease, well-being, satisfaction, excitement, or passion. One can recognize affective labor, for example, in the work of legal assistants, flight attendants, and fast food workers (service with a smile)" (108).

4. In the first half of the twentieth century, Fascism and Nazism in particular are noteworthy for their mobilization of cinematic affect; though arguably Soviet communism and liberal capitalism also mobilized such affect in their own ways. Much has been written in the last half-century about the Nazis' use of cinema, Goebbels' manipulation of the media, and the affective structure of films like Leni Riefenstahl's *Triumph of the Will*. But already in the 1930s, Georges Bataille pointed to the centrality of affective politics in his analysis of "The Psychological Structure of Fascism" (Bataille 1985, 137-160). And Walter Benjamin explicitly linked this fascist mobilization of affect to its use of the cinematic apparatus in his essay on "The Work of Art in the Age of Its Technological Reproducibility" (Benjamin 2003, 251-283), especially when he diagnoses fascism's "aestheticizing of politics" (270). Part of my aim here is to work out how the post-cinematic manipulation and modulation of affect, as we are experiencing it today, differs from the mass mobilization of cinematic affect in the early and middle twentieth century.

5. Affect theory, or "non-representational theory" (Thrift 2008), is usually placed in sharp opposition to Marxist theory, by advocates of both approaches. I am arguing, instead, that we need to draw them together. This is precisely what Deleuze and Guattari attempted to do in *Anti-Oedipus* (1983). The attempt was

not entirely successful, but it seems prescient in the light of subsequent "neoliberal" developments in both affective and political economies.

To put this in a slightly different way, I am largely sympathetic to Bruno Latour's insistence that networked social processes cannot be explained in terms of global categories like "capital," or "the social" – because these categories themselves are what most urgently need to be explained. As Whitehead says, the business of philosophy "is to explain the emergence of the more abstract things from the more concrete things," rather than the reverse (Whitehead 1929/1978, 20). The only way to explain categories like "capital" and "the social" is precisely by working through the network, and mapping the many ways in which these categories function, the processes through which they get constructed, and the encounters in the course of which they transform, and are in turn transformed by, the other forces that they come into contact with. But explaining how categories like "capital" and "society" are constructed (and in many cases, auto-constructed) is not the same thing as denying the very validity of these categories – as Latour and his disciples, in their more uncautious moments, are sometimes wont to do.

6. Jameson explains the difference between knowledge and representation by referring to Althusser's notorious distinction between "science" and "ideology" (Jameson 1991, 53). But however unfortunate his terminology, Althusser is really just restating Spinoza's distinction between different types of knowledge. Spinoza's first, inadequate kind of knowledge corresponds to Althusser's ideology, and to the whole problematic of representation; while his third kind of knowledge, of things according to their immanent causes, *sub specie aeternitatis*, corresponds to Althusser's science. The same Spinozian distinction is the basis for Deleuze and Guattari's contrast between "cartography and decalcomania," or mapping and tracing, where the latter remains at the level of

representation, while the former is directly "in contact with the real" [(Deleuze and Guattari, 1987, 12-14).

For a close look at practices of affective mapping, and their difference from Jameson's "cognitive mapping," see Giuliana Bruno.

7. As Eleanor Kaufman, commenting on Deleuze and Guattari, puts it: "The map is not a contained model, or tracing, of something larger, but it is at all points constantly inflecting that larger thing, so that the map is not clearly distinguishable from the thing mapped" (Kaufman 1998, 5).

8. I am using "diagram" here in the sense outlined by Foucault and by Deleuze. Foucault defines a diagram as "a generalizable model of functioning; a way of defining power relations in terms of the everyday life of men... [The Panopticon] is the diagram of a mechanism of power reduced to its ideal form; its functioning, abstracted from any obstacle, resistance, or friction, must be represented as a pure architectural and optical system; it is in fact a figure of political technology that may and must be detached from any specific use" (Foucault 1979, 205). Deleuze cites this definition, and further elaborates it, in his book on Foucault (1988, 34ff.) and elsewhere.

9. Three additional things need to be noted here. In the first place, Harman's discussion does not privilege human subjectivity in any way. His descriptions of how objects exceed one another's grasp in any encounter applies as much "when a gale hammers a seaside cliff" or "when stellar rays penetrate a newspaper" as it does when human subjects approach an object (Harman 2005, 83). When I use a knife to cut a grapefruit, the knife and the grapefruit also encounter one another at a distance, unable to access one another's innermost being. In the second place, I do not have any privileged access into the depths my own being. My perception of, and interaction with, myself is just as partial and limited as my perception of, and interaction with, any other entity. And finally – although in this respect I am going

against Harman, who argues for the renewal of something like a metaphysics of occult substances – the withdrawal of objects from one another need not imply that any of the objects thus withdrawn actually possess some deep inner essence. The argument is that all entities have more to them than the particular qualities they show to other entities; it says nothing about the status or organization of this *more*.

10. Specifically, Hooker compares the viscous materiality of Jones' video image to the way that a pool of oil fills half the space of the gallery, mirroring the ceiling, in Richard Wilson's installation piece *20:50* (Hooker 2009).

11. Some of these earlier videos can be found at the director's website (http://www.nickhooker.com), and on his MySpace page (http://profile.myspace.com/index.cfm?fuseaction=user.viewprof ile&friendid=130368407).

12. Modulation is initially an analog process, as in the amplitude modulation (AM) or frequency modulation (FM) of radio waves. In analog modulation, "certain *dimensions* of one medium are modulated to serve as imprints bearing the variations of another medium, thereby *transmuting* the original form's embodiment without *transforming* these formal variations." When modulation becomes digital, however, an additional step is added: "in digital we both transform *and* transmute the medium," breaking the chain of analogical resemblances by a translation into binary code, so that variation is not just controlled, but also *coded* and reductively *homogenized* (Shores 2009).

13. Deleuze says that, where the older mechanisms of confinement, foregrounded in Foucault's disciplinary society, are *analogical*, in the emerging control society, with its continual modulations, "the various forms of control...are inseparable variations, forming a system of varying geometry whose language is *digital*" (Deleuze 1995, 178).

14. I am thinking here, in part, of Laura Mulvey's discussion of

how "the cinema is divided into two parts...split between its material substance, the unglamorous celluloid strip running through the projector on one side and, on the other, entrancing images moving on a screen in darkened space." Mulvey aligns this formal division with the "fundamental, and irreconcilable, opposition between stillness and movement that reverberates across the aesthetics of cinema." She further associates moving images with the narrative drive of mainstream fictional films, and stillness with the avant-garde project of bringing "the mechanism and the material of film into visibility" (Mulvey 2006, 67). Mulvey is interested in considering how the transfer of cinematic works to digital media allows for a renewed contemplation of them, precisely because our ability to freeze the frame at any moment makes the cinematic dialectic between stillness and motion more accessible to us. I am trying to look, instead, at the ways in which recent digital video works like "Corporate Cannibal" reject both sides of the stillness/movement dichotomy, and operate according to a different logic: one aligned not around stillness and motion, but around the composition of forces, modulation, and feedback.

15. Actually, Harvey describes three conceptions of space. The first is the *absolute space* of ordinary perception; this is Cartesian-Newtonian space. The second is the *relative space* of Einstein and modern physics. *Relational space* is the third. Harvey emphasizes that it is not a question of determining which of these three would be the "true" concept of space, but of understanding how "space can become one or all simultaneously depending upon the circumstances. The problem of the proper conceptualization of space is resolved through human practice with respect to it" (Harvey 2006, 125-126). I am interested here in how the practices of what Deleuze calls the "control society," and the mechanisms of digital media, participate in, and are themselves in turn affected by, the social construction of relational space.

16. The non-indexicality of digital video has lately perturbed

many film theorists, including Rodowick (2007). For my own earlier take on this issue, see my article "Emotion Capture: Affect in Digital Film" (Shaviro 2007).

17. Filmmakers such as Godard, and film theorists from Eisenstein to Chion, have been concerned with exploring the multiple relations between sound and image, and especially with pointing out how images and sounds are recorded on separate devices, so that their synchronization is an illusion – or at the very least an artifice created after the fact. But digital video is no longer limited by the image/sound dichotomy. "The components of the image" (Deleuze 1989, 225-261) are multiple; and regardless of the sensory sources from which they have been sampled, they are all transcoded into the same indifferent binary code, which then becomes material for new constructions. Not only is digital video *composited* rather than edited, so that it has to do with "a palimpsestic combination of data layers" rather than with "contiguous spatial wholes as blocks of duration" Rodowick 2007, 169); in addition, an input of one sensory mode can become an output for another, as is the case with music visualization programs – which generate patterns similar to those in some of Hooker's earlier music videos.

18. In an article about Andy Warhol, I argue that Warhol's multiple portraits of Marilyn Monroe, all made after the actress' death, dramatize the fact that "even Marilyn Monroe, you might say, was never entirely successful in playing the role of 'Marilyn Monroe'... This discord between the performer and the role, or between the empirical person and the ideal of beauty that she is supposed to incarnate, may well be regarded as the cause of Marilyn Monroe's tragic death, no matter what the actual facts of the case. Marilyn's flesh simply could not bear what she was supposed to be." Warhol's Marilyn portraits, with their numerous random variations, generated by the imperfections of the silkscreening process, illustate "the failure of the enactment to match the role. And this is why these paintings are all pictures of

Marilyn's death" (Shaviro 2004, 134).

Evidently, Jones has succeeded where Monroe did not: in negotiating the gap between the existential person and the celebrity icon. Monroe's endeavor to close the gap, and to live her incarnation as a star, inevitably failed, with tragic consequences. Jones, instead, affirms and even replicates this gap, with an ironic performance strategy of *disidentification*. As Francesca Royster puts it, "Jones' adoption of hypersexualized, animalistic, machinic, and apparently degrading positions act as what Jose Munoz calls 'disidentifications' with the toxic aspects of dominant ideology of black womanhood" (Rosyter 2009, 84). Instead of trying to *become* her celebrity role, therefore, Jones precisely *performs* its impossibility and distance.

19. Of course, this sort of rhythmic experimentation is a wider tendency of Afrodiasporic music in general, throughout the second half of the twentieth century. James Brown is not commonly counted as an Afrofuturist; but when he transforms himself into a "Sex Machine," he is in fact expressing both robotic, mechanistic repetition and superhuman, polyrhythmic dispersal at one and the same time.

20. The classic account of this process remains that of Eric Williams (1994). The industrial capitalist mode of production, with "free" workers selling their labor power to capitalist owners, would seem to be more or less incompatible with formal slavery. But this does not contradict the claim that accumulations of wealth under slavery were a crucial part of the "primitive accumulation" that capitalism needed in order to take off on a global scale. Nor does it contradict the observation that "residual" pockets of slavery continue to exist today within an overall capitalist economy. For "primitive accumulation" is a recurring and continuing phenomenon of capital accumulation, rather than just a "stage" that would precede the establishment of capitalism *tout court*.

21. Of course, mainstream visions of the Singularity – the

most famous of which is probably that propounded by Ray Kurzweil (2005) – are utterly depoliticized, and express little more than adolescent white male power fantasies of infinite potency, and of entrepreneurial accomplishment writ large. I discuss this hegemonic science fiction of the Singularity in a recent essay (Shaviro 2009). Afrofuturist reimaginings of the Singularity, however, transmute it into something crazier and more fantastic, approaching the "ironic political myth" and skewed utopianism of which Donna Haraway writes (Haraway 1991, 149).

22. That is to say, they move away from personal emotion and towards an expression of asubjective, unqualified, and intensive affect.

23. Jean-Paul Goude's music video for the song also deserves commentary. It is a rapid montage of surreal sequences, many of then taken from commercials that Goude made with Jones. There is a strong emphasis on the transformation and distortion of Jones' body through various techniques of (analog, at that time) editing, and on the actual, physical process of producing these distortions. The video even begins with a series of close-ups showing the process of cutting up a photograph of Jones, and then pasting in fragments taken from other copies of the photo, in order to elongate the shape of her face. In this way, "Slave to the Rhythm" video prefigures, by analog means, the distortions that "Corporate Cannibal" produces digitally. The earlier video both displays Jones' body/image as a commodity, and shows the labor required to produce that commodity.

24. I take the term *premediation* from Richard Grusin (2004). Needless to say, this does not mean that our future existence has actually been determined for all time, or that the system of capital is so complete, and so totalizing, that nothing whatsoever can exist outside of its control. It does mean, however, that there is no *pure* otherness, no gesture or position so radical that it cannot possibly be recuperated. We cannot avoid

the risk of recuperation, because every possible change or difference has already been accounted for within capitalism's own calculus and commodification of "risk." Our future has been mortgaged – both literally and metaphorically – to high finance. As Deleuze puts it, in the control society "a man [sic] is no longer a man confined but a man in debt" (Deleuze 1995, 181). In consequence, even if we can imagine all sorts of possible futures, we seem unable to imagine one that would really *make a difference*, in terms of our relation to capitalism. As Slavoj Žižek memorably puts it, "today it's much easier to imagine the end of all life on earth than a much more modest change in capitalism" (Taylor 2005). The desperate vagueness of currently popular Nietzschean, Levinasian, and Derridean invocations of uncertainty, undecidability, and radical alterity seems to me to confirm, and to be symptomatic of, this fundamental failure of imagination. We don't seem to be able to come up with anything concrete that would be independent of the logic of financial flows.

25. In the passage I cite, Deleuze is actually describing the construction of space in the Longchamp and Gare de Lyon sequences of Robert Bresson's *Pickpocket*, in which "the hand ends up assuming the directing function...dethroning the face... vast fragmented spaces [are] transformed through rhythmic continuity shots which correspond to the affects of the thief. Ruin and salvation are played on an amorphous table whose successive parts await the connection which they lack from our gestures, or rather from the mind" (Deleuze 1986, 108-109). The situation in Assayas' films is somewhat different, since in the world of transnational capital neither human gestures nor actions of "the mind" are able to track, much less create, the connections that link fragmented spaces together. These connections are no longer forged by human bodies acting directly, but rather operated by means of digital technologies of computation and communication. Ruin and salvation are still

very much at stake in Assayas' films; but these outcomes are themselves digital and 'machinic.' They no longer seem to have any relation either to individual initiative, or to spiritual faith. These changes are also correlated with recent changes in the nature of what Deleuze calls *any-space-whatevers*; I discuss these latter changes below.

26. I have previously discussed the dilemmas of Bazinian realism in the digital age in my article "Emotion Capture" (Shaviro 2007).

27. Deleuze does not mention Marc Augé, but refers the concept of *any-space-whatever* (*espace quelconque*) to one (otherwise largely unknown) Pascal Augé (Deleuze 1986, 109 and 122). Charles Stivale (2006) discusses this confusion, and suggests that "Pascal" may have been Deleuze's slip for "Marc." However, Stivale also includes an email from Les Roberts claiming that the name "Pascal" is in fact correct, and that Marc Augé had nothing to do with Deleuze's formulation. Be that as it may, the link between Deleuze's *espace quelconque* and Augé's *non-lieu* has entered the literature, as Stivale shows.

28. Translation slightly modified.

29. And in a period of economic crisis, the transformation of frenetically active business centers into decrepit urban ruins can be almost instantaneous. Simon Jenkins (2009) describes one such transformation, as the global crisis of 2008-2009 puts a halt to extravagant building projects in Dubai. Jenkins explicitly compares the hypermodern, half-built or soon-to-be-abandoned, future ruins of Dubai to the past ruins of Detroit.

30. There is a hidden affinity between the aesthetics of Deleuze and of Adorno. For both thinkers, the authentic work of art resists an otherwise ubiquitous culture of commodification, by virtue of its force of negativity (Adorno) or of counter-actualization (Deleuze). Deleuze's account of how modernist art works to "prevent the full actualization" of the event to which it responds (Deleuze 1990, 159), and to reverse "the techniques of

social alienation" into "revolutionary means of exploration" (161), echoes Adorno's insistence that it is "only by virtue of the absolute negativity of collapse" that art can "enunciate the unspeakable: utopia" (Adorno 1997, 32). For both thinkers, and despite their radical differences in vocabulary, art restores potentiality by *derealizing* the actual. The question that haunts aesthetics today is whether such strategies of derealization are still practicable, in a time when negation and counter-actualization have themselves become resources for the extraction of surplus value.

31. This is precisely why, as Jameson argues, the "world space" of transnational capital cannot be represented. In proposing that this irreducibly plural and unintuitable space can nonetheless be *mapped* in terms of "open boxes" and "sealed vessels," I am hijacking a schema that Deleuze introduces in entirely different circumstances. For open boxes and sealed vessels are the two correlative forms of organization that Deleuze discerns in Proust's *In Search of Lost Time* (Deleuze 1972, 103-115). I am undoubtedly doing a certain degree of violence to Deleuze's schema when I transfer it from Proust's early-20th-century modernist novel to Assayas' early-21st-century postmodernist film. However, my implicit argument here is that Deleuze (who detested the term "postmodern") nonetheless generally tends to characterize modernism and modernity in ways that actually apply better to more recent social and cultural formations.

32. The difference between formal and real subsumption is that, in the former case, pre-capitalist or non-capitalist forms of labor, and of socialization, continue to exist – even though their products or outputs are appropriated by capital, so that surplus value may be extracted from them. In contrast, in the case of real subsumption, all aspects of the labor process and of social life are themselves directly "rationalized" according to capitalist imperatives. In such a situation, "all of nature has become

capital, or at least has been subject to capital" (Hardt and Negri 2001, 272). The capitalist system no longer has an "outside." Foucault makes a related point (even though he never uses the term *real subsumption*) when he discusses how neoliberalism reverses the traditional relation between the economy and the State. Where traditional liberalism called on the State to regulate, and insure the fair functioning of, the market, neoliberalism instead "asks the market economy itself to be the principle, not of the state's limitation, but of its internal regulation from start to finish of its existence and action. In other words, instead of accepting a free market defined by the state and kept as it were under state supervision...the [neo]liberals say we should completely turn the formula around and adopt the free market as organizing and regulating principle of the state... In other words: a state under the supervision of the market rather than a market supervised by the state" (Foucault 2008, 116). State functions are not just managed in the interests of capital, but are themselves directly organized according to market principles and imperatives. I follow Hardt and Negri (2001, 254-256) in arguing that, in globalized, post-Fordist capitalism, real subsumption has largely displaced formal subsumption. However – somewhat in contrast to Hardt and Negri – I think that real subsumption is best understood as a continuing *tendency*, rather than as a finally attained state. For capitalism always needs to expand. It will stagnate if it cannot discover new "outsides": new sources of labor to exploit, new sources of raw materials to appropriate, and new markets in which to sell its goods. There is always still some remainder, some aspect of human life or of the world, some reservoir of subjectivity or objectivity, that has not yet been appropriated by capital in the ongoing process of "primitive accumulation."

33. For Marx, the secrets of the valorization of capital, and of the exploitation of labor, can only be unveiled when we "leave this noisy sphere [of circulation], where everything takes place

on the surface and in full view of everyone, and follow them into the hidden abode of production, on whose threshold there hangs the notice 'No admittance except on business' " (Marx 1992, 279-280). But affective labor – a category that includes film acting – is productive only to the extent that it is a public *performance*. It cannot unfold in the hidden depths; it must be visible and audible. We see it displayed right in front of us, both in 'real life' and on the screen.

34. The society of real subsumption is one in which something like Gary Becker's neoliberal vision of society has largely been actualized. Becker regards all aspects of intimate and personal life as "markets" for the investment of "personal capital" (Becker 1978). One's choice of a life partner is, for instance, a business decision, an investment made in the hope of maximizing future earnings. Drug addiction, crime, racism, and so on, are all explained by Becker as rational choices made in order to maximize utility, or to get the best possible returns on one's self-investment. As Foucault puts it, Becker defines *"homo oeconomicus* as entrepreneur of himself, being for himself his own producer, being for himself the source of [his] earnings" (Foucault 2008, 226). This means that consumption is, itself, really just another form of production: "The man of consumption, insofar as he consumes, is a producer. What does he produce? Well, quite simply, he produces his own satisfaction" (Foucault 2008, 226). Fredric Jameson similarly emphasizes that Becker's neoliberal vision "is in reality a production model" (Jameson 1991, 267). For Jameson, "Becker's model seems to me impeccable and very faithful indeed to the facts of life as we know it" under late capitalism; it is only "when it becomes prescriptive" that it leads to "the most insidious forms of reaction" (269).

35. Hoberman doesn't much like *Boarding Gate*, and doesn't really 'get' the film as all; but his description of its style is more or less accurate, as long as we take it in a more positive sense

than he intended. We might also say, as Claire Perkins does, paraphrasing Jonathan Romney, that the film "updates the notion of the *cinéma du look* – that term used in a mostly disparaging sense by critics to describe a strain of 1980s French cinema whose spectacular visual style and perceived lack of ideological depth is understood as something directly influenced by media including television, music video and advertising" (Perkins 2009, 1). Assayas 'redeems' the *cinéma du look*, as it were, by explicitly turning it back upon its own unacknowledged presuppositions.

36. The quintessential postmodern example of this genre might well be Luc Besson's *La femme Nikita* (1991). Evidently, the narrative category of the Eurotrash thriller overlaps with the cinematographic category of the *cinéma du look*.

37. Hayek, of course, makes his argument about "dispersed bits of incomplete and frequently contradictory knowledge" in the course of a polemic against the very possibility of socialist economic planning. But one can appreciate Hayek's warnings about the limitations of individual knowledge, even without sharing his faith in the "marvel" of the "price system" as an automatic mechanism for "solv[ing] problems which we should not be able to solve consciously" (Hayek 1948, 86-87). Where Hayek idealizes the market as the solution to the problem of limited, perspectivist knowledge, one may invert his formulation, and say instead that it is precisely the institution of the "free market" as a "world system" that produces the sort of "individual" for whom such limited knowledge is a problem. From this perspective, Hayek's account of the limitations of explicit knowledge confirms Jameson's observation that transnational capitalism cannot be understood in terms of "existential experience" (Jameson 1991, 53). One can then go on to question Hayek's own extremely circumscribed notion of rationality, and his implicit, empiricist assumption that the only possible form of explicit knowledge is the existential one.

38. Argento's role in *Boarding Gate* is roughly analogous to

those of Connie Nielsen in *Demonlover* and Maggie Cheung in *Clean*. For an overall discussion of female subjectivity in Assayas' trilogy, see Claire Perkins (2009).

39. It might seem like a desperate (or disingenuous) oxymoron to credit Argento with being consciously unselfconscious, and wholehearted at an ironic distance. But I cannot think of any better way to describe the disorienting effect of her performances of "femininity," not only in *Boarding Gate*, but also in Catherine Breillat's *The Last Mistress* (2007) and Abel Ferrara's *New Rose Hotel* (1998), as well as in the films in which she directed herself: *Scarlet Diva* (2000), and *The Heart is Deceitful Above All Things* (2004).

40. For Baudrillard, seduction is a sort of metaphysical striptease, a play of simultaneous revealing and concealing. In opposition to this, consider the "radical disillusion" of Argento's cameo appearance as a stripper in Abel Ferrara's *Go-Go Tales* (2007): the pole-dancing act of Argento's character culminates in an artfully provocative French kiss that she exchanges with her Rottweiler. Here, the play of seduction is itself détourned into a literal "obscene transparency."

41. I am drawing here on Paolo Virno's sense of labor in the post-Fordist era as *virtuosity* (Virno 2004, 52-71). Such skill in performance has a double function. On the one hand, it answers the corporate demand for flexibility and versatility. Virtuosity "characterizes...the totality of contemporary social production. One could say that in the organization of labor in the post-Ford era, activity without an end product, previously a special and problematic case...becomes the prototype of all wage labor" (61). On the other hand, and at the same time, virtuosity is an expression of *general intellect* as the ultimate source of value. General intellect has an "exterior, social character" (38); it involves the entire "communicative capacity of human beings" (65); it belongs to everyone. Today we all face continual pressure, both inside and outside the workplace, to embody and display

our share of general intellect as fully and intensively as possible. This is necessary, in order that general intellect may be extracted from us, and privatized, as a new sort of surplus value. Throughout *Boarding Gate*, Sandra is obliged to demonstrate, in exacerbated form, the performative virtuosity that is compulsory in neoliberal society.

42. Translation slightly modified.

43. Gilles Deleuze uses this phrase from *Hamlet* to describe the Kantian revolution in philosophy, as a result of which time is freed from its classical subordination to movement (Deleuze 1984, vii). This liberation of time, the unveiling of "time itself, 'a little time in its pure state' " (Deleuze 1989, 17), is the key to what Deleuze calls the cinematic *time-image*, in which "we enter into temporality as a state of *permanent crisis*" (112). Both *Donnie Darko* and *Southland Tales* are concerned with such a sense of temporality in crisis, or temporality *as* crisis; though I want to suggest that the latter film moves 'beyond' the Deleuzian time-image in order to articulate a new regime of images and sounds, and a new mode of temporality.

44. Although Barack Obama was elected President on promises to reverse Bush administration policies, and although he has curbed some of its worst excesses, at this writing (2009) the wars in Iraq and Afghanistan continue, surveillance remains widespread, and the White House still endorses the use of preventive detention without trial.

45. In other words, science fiction is a kind of "realism": but it is a realism of what Deleuze calls the *virtual*, rather than one of the actual here and now. For Deleuze, "the virtual is fully real" on its own account; but it is a special sort of reality, "real without being actual, ideal without being abstract, and symbolic without being fictional" (Deleuze 1994, 208). I discuss science fiction as a realism of the virtual, which "addresses events in their potentiality," in my book *Connected* (Shaviro 2003a, xi and passim).

46. Ironically, very few people have seen *Southland Tales* on the big screen; in its limited release to movie theaters, it was a calamitous flop. The film disappointed fans of *Donnie Darko*, because it was so oblique and disjointed narratively, and because it was impossible to "identify" with any of the characters in the way that so many viewers did with *Darko*'s eponymous protagonist. As I will argue below, *Southland Tales* is no less empathetic to its characters than *Donnie Darko* is; but this empathy no longer takes the form of traditional cinematic "identification." As for film critics, *Southland Tales* had a few enthusiastic supporters among them: J. Hoberman (2007), Manohla Dargis (2007), and especially Amy Taubin (2007). But the majority of critics rejected it, perturbed by its loose ends, nonlinearity, and resolutely post-cinematic forms. Links to other reviews of the film can be found at <http://www.mrqe.com/movies/m100064789?s=1>. I can only hope that *Southland Tales* will find a new audience, thanks to its recent DVD and Blu-Ray releases.

47. The film critics Richard T. Jameson and Kathleen Murphy include the shot of G. I. Joe in their list of "favorite moments" from the movies of 2007: <http://movies.msn.com/movies/2007 review/moments_2/>. It is worth noting that much of the recent theoretical discussion of *cinephilia* has been concerned with "the cinephiliac moment": that is to say, with the way that cinephiles tend to focus upon, and even obsessively fetishize, particular shots, instants, or details of a film, which they extract and isolate from the film as a whole (Keathley 2006, 29-53). But *Southland Tales* is edited in such a way that each of its moments is, as it were, *already* thus extracted and isolated for cinephiliac delectation. Kelly simultaneously overloads us with "information," and disperses that information in such a way that we cannot bring it together, and grasp it as a whole.

48. The notion of *weak ties*, originally proposed by the sociologist Mark Granovetter (1973), has been applied to the

Internet by such network theorists as Duncan Watts (2004) and Albert-László Barabási (2003). If anything, the concept has been overused in recent years. I use it here only as a marker in order to help describe what I see as the dominant aesthetic of post-cinematic media forms, in which links and correspondences proliferate, without coming together in the unity of an overarching structure. Although the concept was originally meant to describe social links among individuals, I think it is useful as well to describe the way in which documents are loosely connected to one another via hyperlinks.

49. Emerson originally called his review "Is It Even a Movie? "; but he subsequently changed the title to: "Southland Tales: No Sparkle, No Motion." As he explains: "I don't want to sound like one of those people who says, for instance, 'Rap isn't even music! ' Not my intention. So I changed it." I am recalling Emerson's original title not to embarrass him or take him to task, but precisely to suggest that he was right in apprehending that, in a certain sense, *Southland Tales* isn't quite a movie any longer – and that this is probably what put him off when he watched it.

50. On a scene by scene basis, Kelly doesn't necessarily depart from the norms of what David Bordwell describes as the style of "intensified continuity" in recent American films (Bordwell 2002). But to the extent that this is so, it only shows the limitations of Bordwell's formalist claim that "nearly all scenes in nearly all contemporary mass-market movies (and in most 'independent' films) are staged, shot, and cut according to principles which crystallized in the 1910s and 1920s" (24). Indeed, Bordwell is accurate in describing how physical action is made intelligible within a single scene – not just in recent American film, but in television and music video as well. The trouble is that Bordwell takes far too narrow a view of expressive form in moving-image media. There are other modes of articulation in audiovisual media, in addition to the one that Bordwell privileges: tracking the locations and movements of

physical bodies in space. These other modes range from the modulation of the audiovisual spectator's moment-by-moment affective response on a micro-level, through the organization of spectatorial identification with characters or personas on a medium level, all the way up to general narrative organization on the macro-level. On all these levels, there is a much greater variety in regimes of vision and audition, and in modes of address, than Bordwell's shot analysis is able to account for. And this is especially the case with works produced using the new digital technologies, as well as with television, video, and computer-based media, and with films like *Southland Tales* that adopt the procedures of these post-cinematic media.

51. Deleuze uses this word to describe Leibniz's conception of the divergence between incompatible worlds (Deleuze 1993, 59ff.). The question is not whether two events or instances contradict one another; it is rather whether the two events can take place in the same world, or whether they necessarily imply different timelines. "Incompossibility is an original relation, distinct from impossibility or contradiction" (62). For the clash of contradiction can only take place within a given single world; the divergence of worlds or timelines exceeds any possibility of mere contradiction. Where Leibniz presents God as chosing the best among incompossible worlds, Deleuze sees in modern art and philosophy the simultaneous affirmation of all the incompossibles (81).

52. I take the concept of *flat ontology* from Manuel DeLanda, who uses it to characterize a view in which all entities at all scales have the same degree of reality and the same sorts of properties: "while an ontology based on relations between general types and particular instances is *hierarchical*, each level representing a different ontological category (organism, species, genera), an approach in terms of interactive parts and emergent wholes leads to a *flat ontology*, one made exclusively of unique, singular individuals, differing in spatio-temporal scale but not in

ontological status" [(DeLanda 2002, 47). DeLanda hedges on the question of whether Deleuze's ontology is really a flat one (DeLanda 2002, 178, 195). This is because he objects to Deleuze's willingness to speak "without hesitation" of entities such as "society" and "science," which DeLanda rejects as illegitimate, pre-given "totalities" (178). However, I would argue that a flat ontology only makes sense if it operates all the way up, as well as all the way down. DeLanda offers no good philosophical grounds for his reluctance to accept that "society" is just as much an individual, or a real entity, as are the "individual decision-makers, individual institutional organizations, individual cities, individual nation-states" (195) that form a population and thereby make it up. DeLanda's flat ontology is equivalent to what Deleuze calls *univocity*: the proposition that Being speaks with "a single voice," that "Being is said in a single and same sense of everything of which it is said," even though those things *of which* it is said "are not equal" and "do not have the same sense" (Deleuze 1994, 35-36).

53. At least one website, *Life in Motion*, identifies Dion and Dream as the Two Witnesses ("*Southland Tales* and Unanswered Questions," <http://oasis1315.wordpress.com/2009/03/16/south land-tales-whatta-flic/>). Other websites, however, suggest that the Two Witnesses are Ronald and Boxer – precisely because they are the ones who witness the murder of Dion and Dream (e.g., "Everything You Were Afraid To Ask About *Southland Tales*," <http://www.salon.com/ent/movies/feature/2007/12/19/southland _tales_analysis/print.html>). The former of these readings seems to me to be the more accurate one. Dion and Dream, as performers, are the ones who give "testimony" about the hypocrisy of their society, as the Biblical Witnesses are said to do. Ronald, together with his "brother"/double Roland, has the properly Messianic role in the film; and Boxer is his prophetic precursor, sort of a John the Baptist figure.

54. The analog cinematic image is indexical, in the well-known

sense defined by André Bazin; but the digital image is not. Where the cinematic image is a copy, the digital image is rather a simulacrum. Deleuze distinguishes the copy from the simulacrum as follows: the copy imitates, more or less faithfully, the model of which it is a copy; on the other hand, even if the simulacrum "still produces an *effect* of resemblance...this is an effect of the whole, completely external and produced by totally different means than those at work within the model" (Deleuze 1990, 258). The copy (or the Bazinian image) is mimetic in the deep sense that its production is continuous with the existence of its model; the cinematic image "shares, by virtue of the very process of its becoming, the being of the model of which it is the reproduction" (Bazin 2004, 14). But in digital simulation, this is no longer the case; the effect of mimetic resemblance is produced by means that are not themselves mimetic or resembling. The digital image gives us only "the pseudorealism of a deception aimed at fooling the eye (or for that matter the mind); a psuedorealism content in other words with illusory appearances" (Bazin 2004, 12). Even if Hollywood mostly uses digital imaging techniques for the purpose of achieving a convincing "perceptual realism," as Stephen Prince argues (1996), the result is still a simulacrum rather than a 'legitimate' copy.

55. The work of a younger-generation Hollywood blockbuster director like Michael Bay could usefully be examined in the light of these distinctions. Bay's films – in contrast to those of Spielberg and Zemeckis – eschew considerations of continuity almost entirely, in favor of disjunctive cutting engineered so as to maximize shock. In Bay's films, as Bruce Reid puts it, "edits seem random, every rule of film grammar is tossed out the window, and the headlong rush of movement forward is all." Bay's aesthetic is based upon the faith that you can "splice any two shots together and they'll match." The result is a cinema that is entirely incoherent, and yet "immediately legible to anyone" – as

Bay's high box office numbers prove (Reid 2001). Or, as Charlie Jane Anders puts it, the lesson of Bay's cinema is "that once the world is reduced, forever, to a kaleidoscope of whirling shapes, you are totally free. Nothing matters, effect precedes cause, fish spawn in mid-air, and you can do whatever you want" (Anders 2009). Using the tools of digital editing and compositing, together with CGI, Bay makes films that are utterly disjointed, and yet unfold in such a "smooth space" that these disjunctions scarcely matter to mass audiences. Even in mainstream popular cinema, we now have films that, in Deleuze's terms, evidence "a new status of narration," in which "narration ceases to be truthful, that is, to claim to be true, and becomes fundamentally falsifying" (Deleuze 1989, 131). Bay's films, no less than the art films of the Deleuzian *time-image*, reject organic unity, and are littered instead with gaps and false accords.

56. In the original version of *Southland Tales* shown at Cannes in May 2006, the tone of Timberlake's voiceover was apparently more sarcastic; Kelly says that, in reworking the film for its 2007 commercial release, "I also had Justin rerecord his narration to be more like Martin Sheen's in *Apocalypse Now*. I had him do it really deadpan" (Steuer 2007).

57. This is the case, for instance, in Robert Aldrich's *Kiss Me Deadly*, a film that is referenced several times in *Southland Tales*. The stentorian, masculine voice of the villain, Dr. Soberin, is heard throughout; but we do not get to see his face until the very end of the movie. The film emphasizes "the invulnerability of that voice during the extended period of time when its source remains invisible, and its abruptly actualized mortality the moment its source comes into view" (Silverman 1988, 62).

58. For the notion of the "audiovisual passage," I draw upon the work-in-progress of Carole Piechota (2009). At certain privileged moments in many recent American films, she writes, the director "subordinate[s] the image to the counters and tempo of the music" (21). A familiar pop song is played in its entirety; its

excessive insistence within the film addresses, and affects, the viewer/listener directly, demanding an immediate emotional response. Interpellated in this way, the viewer/listener cannot understand the song just as an expression of the protagonist's sensibility. The music overflows the diegetic situation in which it arises, and to which it ostensibly refers. "As these passages frequently last for several minutes (often the length of a pop song) and either lack or downplay dialogue, the perceiver is left with more time to acknowledge or contemplate her bodily and affective experiences" (22).

59. See Timberlake's videos with Rihanna ("Rehab," directed by Anthony Mandler, 2007), Ciara ("Love Sex Magic," 2009, directed by Diane Martel), and Madonna ("Four Minutes," 2008, directed by Jonas & François). These videos may be contrasted with the videos from Timberlake's own *FutureSex/LoveSounds* album, which Joshua Clover convincingly describes as a "homosocial" exchange between Timberlake and his producer Timbaland: "The album itself, both in its sonic intertwinings and lyrics, is almost entirely about the great love between Justin Timberlake and Tim Mosely, who basically sing, rap and murmur romantic, sensual phrases to each other for about an hour, climaxing mid-album with the slinky, beautiful 'What Goes Around...' " (Clover 2006). In this case as well, sexual intensity seems to be conjured out of almost nothing. It's as if the glamour and heat were not anchored in Timberlake's physical or empirical presence, but arose precisely out of the gap or distance between that actual presence and the endlessly reproduced, fluttering image of Timberlake as pure media product. The aura doesn't come from the performer himself, so much as from the *production process* in the course of which he is transfigured. The old Hollywood manufactured celebrities, of course. But Timberlake's post-cinematic celebrity is different, in that it openly attaches itself to the actual process of manufacture, rather than just to its result.

60. Though I am still using the word "image" here, this must be understood in a multimedia sense, as Deleuze uses it towards the end of his second *Cinema* volume: the audiovisual image can be a "sound image" as well as a "visual image" (Deleuze 1989, 241-261).

61. The classic reference point for these matters is Lionel Trilling's *Sincerity and Authenticity* (1972). Trilling sees authenticity as a modernist invention, while sincerity has a much longer genealogy. As Orlando Patterson summarizes it, updating Trilling's distinction for the twenty-first century: "sincerity... requires us to act and really be the way that we present ourselves to others. Authenticity involves finding and expressing the true inner self and judging all relationships in terms of it" (Patterson 2006). Today, I think that we have good reason to be suspicious of claims to authenticity: in the first place, because such claims rely upon a modernist sense of depth which is no longer tenable in an age of universal commodification or "real subsumption"; and in the second place, because "authenticity" has become entirely a category used by advertising and marketing. Sincerity, however, has a much wider range of application; it does not presuppose the existence of any "true inner self" to which one must remain faithful at all costs. A fiction, fabrication, or construction may well be sincere, even though it is evidently not authentic.

62. So understood, Harman says, sincerity is "a universal structure that is inescapable by any entity, one that is present at all moments in all parts of the universe" (Harman 2005, 136). I find this useful as a background assumption, in opposition to the universal cynicism that is sometimes assumed in accounts of the "postmodern." But I still claim that sincerity is manifested in different ways, and to different degrees, as objects relate to other objects, or more generally to their surroundings.

63. I am, of course, taking the notion of a "cultural dominant" from Fredric Jameson, who uses it to describe the way that a particular form may be "a dominant cultural logic or hegemonic

norm" in a given historical period, without thereby implying "an idea of the historical period as massive homogeneity." The notion of a "cultural dominant" thus leaves things open for understanding the play, as well, of "what Raymond Williams has usefully termed 'residual' and 'emergent' forms of cultural production" (Jameson 1991, 3-4,6).

Today, cinema is undoubtedly a residual cultural form – which doesn't mean that it is going to disappear any time soon. The technological innovations of such directors as Robert Zemeckis, Michael Bay, and James Cameron are attempts to reclaim hegemonic cultural status for the movies. I am arguing here that, in contrast to such mainstream directors, and precisely thanks to their low budget, exploitation-feature market niche, Neveldine/Taylor actively affirm the residual status of the movies, and link this directly to certain emergent cultural practices, in a way that does an end run around the cultural dominant. (This dominant can best be described as involving pervasive digitalization, ubiquitous algorithmic procedures, the hyperrealist simulation of images and sounds, and incessant, 24/7 networking). *Gamer* is so profoundly *actual*, or contemporary, because of the way that it simultaneously highlights the cultural dominant, and evades it or works around it. I do not claim that this evasion is automatically subversive, resistant, or oppositional – at least in the way these terms have been commonly understood. But I want to suggest that the film's unflinching insistence upon "this exact moment" opens the way to a consideration of alternatives to our current condition of "capitalist realism" (Fisher 2009).

64. The strategy of ironic recycling is central to the work of such important contemporary directors as Quentin Tarantino and the Coen Brothers. In a different way, the current international style of "contemplative cinema" (Tuttle 2009) is also a strategy of nostalgic recycling – though in this case, what is being recycled is neither classic Hollywood (the Coens) nor low-

budget exploitation fare (Tarantino), but rather the art films of the 1960s.

65. As one pseudonymous blogger complained in his review of the film: "I thought the film viciously exploited stereotypes in creating its media obsessed future-world. Every character who plays games in the film is portrayed as either a complete pervert (Ramsey Moore), a douche bag (Logan Lerman), or just plain evil (Michael C. Hall). Not really a surefire way to get the real gamers of the world to rally around your film, now is it? " (agentorange 2010). It should be noted, however, that Neveldine/Taylor are clearly working from a position of close familiarity with gaming environments; their satire has little to do with the moralistic condemnations of gaming one often finds in the mainstream media.

66. Second Life's website boasts of the fact that the world of the game is "user-created" (http://secondlife.com). In practice, this means that the work of designing the virtual world is in fact performed by the very people who pay to "own land" and otherwise participate in it. For a fuller discussion of this process, see my article "Money for Nothing: Virtual Worlds and Virtual Economies" (Shaviro 2008).

67. *Gamer* was largely shot using the RED ONE digital camera system (http://www.red.com/cameras/). The cameras were handheld, and the directors frequently shot scenes while holding the cameras and following the action on rollerblades. The action sequences were shot by as many as seven cameras simultaneously; this extensive coverage gave the directors sufficient material for their rapid-fire editing. Nearly all the action sequences in the film were shot live; Neveldine/Taylor made very little use of green screens and CGI (Kara 2009). For technical details of the film's production, see the discussion by the website Videography (2009).

68. The most famous use of the subjective camera in classical cinema is that of Robert Montgomery's *Lady in the Lake* (1947),

shot almost entirely from the POV of the protagonist. The result is not empathy, or identification with the protagonist, but rather a general feeling of distance and unease. In the absence of a reverse shot, allowing us to see the protagonist looking, we do not feel anchored in the diegetic world of the film. Today, the subjective shot is almost exclusively used in horror films, in order to convey the POV of the monster – following the example of the shark's-eye POV shots used by Steven Spielberg in *Jaws* (1975). To see through the monster's eyes is precisely not to see the monster, but only its victim. The audience is titillated by an uncanny sense of complicity with the monster; but this is very different from the way that identification with the protagonist generally works in mainstream narrative film. I have previously considered the strange qualities of the first-person POV shot in a discussion of Kathryn Bigelow's highly reflexive use of this technique in her 1995 film *Strange Days* (Shaviro 2003).

69. Indeed, early filmmakers and film theorists explicitly celebrate the movie camera's separation from, and transcendence of, merely human (subjective, first-person, fully embodied) vision. For Dziga Vertov, the camera operates "in a manner wholly different from that of the human eye"; it is no longer "forced...to copy the work of the eye," but is instead liberated "for the exploration of the chaos of visual phenomena that fills space" (Vertov 1984, 15-16). For Walter Benjamin, "clearly, it is another nature which speaks to the camera as compared to the eye... a space informed by human consciousness gives way to a space informed by the unconscious... It is through the camera that we first discover the optical unconscious, just as we discover the instinctual unconscious through psychoanalysis" (Benjamin 2003, 266). In both cases, the camera gives us a point of view which cannot be identified with that of any of the characters within the diegesis.

70. It is André Bazin, of course, who champions a cinema that seeks "to do away with montage and to transfer to the screen the

*continuum* of reality" (Bazin 2004, 37), and "to make cinema the asymptote of reality" (Bazin 2005, 82). This implies, however, "that it should ultimately be life itself that becomes spectacle in order that life might in this perfect mirror be visible poetry, be the self into which film finally changes it" (Bazin 2005, 82). It is a cruel historical irony that, today, we would seem to be getting closer than ever before to Bazin's ideal of an "integral realism" (2004, 21), or of a seamless continuity of spectacle, not by embracing the real, but by getting rid of it altogether, and putting in its place an entirely simulated world. The problem, as Bazin himself is well aware, is that no "transference of reality from the thing to its reproduction" (2004, 14) is ever complete enough so as to obviate the need for montage and for selection. Something has always been left out; and some degree of editing is always needed in order to compensate for (or to supplement, in Derrida's sense) that which has been left out.

Computer games, unlike films, escape this dilemma to the extent that their worlds are generated algorithmically from the beginning, rather than being selected from a pre-existing reality. The problem is that, thus far at least, no digitally rendered world has quite attained the sensorial richness of the actual world we live in; and therefore no digital simulation has achieved Bazin's dream of "the reconstruction of the reconstruction of a perfect illusion of the outside world in sound, color, and relief" (Bazin 2004, 20). Recent spectacular films like James Cameron's *Avatar* (2009) seek to overcome this difficulty by combining computer animation with motion capture of the gestures, expressions, and movements of flesh-and-blood actors

71. How do we *judge* the ontological difference between analog and digital media, and in particular between celluloid movies and first-person computer games? David Rodowick covers much of the same ground as Alexander Galloway, but comes to radically different conclusions. For Rodowick, "typically a subjective traveling shot in film is one kind of long

take, but not characteristic of the mobile frame itself. It lends itself to the multiplication of points of view and, through the camera, enjoins the spectator to partake of a multiplicity of perspectives through mobile viewpoint. Alternatively, perceptual immersion in virtual worlds amplifies a certain form of skepticism. Indeed, it produces a form of monadism in which there is no present other than mine, the one I occupy now; there is no presence other than myself" (Rodowick 2007, 171-172).

In effect, Rodowick claims that old-style movies are morally superior to newfangled video games, in much the same way that André Bazin made a claim for the moral superiority of mise-en-scène over montage. In Rodowick's argument as in Bazin's, the ambiguity and freedom of interpretation allowed by the movies (or by mise-en-scène) is set against the fixity and single meaning imposed by video games (or by montage). In addition, Rodowick draws on Stanley Cavell's notion of film as "a moving image of skepticism" (Cavell 1979, 188). But where the movies "pose both the condition of skepticism and a possible road of departure, the route back to our conviction in reality" (Rodowick 2007, 69), video games for Rodowick do nothing but imprison us yet further in "a certain form of skepticism," which is to say, a situation of total alienation from the world.

I find Rodowick's polemic here as dubious as it is remarkable. He is right to insist upon the radical ontological difference between celluloid film and the newer digital media. But he imposes an *a priori*, univocal reading of the meaning and possibilities of the digital – although he would never accept so reductive an argument in the case of film. Rodowick fails to give us an account of digital ontology that is anywhere as open, sensitive, and generous as were Bazin's and Cavell's accounts of the ontology of photography and film. My hope, in discussing the ways that a digital film like *Gamer* moves between the realms of the movies and of computer games, is that I may at least begin the task of working out a more adequate account of the ontology

of the digital.

72. This is according to the Internet Movie Database: "The opening montage of time-lapse shots and other scenes of the world where we see ads for Kable and/or graffiti of Ken Castle overlaid on buildings or walls are mostly taken from Ron Fricke's wordless film *Baraka* (1992), for example, the shots of the Giza Pyramids, India, homeless man sleeping under a bridge among others" (http://www.imdb.com/title/tt1034032/trivia).

73. As quoted on the website "Spirit of Baraka" (http://www.spiritofbaraka.com/ron-fricke).

74. This is the reason why "science fiction" has today come to be pretty much the equivalent of social realism. In one sense, the most intense aspect of our lives today is our sense of futurity, of continual innovation and continual product turnover; and yet this futurity has no other content than "more of the same," or what Ernst Bloch called "sheer aimless infinity and incessant changeability... a merely endless, contentless zigzag" (Bloch 1986, 140). Thus, we are always being urged to upgrade our computers, which fall quickly into obsolescence through the force of Moore's Law; we are always looking for the next fad, the next cool thing, to such an extent that all fads and fashions seem to exist simultaneously. This urgency without change, or novelty without difference, is an expression of the commercial product cycle that dominates all aspects of our lives; it is the equivalent, on the level of content, to genre-conformity on the level of form. As with every other aspect of its production, the strategy of *Gamer* in this regard is not to offer a critique, but to embody the situation so enthusiastically, and absolutely, as to push it to the point of absurdity.

75. There are many issues here that merit further discussion. For one thing, I have deliberately left open the question of whether the filmviewer's "identification...via empathic mirroring" be thought about in psychoanalytic terms, in affective terms, or even in neurological terms (via the currently much-

discussed phenomenon of "mirror neurons"). For another thing, *Gamer*'s central conceit of players controlling the actions of real-life avatars foregrounds the question of how the so-much-vaunted interactivity of computer games – and of Web 2.0 technologies more generally – is in fact intertwined with its obverse: the increasing sense, in a speeded-up and highly networked society, that we are in fact being constrained, or even operated, by *remote control*. And for yet another thing, the experience of remote agency, or involvement at a distance, might well be thought in terms of Graham Harman's notion of *vicarious causation* (Harman 2007). For Harman, the world is "made up of vacuum-sealed objects" (194), which can only contact one another allusively and aesthetically. Every contact happens at a distance, Harman says; "two objects must somehow touch without touching" (204).

76. It should be noted that this murder footage also appears elsewhere in the film, in other contexts. For instance, the Humanz initially gain Simon's attention by showing him a fragment of the murder sequence, looped and repeated – despite the fact that this takes place well *before* they retrieve the scene from Kable's memory. At this point in the film, the audience cannot make sense of the sequence – just as, within the diegesis, the Humanz could not possibly have access to it yet. In addition, when the sequence is shown to Simon, it is clearly marked as surveillance footage, with a timestamp and the words "Exhibit 11" (suggesting, perhaps, that it was used as evidence in Kable's trial – which would explain its availability, but at the price of undermining the later plot point in which the Humanz urgently need to retrieve the sequence from Kable's mind). These markings are lacking when the sequence reappears as a literal transcription of Kable's memories.

Of course, this sort of ambiguity is not unusual, particularly in exploitation movies, where the filmmakers frequently take such shortcuts, either out of sloppiness or because they hope the

audience won't notice. But in *Gamer*, such accidents and/or cheats are themselves meaningful, and almost systematic. The fact that a transcription of Kable's intimate (and perhaps repressed) memories should be indistinguishable (aside from the timestamp) from objective videocam surveillance footage is an important part of the movie's explicit point.

77. This is confirmed by the directors' commentary on the *Gamer* DVD.

78. I am sympathetic to Daniel Frampton's suggestion that a film itself may be said to think – independently of the thoughts either of characters within the film, or of the filmmaker as *auteur* (Frampton 2006). However, in determining *how* a film thinks as well as *what* it thinks, we need to pay more attention than Frampton does to questions both of media ontology, and of the ways that economic and social forces invest a given film.

79. Once again, I find Rodowick's distinctions between analog movies and digital games useful, even though I do not share his melancholy nostalgia for the former: "We recognize the perceptual power of photography and film retroactively as a disappearing or vanished world; we are drawn to digital or inter-active screens as a will to grasp a future that is always running ahead of us and pulling us forward in its slipstream... Technological innovation always seems to run ahead of the perceptual and cognitive capacity to manipulate them for our own ends. It is the failure to arrive at what always comes ahead" (Rodowic 2007, 176). In this way, "the modularity, incom-pleteness, and mutability of the digital electronic image, as well as its inseparability from an interactive screen, are equally expressive of this temporal state that draws us toward the future rather than engaging us with the past" (177).

*Gamer*'s actualism does indeed express a sort of orientation towards the future that cannot be described in the traditional terms of duration, or of a horizon of expectations. Futurity is more like a combination of transience and incipience. It is already

implicit within the Here and Now. The future is always coming towards us; it never actually arrives, but it continually gives us an ever-more-vivid sense of its ever-impending arrival. This is one reason for the extremely stylized fragmentation that is characteristic of recent action films by such directors as Tony Scott and Michael Bay, and that Neveldine/Taylor hone to so concise a point in *Gamer*.

80. The only way to eliminate the ping is to eliminate the controller, and allow the avatar autonomous freedom of action. Such is the case with Hackman, the mad killer whom Castle sends into Slayer for the express purpose of bringing down Kable. Hackman adds an unpredictable, rogue element to the game, but he also remains entirely a tool of Castle. When Hackman first encounters Kable, in prison, he sings a grotesque version of the song "I've Got No Strings" (from Disney's *Pinocchio*). The song emphasizes the fact that Hackman is not directly controlled by any outside gamer, and hence not subject to the delays of the ping; but it also perhaps suggests that he is still a puppet nonetheless. As for Kable himself, when the Humanz free him from his controller, he uses the opportunity to escape from the Slayer gameworld altogether. We later learn, however, that this release from control is only temporary. We also discover that Kable remained under surveillance during the entire time that he was acting freely; by tracking Kable, Cable's men are able to locate the Humanz's headquarters, and wipe them out. In effect, the online gaming definition of "ping" as network latency is simply replaced by the (slightly older) computing definition of "ping" as a notification signal passed by one computer to another. In either case, what would seem at first glance to be a gap or interruption in the seamless operation of the network turns out, upon further examination, actually to facilitate control.

81. Darko Suvin first defined science fiction as a literature of "cognitive estrangement" in a book published originally in 1972

(Suvin 1979). More recently, Carl Freedman has extended and expanded this definition (Freedman 2000). While the notion of cognitive estrangement, with its deliberate echo of Brecht's *Verfremdungseffekt*, works well for the mid- to late-twentieth century literary science fiction discussed by Suvin and Freedman, the historical limits of this concept (or practice) need to be recognized. In a world where the cultural and economic spheres largely intersect, where modernist distanciation techniques are routinely used in advertising and publicity, where the media address spectators and users affectively, bypassing the cognitive altogether, and where the aesthetics of rupture and shock have themselves become entirely normative, the whole question of subversion in art and culture needs to be radically rethought.

82. I am thinking here of Ian Bogost's notion of the *procedurality* of computer- and technology-based works in particular, but more generally of all cultural artifacts in the digital age (Bogost 2006, 46). Bogost's procedural forms, like Franklin's executive ones, depend upon rule-based "unit operations" and manipulations of symbols. Bogost later extends this to a concern with "procedural rhetoric" as a basic new-mediatic form of persuasion and control (Bogost 2007).

83. David Bordwell is unsurpassed when it comes to exploring film stylistics in detail. But he is flat and unconvincing when he tries to explain his observations in cognitivist terms. In classical fight sequences, he argues, "the stylistic orchestration of the fight trips off optical, auditory, and muscular responses in our bodies, while the pauses give the movement a chance to echo" (Bordwell 2008). That is to say, Bordwell claims that the orchestration of motion through space and time in classical fight sequences is beautiful and effective because it stimulates the human sensory-motor system in a certain normative way. But such an account is entirely inadequate to the aesthetic intensity of action sequences by directors like Siegel and Mann – or for that matter, Peckinpah and Woo. These classical fight scenes articulate time and space in

such a way as to establish an *ontological consistency* that goes well beyond sensory-motor stimulation. And this consistency is anything but normative; it is rather a singular concatenation of "extraordinary points of view" (Deleuze 1986, 15). As Deleuze insists, classical (movement-image) and modern (time-image) cinema alike depend, not upon the normative completion of the sensory-motor circuit, but rather upon its unanticipated *breakdown*: "an *interval* appears – a gap between the action and the reaction," or between stimulus and response (Deleuze 1986, 61).

In contrast to both classical and modern cinema, post-continuity filmmaking abandons the ontology of time and space; it no longer articulates bodies in relation to this. Instead, it sets up rhythms of immediate stimulation and manipulation. The shots are selected and edited together only on the basis of their immediate visceral effect upon the audience moment to moment. There is no concern for any sort of pattern extending further in space and time. This is precisely why – as Bordwell complains – post-continuity action editing gives us only the impression of "a vague busyness, a sense that something really frantic but imprecise is happening" (Bordwell 2008). In other words, and quite ironically, it is Michael Bay's cinematic practice, utterly deplored by Bordwell, that really conforms to Bordwell's cognitivist view of a cinema that works to "trip off optical, auditory, and muscular responses in our bodies." Conversely, the practice that Bordwell (rightly) celebrates for its cinematic mastery resists being understood in Bordwell's reductionistic terms.

84. According to the directors' commentary on the *Gamer* DVD, the film was made on a budget of $50 million – not a tremendous amount by current Hollywood standards, but well above the low end, and considerably more than the directors had at their disposal for their two *Crank* features.

85. Thanks to Seb Franklin (2009b) for demonstrating, and working through, the ways in which Deleuze and Guattari's

notion of "minor literature" is particularly applicable to media counter-practices in what Deleuze calls the control society.

86. It is precisely because *Gamer* is an action-oriented exploitation flick, rather than a movie that seeks to express the psychological interiority of its characters, that it is able to provide us with something like what Fredric Jameson calls a "cognitive mapping" of postmodern capitalism, giving us "some new heightened sense of [our] place in the global system" (Jameson 1991, 54).

87. Michael Hardt and Antonio Negri define "real subsumption" as the moment when "labor practices and relations created outside of capitalist production" are no longer "imported intact under its rule" (which is what happens in merely "formal subsumption"), but instead "capital creates new labor processes no longer tied to the noncapitalist forms, and thus properly capitalist" (Hardt and Negri 2009, 229). Hardt and Negri suggest that globalized capitalism not only "involves a general passage from formal to real subsumption," but also provokes "a reciprocal movement... from the real subsumption to the formal, creating not new "outsides" to capital but severe distinctions and hierarchies within the capitalist globe" (230). As I have already suggested, however, I think that it is better to conceive the whole process as a *tendential* movement from formal to real subsumption. A tendential movement is just that: a tendency and not a fatality. It is never entirely accomplished, both because it is always opposed by what Marx calls "counteracting factors," and because it never achieves any sort of teleological closure, but always reproduces its own tensions on an expanded scale. Marx develops his theory of tendential processes in *Capital* volume 3 (Marx 1993, 317-375).

88. If we accept Gregory Bateson's famous definition of *information* as "a difference which makes a difference" (Bateson 2000, 459), then we might say that the current Internet information glut is really a condition of maximal indifference or

entropy.

89. Today, of course, such processes particularly take the form of the disaggregation and precarization of labor, the aggressive privatization of public and common goods, the dominance of finance over production, and the continuing "primitive accumulation" of previously untapped and uncommodified areas of life and experience. Behind all these lies the neoliberal credo, which inverts the relationship of part and whole: instead of the market being understood as a part of society, all social processes are now exclusively understood in terms of the market. The nineteenth-century roots of this synecdochial inversion are traced in great detail by Karl Polanyi (2001); the recent neoliberal reinvention and intensification of the reversal is dissected by Foucault (2008). The economic crisis that started in 2008 has, alas, not led to any rethinking of this fundamental assumption.

90. These lines come from the first edition of Attali's book, originally published in French in 1977. They are omitted from the (as yet untranslated) revised edition of 2001.

91. An earlier Marxist theory would have spoken here of capitalism's "crises" and "contradictions." In recent years, we have learned, to our cost, that crises and contradictions work more to reinvigorate capitalism than to endanger it. Mainstream neoclassical economics still tends to use equilibrium models; but actually existing capitalism is *metastable* rather than truly stable (cf. Simondon 2005). It functions as a *dissipative system* (cf. Prigogine and Stengers 1984), operating most effectively, and reproducing itself on an expanded scale most successfully, in far-from-equilibrium conditions.

92. Noys locates accelerationism particularly in certain theoretical texts originally written and published in France in the 1970s: Deleuze and Guattari's *Anti-Oedipus* (1983), Jean-François Lyotard's *Libidinal Economy* (1993), and Jean Baudrillard's *Symbolic Exchange and Death* (1993). He sees the

accelerationist theorizing of these texts as an understandable, if ultimately unsuccessful, attempt to "stay faithful to the libertarian effects of May '68 that involved the breaking-up of pre-existent moral and social constraints, especially in education, sexuality, and gender relations," while at the same time resisting the process by which this libertarian impulse was recuperated within the post-Fordist "new spirit of capitalism" (Boltanski and Chiapello 2007). The question of what value accelerationism might have today, thirty-five years after the fact, is one that I am trying to answer here in explicitly "aestheticist" terms.

93. Despite my general sympathy for Hardt and Negri's position, I find it difficult to credit their claim that the movement of real subsumption – involving the increased precarization and fragmentation of labor, and the horrific development of a "society-based capital in which society as a whole is the chief site of productive activity," and hence of expropriation or surplus value extraction – somehow leads to a situation in which "labour-power is thus no longer variable capital, integrated within the body of capital, but is a separate and increasingly oppositional force" (Hardt and Negri 2009, 292). It would seem, rather, that labour-power is more integrated within the body of capital than ever, insofar as it is now 'on call' 24/7, with its leisure time as well as its formal work time, and its common social activity as well as its particular laboring tasks, harvested for the extraction of relative surplus value.

94. The more literal alternative translation suggested in the Notes to Benjamin's *Selected Writings* is perhaps better: the shock effect of film, like all shock effects, "seeks to be buffered by intensified presence of mind" (Benjamin 2003, 281). The point is that the shocks of industrial, capitalist modernity are accelerated by the cinematic apparatus, thus allowing spectators to adapt themselves, and habituate themselves, to such shocks. Thus "humanity's need to expose itself to shock effects represents an adaptation to the dangers threatening it" (281). We are presented

in the modern world with "new tasks of apperception"; film trains us to master these tasks by creating the conditions under which "their performance has become habitual" (268).

95. I have taken the phrase "free-floating and impersonal" from Jameson (1991, 16), but applied it to the financial flows themselves, rather than just (as Jameson does) to the structures of feeling associated with them.

96. I am thinking here, of course, of Bruno Latour's principle that "there are no equivalents, only translations... If there are equivalences, this is because they have been built out of bits and pieces with much toil and sweat, and because they are maintained by force" (Latour 1988, 162). Or, as Graham Harman summarizes this principle of Latour's, "there is no such thing as transport without transformation" (Harman 2009, 76).

Contemporary culture has eliminated both the concept of the public and the figure of the intellectual. Former public spaces – both physical and cultural – are now either derelict or colonized by advertising. A cretinous anti-intellectualism presides, cheerled by expensively educated hacks in the pay of multinational corporations who reassure their bored readers that there is no need to rouse themselves from their interpassive stupor. The informal censorship internalized and propagated by the cultural workers of late capitalism generates a banal conformity that the propaganda chiefs of Stalinism could only ever have dreamt of imposing. Zer0 Books knows that another kind of discourse – intellectual without being academic, popular without being populist – is not only possible: it is already flourishing, in the regions beyond the striplit malls of so-called mass media and the neurotically bureaucratic halls of the academy. Zer0 is committed to the idea of publishing as a making public of the intellectual. It is convinced that in the unthinking, blandly consensual culture in which we live, critical and engaged theoretical reflection is more important than ever before.